序

對於茶，雖然不至於像對於酒那樣，我絕對不喝，却也喝得很少現在我所喝的，就只是開水。

一天到晚在冬季，我大約要喝一壺開水在夏季，則至少兩壺，如果打了球那就三四壺都說不定。

我只用一把瓷壺，不用杯子，嘴對嘴喝着我以爲這種喝最衞生最爽快爲什麼要用杯子多所麻煩

呢」反正這一把壺又只有我一個人喝（偶然我的妻與兒女也要喝，我也由他們喝，反正同爲一家人

吃同一隻鍋子燒出來的同一隻碗盛出來的飯與菜，要避免什麼不良的傳染也避免不到什麼地方

去何况我相信我們一家人都十分健全誰的口腔裏也不含有一些傳染病不過這也許不能通行到

別人家去那末我還是主張一人一把壺嚴去杯子就是了）

我最不喜歡喝熱水瓶中倒出來的熱開水，而只喜歡喝冷開水。這在夏天，固然很涼，也許爲別人

所歡迎在冬天恐怕就有人要對之搖頭吧。但我却以爲冬天喝冷開水其味無窮並不下於夏天的冰

淇淋假使你不相信，請你嘗嘗看。

我這樣的喝開水不喝茶甚至冬天喝冷開水，不喝熱開水當然是有原因的，並非我窮得連茶葉

都買不起，或故意要驚世駭俗作此怪僻的行為原因很簡單，就是怕麻煩。既然喝茶是為了解渴開水

冷開水都可以解渴何必一定要喝茶要喝熱開水呢？若說喝茶並非為了解渴是為了享受茶味，為了

助談與與人聯歡那末我沒有這種心思這種工夫由別人去吧，我不反對，但同時我希望別人也不要

勉強我勉強我去喝這樣的茶。

蘇州人上茶館似乎是很出名的。我曾在蘇州作過事可是一年之內我只上過一次，至多二次茶

館，那是為了朋友約在那處，不能不去在故鄉在別處，我就從來不一個人或和別人上茶館去喝茶除

了有時為人所約，非在這種地方不可之外。

不過我的喝冷開水也不自今日始我從小就喝過各種水。我是鄉下人出身，我正可以告訴你一

些鄉下人，也就是我所喝的水最普通的是缸裏的河水這在我家是用礬澄清過的在有些人家根本

就不用礬夏天喝井水涼沁心脾決不下於冰凍荷蘭水池水我也喝過我最記得由我鄉間的故鄉上

城時必須走過一個出名的「清水池塘」在熱天我走到那裏和別人一般總要蹲下去用手掬着喝

一個飽。山間的泉水當然是最好的，我往往要伏下去作一會牛飲此外還有「天落水」我也喝過甚

至我祖母所說的「竈家菩薩的洗脚水」就是「湯罐水」我也喝過。

我的祖母是不許我喝「生水」的，甚至也不給我喝開水，而給我喝茶。但我也許生性不習上看

心一堂　飲食文化經典文庫

見左鄰右舍同樣的孩子，甚至在喝着污水並不哼一下肚子痛，我就羨慕得不得了。我要自由喝水我不願意在喝時受束縛，所以在我的祖母管不着我時，我就喝着上述的種種水。僥倖我也並沒有因此鬧過一次肚子。二十多年前在上海有一年我就完全喝自來水，原因是只有一個人不高興每天上老虎竈去泡開水，結果也很好並沒有意外。

我的確主張喝生水，這有什麼不好呢？有幾個鄉下人是喝熟水的？我以為只要身體健康，就百病消除不信，正可以使我們記起這樣的醫藥故事：某醫藥教授在其身體健康時當衆喝下一杯霍亂菌，結果揚揚如平時並未吐瀉據說，航海的人缺了淡水，可以用布絞了鹹水喝旅行沙漠的人缺了鮮水，連泥漿都會喝下去安知我們就不會有這一天呢？到了這一天你將如何呢？（我主張積極的壓倒病菌的衛生不主張消極的，處處向病菌示弱的衛生理由很多，大家總能想到。）

我那樣的生水都喝過我的喝冷開水又何足為奇！不但不足為奇，簡直已經很奢侈了：烹熟的，還要用瓷壺裝，雖然勉強取消了一隻杯子。

不過我在鄉間的兒童時代到底是喝茶的時候為多，而喝生水或開水的時候為少，原因就為了我的祖母是「城裏人」出身她的飲食起居不同於一般鄉下人所以我在解渴時總喝着茶。

最普通的茶是到街上去囘買來的茶梗泡的牠的味道平常得很無可紀念使我至今還忘不掉

的是這種茶：一焦大麥茶這是許多種田人都喝的，其甘香之味，我以爲遠勝於武彝或普洱二，鍋巴

茶據說從前某皇帝正德或乾隆，出外「游龍」在一個鄉下人家喝了鍋巴茶囘到皇宮裏因爲御茶

房燒不出這種茶殺了不知多少人其味之佳可想而知。三棠棣茶這是生在山上的較小的一種山楂

樹，將牠的葉子採囘來炒焦了也可以泡茶吃我家沒有偶然在鄰家喝到，其味似乎有些澀的。四夏枯

草茶這也在鄰家喝到有些藥味，不過澀與藥也另有清涼之味。

我家還背買茶葉——其實是茶梗——，所以還有眞正的茶喝一般茶的，就大

都只用焦大麥與鍋巴來泡茶。因爲這不必費錢去買大麥與鍋巴，都是自己家裏有的東西只要炒炒

焦就是了。還有些二人家，爲了捨不得大麥與鍋巴而也要嘗嘗茶味，就只有採取野生的棠棣和夏枯草

了。我忝爲鄉下人總算都嘗到了這些好茶我想，如果將這些茶料裝潢起來，放在錦盒中題個什麼佳

名或者甚至說是外國來的，有如 Lipton，放在上海各大公司的櫥窗裏出售，也許會被高等士女所

嘖嘖稱道吧！咖啡和可可都是南美洲土人喝的東西，但一經提倡便風行全球安知牠們不會也有這

一天呢！「口之於味也有同嗜焉」至少在現今的時世，不大靠得住可惜牠們都埋沒在鄉間終於難

登大雅之堂然而牠們到底還是儌倖的牠們保全了牠們的天眞本味與鄉下人爲伍得到了鄉下人

爲知巳並沒有爲高等的士女所汚辱。

懷說，有些地方還有炒柳葉或槐葉當茶葉的，我沒有嘗過這種茶，不知是什麼味道，但我卻贊成

這個辦法我相信可以泡茶的植物一定是多的，其效用也不會亞於茶的，何必一定要求茶呢？菊花已

很普通當我小學時，我還在校用枯乾的木香花瓣泡過茶，其味也不見得比菊花壞扳，我以為凡物要

被大人先生或高等士女弄得非驢非馬，引為他們的專有品，就由牠們去好在天地之大無所不有，我

們正可以另從便利的入手，既然取之不盡用之不竭，還得到了他們所永遠嘗不到的真正美味，例如

焦大麥等我們又何樂而不為──

以我這樣喝冷開水甚至喝生水的人來說「茶事」雖然不見得會被人笑掉牙齒，也許要被人

讃為不自量力，附庸風雅吧。對的，我是不自量力但附庸風雅到未必。因為我已自承不喝茶了

「附庸」之嫌至於我不喝茶而說「茶事」則本着述而不作的成法似乎也與我的「力」無關。

我的「古今茶事」就因為有了「古今酒事」在茶酒不相離的關係之下不管上面二種的顧忌而

就此集成的。

此外我也可以援知酒之例，自認為知茶，知各山所出之茶。不過這不是現在所需要的事情，更

不是我現在所需要的事情所以我究竟如何知法知到如何程度，我也只好存而不論以待異日了。

本書也和「古今酒事」一樣在「八一三」之前早就齊稿序也早已寫好不料「八一三」事

起，比了「酒事」還要不幸不但序未帶出來，連稿也未帶出來。本書局當局為了這是「酒事」的姊妹篇不能不出以完成一個系統所以又在一年多以前叫我重新從事於此，我也顏有此心，就在百忙中再從各書中去搜尋材料「喝茶」照理要比「飲酒」普遍得多但等到搜集材料的時候，「茶事」似乎要比「酒事」反而少得多也許因為茶的刺激不如酒的那樣厲害所以因喝茶而發生的韻事也就減少了；又或者為了我的時間匆促，尚有遺漏之處那只好等到後來有工夫再補了。至於原序我究竟說些什麼話已一句也不記得只好另外寫了上面這一篇我以為這書的經過如此，也值得提出所以補識於此。

編者　三十年七月

凡　例

一　本書目的，擬將古今有關茶事之文獻彙成一編以資欣賞。

一　本書材料統由各種叢書及筆記中採撮而來。

一　「故事」中各篇，均註明出處藉明來歷。

一　取材以清末爲止民國後不錄。

一　「故事」約三百數十條範圍最爲廣博，今因便於翻閱起見分成十一類。然其中界限有極難劃分者，如有不當之處，尚請讀者原諒。

一　本書排版完成後又在各叢書及筆記中陸續發見尚未收入之材料甚夥，擬待至相當時期，另出續編。

一　本書以編者一人之力三五年之工夫搜羅所得當然難稱完善。如承海內同好，於本書所已有者外代爲搜羅以便將來收入續編俾成茶事完作曷勝企禱之至！

一　本書與「古今酒事」爲姊妹作，合而觀之當有相得益彰之妙。

心一堂 飲食文化經典文庫

古今茶事總目

第一輯　專著

心一堂　飲食文化經典文庫

第一輯 專著

茶經

陸羽

序

案周禮酒正之職。辨四飲之物。其三曰漿。又漿人之職。供王之六飲。水、漿、醴、涼、醫、酏。入於酒府。鄭司農云。以水和酒也。蓋當時人率以酒醴為飲。何得姬公製爾雅云。檟苦荼。即不撾而飲之。以酒醴之醨者也。何得姬公製爾雅云。檟苦荼。即不撾而飲之。豈聖人之純於用乎。亦草木之濟人。取捨有時也。自周以降。及於國朝茶事竟陵之陸季疵言之詳矣。然季疵以前稱茗飲者。必渾以烹之。與夫瀹蔬而啜者無異也。季疵始為經三卷。由是分其源制其具教其造設其器命其養飲之者。除痟而癘去雖疾醫之不若也。其為利也。於人豈小哉。余始得季疵書以為備矣。後又獲其顧渚山記二篇。其中多茶事。後又太原溫從雲武威段碣之各補茶事十數節。並存於方冊。茶之事。由周至今竟無纖遺矣。昔晉杜毓有荈賦。季疵有茶歌。余缺然於懷者謂有其具而不形於詩亦季疵之遺恨也。遂為十詠寄天隨子唐皮日休撰。

一之源

茶者，南方之嘉木也。一尺二尺迺至數十尺。其巴山峽川有兩人合抱者，伐而掇之。其樹如瓜蘆，葉如梔子，花如白薔薇，實如栟櫚，葉如丁香，根如胡桃。瓜蘆木出廣州，似茶，至苦澀。栟櫚，蒲葵之屬，其子似茶。胡桃與茶根皆下孕，兆至瓦礫，苗木上抽。

其字，或從草，或從木，或草木并。從草，當作茶，其字出開元文字音義。從木，當作搽，其字出本草。草木并，作茶，其字出爾雅。

其名，一曰茶，二曰檟，三曰蔎，四曰茗，五曰荈。周公云：檟，苦茶。揚執戟云：蜀西南人謂茶曰蔎。郭弘農云：早取為茶，晚取為茗，或一曰荈耳。

其地，上者生爛石，中者生櫟壤〔按櫟當從石為礫〕，下者生黃土。凡藝而不實，植而罕茂，法如種瓜，三歲可採。野者上，園者次。陽崖陰林，紫者上，綠者次；筍者上，牙者次；葉卷上，葉舒次。陰山坡谷者，不堪採掇，性凝滯，結瘕疾。

茶之為用，味至寒，為飲最宜。精行儉德之人，若熱渴凝悶，腦疼目澀，四支煩，百節不舒，聊四五啜，與醍醐甘露抗衡也。採不時，造不精，雜以卉莽，飲之成疾。茶為累也，亦猶人參。上者生上黨，中者生百濟新羅，下者生高麗。有生澤州、易州、幽州、檀州者，為藥無效，況非此者。設服薺苨，使六疾不瘳。知人參為累，則茶累盡矣。

心一堂　飲食文化經典文庫

二之具

籝。一曰籃。一曰籠。一曰筥。以竹織之。受五升或一斗、二斗、三斗者。茶人負以採茶也。

籝漢書音盈所謂黃金滿籯不如一經顏師古云籯竹器也容四升耳。

灶。無用突者。釜。用脣口者。

甑。或木或瓦。匪腰而泥。籃以箅之。篾以系之。始其蒸也。入乎箅。既其熟也。出乎箅。釜涸注於甑中。甑不帶而泥之。又以穀木枝三亞者制之。亞當作椏木椏枝也。散所蒸牙筍并葉。畏流其膏。

杵臼。一曰碓。惟恆用者佳。

規。一曰模。一曰棬。以鐵制之。或圓或方或花。

承。一曰臺。一曰砧。以石為之。不然以槐桑木半埋地中。遣無所搖動。

檐。一曰衣。以油絹或角衫單服敗者為之。以檐置承上。又以規置檐上以造茶也。茶成舉而易之。

芘莉。一曰籯子。一曰旁筤。以二小竹長三尺闊一尺五寸柄五寸以篾織方眼如圃人土羅闊二尺以列茶也。

棨。一曰錐刀。柄以堅木為之。用穿茶也。

撲。一曰鞭。以竹為之。穿茶以解茶也。

焙鑿地深二尺。闊二尺五寸長一丈。上作短牆高二尺。泥之。

貫削竹為之長二尺五寸以貫茶焙之。

棚一曰棧以木構於焙上編木兩層高一尺。以焙茶也。茶之半乾升下棚。全乾升上棚。

穿音釧江東淮南剖竹為之巴州峽山紉穀皮為之江東以一斤為上穿半斤為中穿四兩五兩為小穿峽

中以一百二十斤為上穿八十斤為中穿五十斤為小穿字舊作釵釧之釧字或作貫串今則不然如磨

扇彈鑽縫五字文以平聲書之義以去聲呼之其字以穿名之。

育以木制之以竹編之以紙糊之中有隔上有覆下有牀傍有門掩一扇中置一器貯糠煨火令熅熅然。

江南梅雨時焚之以火。

育者以其藏養為名。

三之造

凡採茶在二月三月四月之間茶之筍者生爛石沃土長四五寸若薇蕨始抽陵露採焉茶之牙者發於

藂薄之上有三枝四枝五枝者選其中枝穎拔者採焉其日有雨不採晴有雲不採晴採之蒸之搗之拍

之焙之穿之封之茶之乾矣茶有千萬狀鹵莽而言如人靴者蹙縮然

京錐文也。

心一堂 飲食文化經典文庫

鞏牛臆者廉檐然浮雲出山者輪菌然經颷拂水者涵澹然有如陶家之子羅膏上以水澄泚之。

謂澄泥也。

四之器

又如新治地者遇暴雨流潦之所經。此皆茶之精腴有

如霜荷者莖葉彫沮易其狀貌故厥狀委萃然。此皆茶之瘠老者也自採至於封七經目自胡靴至於霜

荷八等或以光黑平正言嘉者斯鑒之下也以皺黃坳垤言佳者鑒之次也若皆言嘉及皆言不嘉者鑒

之上也何者出膏者光含膏者皺宿製者則黑日成者則黃蒸壓則平正縱之則坳垤此茶與草木葉一,

也。茶之否臧存於口訣。

風爐 灰承

風爐以銅鐵鑄之。如古鼎形。厚三分。緣闊九分。令六分。虛中致其杇墁。凡三足。古文書二十一字。一足

云坎上巽下離於中。一足云體均五行去百疾。一足云聖唐滅胡明年鑄。其三足之間設三牕底一牕

以爲通飈漏燼之所。上並古文書六字。一牕之上書伊公二字。一牕之上書羹陸二字。一牕之上書氏

茶二字。所謂伊公羹陸氏茶也。置墆㙷於其內設三格。其一格有翟焉。翟者火禽也畫一卦曰離。其一

格有彪焉。彪者風獸也畫一卦曰巽。其一格有魚焉。魚者水蟲也畫一卦曰坎。巽主風離主火坎主水。

風能與火火能熟水故備其三卦焉其飾以連葩垂蔓曲水方丈之類其爐或鍛鐵爲之其運泥爲之。

其灰承作三足鐵柈擡之。

筥

筥以竹織之高一尺二寸徑闊七寸或用籐作木楦如筥形織之六出圓眼其底蓋若利篋口鑠之。

炭檛

炭檛以鐵六稜制之若今之河隴軍人木吾也或作鎚或作斧隨其便也。

火筴

火筴一名筋若常用者圓直一尺三寸頂平截無葱臺勾鏁之屬以鐵或熟銅製之。

鍑　音輔。或作釜。或作鬴。

鍑以生鐵爲之今人有業冶者所謂急鐵其鐵以耕刀之趄錬而鑄之內模土而外模沙土滑於內易其摩滌沙澀於外吸其炎焰方其耳以正令也廣其緣以務遠也長其臍以守中也臍長則沸中沸中則末易揚末易揚則其味淳也洪州以瓷爲之萊州以石爲之瓷與石皆雅器也性非堅實難可持久。

交牀

用銀爲之至潔但涉於侈麗雅則雅矣潔亦潔矣若用之恆而卒歸於銀也。

交牀以十字交之。剜中令虛以支鍑也。

夾

夾以小青竹爲之。長一尺二寸。令一寸有節。節已上剖之。以炙茶也。彼竹之篠津潤於火假其香潔以

益茶味。恐非林谷間莫之致。或用精鐵熟銅之類。取其久也。

紙囊

紙囊以剡藤紙白厚者夾縫之。以貯所炙茶使不泄其香也。

碾拂末

碾以橘木爲之。次以梨桑桐柘爲之。內圓而外方。內圓備於運行也。外方制其傾危也。內容墮而外無

餘木墮形如車輪不輻而軸焉長九寸闊一寸七分墮徑三寸八分中厚一寸邊厚半寸軸中方而執

圓其拂末以鳥羽製之。

羅合

羅末以合蓋貯之以則置合中用巨竹剖而屈之以紗絹衣之其合以竹節爲之或屈杉以漆之高三

寸蓋一寸底二寸口徑四寸。

則

則以海貝蠣蛤之屬。或以銅鐵竹匕策之類。則者量也。準也度也。凡煮水一升用末方寸匕若好薄者
減嗜濃者埤。故云則也。

水方

水方以椆木槐楸梓等合之。其裏並外縫漆之。受一斗。

漉水囊

漉水囊若常用者。其格以生銅鑄之。以備水濕無有苦穢腥澀意。以熟銅苦穢鐵腥澀也。林栖谷隱者。
或用之竹木與竹非持久涉遠之具。故用之生銅其囊織青竹以捲之。裁碧縑以縫之。細翠鈿以綴
之。又作綠油囊以貯之。圓徑五寸柄一寸五分。

瓢

瓢一曰犧杓。剖瓠為之。或刊木為之。晉舍人杜毓荈賦云。酌之以匏。匏瓢也。口闊頸薄柄短。永嘉中餘
姚人虞洪入瀑布山採茗。遇一道士云。吾丹丘子祈子他日甌犧之餘乞相遺也。犧木杓也。今常用以
梨木為之。

竹夾

竹夾或以桃柳蒲葵木為之。或以柿心木為之。長一尺。銀裹兩頭。

鹺簋揭

鹺簋以瓷為之。圓徑四寸若合形。_{或瓶或罍貯鹽花也。其揭竹制長四寸一分闊九分揭策也。}或即今_{盒字}

熟盂

熟盂以貯熟水。或瓷或沙受二升。

盌

盌越州上。鼎州次。婺州次。岳州次。壽州洪州次。或者以邢州處越州上。殊為不然。若邢瓷類銀。越瓷類玉。邢不如越一也。若邢瓷類雪則越瓷類冰。邢不如越二也。邢瓷白而茶色丹越瓷青而茶色綠邢不如越三也。晉杜毓荈賦所謂器澤陶揀出自東甌甌越也。甌越州上口唇不卷底卷而淺受半斤已下。越州瓷岳瓷皆青青則益茶茶作白紅之色邢州瓷白茶色紅壽州瓷黃茶色紫洪州瓷褐茶色黑悉不宜茶。

畚

畚以白蒲捲而編之。可貯盌十枚。或用筥其紙帊以剡紙夾縫令方亦十之也。

札

札緝栟櫚皮以茱萸木夾而縛之或截竹束而管之若巨筆形。

滌方

滌方以貯滌洗之餘。用楸木合之。製如水方受八升。

滓方

滓方以集諸滓。製如滌方處五升。

巾

巾以絁布為之長二尺。作二枚互用之以潔諸器。

具列

具列。或作牀或作架。或純木純竹而製之。或木或竹黃黑可扃而漆者長三尺。闊二尺。高六寸具列者。悉歛諸器物悉以陳列也。

都籃

都籃以悉設諸器而名之以竹篾內作三角方眼外以雙篾闊者經之。以單篾纖者縛之。遞壓雙經作方眼。使玲瓏高一尺五寸低闊一尺。高二寸長二尺四寸闊二尺。

　　五之煮

凡炙茶愼勿於風爐間炙。熛焰如鑽。使炎涼不均。持以逼火。屢其翻正候炮出培塿狀蝦蟆背。然後去火

五寸。卷而舒則本其始。又炙之若火乾者。以氣熱止。曰乾者。以柔止。其始若茶之至嫩者。蒸罷熱搗葉爛

而芽筍存焉。假以力者持千鈞杵。亦不之爛。如漆科珠壯士接之不能駐其指。及就。則似無穰骨也。炙之。

則其節若倪倪如嬰兒之臂耳。既而承熱用紙囊貯之。精華之氣無所散越。候寒末之。

末之上者其屑如細米。末之下者其屑如菱角。

其火用炭。次用勁薪。

謂桑槐桐櫪之類也。

其炭曾經燔炙。爲膻膩所及。及膏木敗器不用之。

膏木爲柏桂檜也。敗器爲朽廢器也。古人有勞薪之味。信哉。

其水用山水上。江水中。井水下。

荈賦所謂水則岷方之注挹彼清流。

其山水揀乳泉石池漫流者上。其瀑涌湍漱勿食之。久食令人有頸疾。又多別流於山谷者。澄浸不洩。自

火天至霜郊以前。或潛龍蓄毒於其間。飲者可決之以流其惡。使新泉涓涓然酌之。其江水取去人遠者。

井取汲多者。其沸如魚目微有聲爲一沸。緣邊如湧泉連珠爲二沸。騰波鼓浪爲三沸。已上水老不可食

也。初沸則水合量調之以鹽味。謂棄其啜餘。無迺䘥䘥而鍾其一味乎。第二沸出水一瓢。以竹筴環激湯

心。則暈未常中心而下有頃勢若奔濤濺沫以所出水止之而育其華也。凡酌置諸盌令沫餑均沫餑湯

之華也。華之薄者曰沫厚者曰餑細輕者曰花。如棗花漂漂然於環池之上。又如迴潭曲渚青萍之始生。

又如晴天爽朗有浮雲鱗然其沫者若綠錢浮於水謂又如菊英墮於樽俎之中。餑者以滓煮之及沸則

重華累沫皤皤然若積雪耳。荈賦所謂煥如積雪煜若春藪有之。第一煮水沸而棄其沫之上有水膜如

黑雲母飲之則其味不正。其第一者爲雋永。

徐縣全縣二反。至美者曰雋永。雋味也。永長也。史長曰雋永。漢書蒯通著雋永二十篇也。

或留熟以貯之以備育華救沸之用諸第一與第二第三盌次之第四第五盌外非渴甚莫之飲。凡煮水

一升酌分五盌。

盌數至少三多至五。若人多至十加兩爐。

乘熱連飲之以重濁凝其下精英浮其上。如冷則精英隨氣而竭飲啜不消亦然矣。茶性儉不宜廣則其

味黯淡且如一滿盌啜半而味寡況其廣乎其色縮也。其馨欤也。

香至美曰欤音備。

其味甘槚也。不甘而苦荈也。啜苦咽甘茶也。

一本云。其味苦而不甘槚也。甘而不苦荈也。

六之飲

翼而飛毛而走呿而言此三者俱生於天地間飲啄以活飲之時義遠矣哉至若救渴飲之以漿蠲憂忿飲之以酒蕩昏寐飲之以茶茶之為飲發乎神農氏聞於魯周公齊有晏嬰漢有揚雄司馬相如吳有韋曜晉有劉琨張載遠祖納謝安左思之徒皆飲焉滂時浸俗盛於國朝兩都并荊渝。

愈常作渝巴渝也。

間以為比屋之飲飲有觕茶散茶末茶餅茶者乃斫乃熬乃煬乃舂貯於瓶缶之中以湯沃焉謂之痷茶。或用葱薑棗橘皮茱萸薄荷之等煮百沸或揚令滑或煮去沫斯溝渠間棄水耳而習俗不已於戲天育萬物皆有至妙人之所工但獵淺易所庇者屋屋精極所著者衣衣精極所飽者飲食與酒皆精極之茶有九難一日造二日別三日器四日火五日水六日炙七日末八日煮九日飲陰採夜焙非造也嚼味嗅香非別也膻鼎腥甌非器也膏薪庖炭非火也飛湍壅潦非水也外熟內生非炙也碧粉縹塵非末也操艱攪遽非煮也夏興冬廢非飲也夫珍鮮馥烈者其盌數三次之者盌數五若坐客數至五行三盌至七行五盌若六人已下不約盌數但闕一人而已其雋末補所闕人。

七之事

三皇炎帝神農氏周魯周公旦齊相晏嬰漢仙人丹丘子黃山君司馬文園令相如揚執戟雄吳歸命侯。

韋太傅弘嗣。晉惠帝劉空琨兄子兗州刺史演張黃門孟陽傅司隸咸江洗馬統孫參軍楚左記室

太冲陸吳興納兄子會稽內使俶冠軍安石郭弘農璞桓揚州溫杜舍人毓武康小山寺釋法瑤沛

國夏侯愷餘姚虞洪北地傅巽丹陽弘君舉高安任育長。

育長任瞻字元本遺長字今增之。

宣城秦精燉煌單道開剡縣陳務妻廣陵老姥河內山謙之後魏瑯琊王蕭宋新安王子鸞弟豫章王

子尚鮑昭妹令暉八公山沙門譚濟齊世祖武帝梁劉廷尉陶先生弘景皇朝徐英公勣

神農食經茶茗久服人有力悅志。

周公爾雅檟苦茶廣雅云荆巴間採葉作餅葉老者餅成以米膏出之欲煑茗飲先炙令赤色搗末置瓷

器中以湯澆覆之用葱薑橘子芼之其飲醒酒令人不眠。

晏子春秋嬰相齊景公時食脫粟之飯炙三戈五卵茗菜而已。

司馬相如凡將篇烏喙桔梗芫華款冬貝母木蘗蔞芩草芍藥桂漏蘆蜚廉雚菌荈詫白斂白芷菖蒲芒

消莞椒茱萸。

方言蜀西南人謂茶曰蔎。

吳志韋曜傳孫皓每饗宴坐席無不率以七勝爲限雖不盡入口皆澆灌取盡曜飲酒不過二升皓初禮

異密賜茶荈以代酒。

晉中興書陸納爲吳興太守時。衛將軍謝安常欲詣納（晉書云納爲吏部尚書）

納兄子俶怪納無所備。不敢問之。乃私蓄數十人饌安旣至所設唯茶果而已。俶遂陳盛饌珍羞必具及

安去納杖俶四十云。汝旣不能光益父奈何穢吾素業。

晉書桓溫爲揚州牧性儉每讌飲唯下七奠拌茶果而已。

搜神記夏侯愷因疾死宗人字苟奴察見鬼神見愷來收馬幷病其妻著平上幘單衣入坐生時西壁大

牀就人覓茶飲。

劉琨與兄子南兗州刺史演書云前得安州乾薑一斤桂一斤黃芩一斤皆所須也吾體中憒悶常仰其

茶汝可置之。　遺當作憒

傳咸司隸教曰聞南方有以困蜀嫗作茶粥賣爲廉事打破其器具又賣餅於市而禁茶粥以蜀姥何哉。

神異記餘姚人虞洪入山採茗遇一道士牽三青牛引洪至瀑布山曰予丹丘子也聞子善具飲常思見

惠山中有大茗可以相給祈子他日有甌犧之餘乞相遺也因其奠祀後常令家人入山獲大茗焉。

左思嬌女詩吾家有嬌女皎皎頗白皙小字爲紈素口齒自清歷有姊字惠芳眉目粲如畫馳騖翔園林。

果下皆生摘貪華風雨中倏忽數百適心爲茶荈劇吹噓對鼎鑬。

張孟陽登成都樓詩云。借問揚子舍。想見長卿廬程十累千金驕侈擬五都門有連騎客翠帶腰吳殫鼎食隨時進百和妙且殊披林採秋橘臨江釣春魚黑子過龍醢果饌踰蟹蜻芳茶冠六情溢味播九區人生苟安樂茲土聊可娛。

傅巽七誨蒲桃宛柰齊柿燕栗峘陽黃梨巫山朱橘南中茶子西極石蜜。

弘君舉食檄寒溫既畢應下霜華之茗三爵而終應下諸蔗木瓜元李楊梅五味橄欖懸豹葵羹各一杯。

孫楚歌茱茰出芳樹顛鯉魚出洛水泉白鹽出河東美豉出魯淵薑桂茶荈出巴蜀椒橘木蘭出高山蓼蘇出溝渠精稗出中田。

華陀食論苦茶久食益意思。

壺居士食忌苦茶久食羽化與韭同食令人體重郭璞爾雅注云樹小似梔子冬生葉可煑羹飲今呼早取為茶晚取為茗或一曰荈蜀人名之苦茶。

世說任瞻字育長少時有令名自過江失志既下飲問人云此為茶為茗覺人有怪色乃自申明云向問飲為熱為冷耳。

下飲為設茶也。

續搜神記晉武帝時宣城秦精常入武昌山採茗遇一毛人長丈餘引精至山下示以藂茗而去俄而復

還。乃探懷中橘以遺精。精佈負茗而歸。

晉四王起事惠帝蒙塵還洛陽黃門以瓦盂盛茶上至尊。

異苑剡縣陳務妻少與二子寡居好飲茶茗以宅中有古塚每飲輒先祀之二子患之曰古塚何知徒以勞意欲掘去之母苦禁而止其夜夢一人云吾止此塚三百餘年卿二子恆欲見毀賴相保護又享吾佳茗雖潛壤朽骨豈忘翳桑之報及曉於庭中獲錢十萬似久埋者但貫新耳母告二子慙之從是禱饋愈甚。

廣陵耆老傳晉元帝時有老姥每旦獨提一器茗往市鬻之市人競買自旦至夕其器不減所得錢散路傍孤貧乞人人或異之州法曹縶之獄中至夜老姥執所鬻茗器從獄牖中飛出。

藝術傳燉煌人單道開不畏寒暑常服小石子所服藥有松桂蜜之氣所餘茶蘇而已。

釋道該說續名僧傳宋釋法瑤姓楊氏河東人永嘉中過江遇沈臺真請真君武康小山寺年垂懸車飯所飲茶。永明中勅吳興禮致上京年七十九。

縣車喻日入之候指人垂老時也淮南子曰日至悲泉爰息其馬亦此意也。

宋江氏家傳江統字應元遷愍懷太子洗馬常上疏諫云今西園賣醯麪藍子菜茶之屬虧敗國體。

宋錄新安王子鸞豫章王子尚詣曇濟道人於八公山道人設茶茗子尚味之曰此甘露也何言茶茗。

王微雜詩。寂寂掩高閣。寥寥空廣廈。待君竟不歸。收領今就槚。

鮑昭妹令暉著香茗賦。

南齊世祖武皇帝遺詔。我靈座上慎勿以牲爲祭。但設餅果茶飲乾飯酒脯而已。

梁劉孝綽謝晉安王餉米等啓。傳詔李孟孫宣教旨。垂賜米酒瓜菹脯酢茗八種。氣苾新城。味芳雲松。江潭抽節。邁昌荇之珍。壃場擢翹。越茸精之美。羞非純束野麕。裛似雪之驢。酢異陶瓶河鯉。操如瓊之粲。茗同食粲。酢顏望柑。免千里宿舂。省三月糧聚。小人懷惠。大懿難忘。

陶弘景雜錄。苦茶輕換膏昔丹丘子黃山君服之。

後魏錄。瑯琊王肅仕南朝。好茗飲蓴羹。及還北地又好羊肉酪漿。人或問之茗何如酪。肅曰茗不堪與酪爲奴。

桐君錄。西陽武昌江晉陵好茗皆東人作清茗茗有餑飲之宜人凡可飲之物皆多取其葉天門冬菝葜取根皆益人又巴東別有眞茗茶煎飲令人不眠。俗中多煮檀葉並大皂李作茶並冷又南方有瓜蘆木亦似茗。至苦澀取爲屑茶飲亦可通夜不眠。煮鹽人但資此飲而交廣最重客來先設乃加以香芼輩。

坤元錄。辰州漵浦縣西北三百五十里無射山云蠻俗當吉慶之時親族集會歌舞於山上山多茶樹括

地圖臨遂縣東一百四十里有茶溪山謙之吳興記烏程縣西二十里有溫山出御荈。

夷陵圖經黃牛荊門女觀望州等山茶茗出焉。

永嘉圖經。永嘉縣東三百里有白茶山

淮陰圖經山陽縣南二十里有茶坡。

茶陵圖經云茶陵者所謂陵谷生茶茗焉本草木部茗苦茶味甘微寒無毒主瘻瘡利小便去痰渴熱令

人少睡秋採之苦主下氣消食注云春採之。

本草菜部苦茶一名茶一名選,一名游冬生益州川谷山陵道傍凌冬不死三月三日採乾注云疑此即

是今茶一名茶令人不眠本草注按詩云誰謂茶苦又云堇茶如飴皆苦菜也陶謂之苦茶木類非菜流。

茗春採謂之苦茶。

枕中方療積年瘻苦茶蜈蚣並炙令香熟等分搗篩煮甘草湯洗以末傅之孺子方療小兒無故驚蹶以

苦茶蔥鬚煮服之。

八之出

山南以峽州上。

峽州生遠安宜都夷陵三縣山谷。

襄州荊州次。

襄州生南鄣縣山谷荆州生江陵縣山谷。

衡州下。

生衡山茶陵二縣山谷。

金州梁州又下。

金州生西城安康二縣山谷梁州生襄城金牛二縣山谷。

淮南以光州上。

生光山縣黃頭港者與峽州同。

義陽郡舒州次。

生義陽縣鐘山者與襄州同舒州生太湖縣潛山者與荆州同。

壽州下。

盛唐縣生霍山者與衡山同也。

蘄州黃州又下。

蘄州生黃梅縣山谷黃州生麻城縣山谷並與荆州梁州同也。

浙西以湖州上。

湖州生長興縣顧渚山谷與峽州光州同生山桑儓師二寺自茅山縣腳嶺與襄州荊南義陽郡同生鳳亭山伏翼閣飛雲曲水二寺啄木嶺與壽州常州同生安吉武康二縣山谷與金州梁州同。

常州次。

常州義興縣生君山縣腳嶺北峯下與荊州義陽郡同生圈嶺善權寺石亭山與舒州同。

宣州杭州睦州歙州下。

宣州生宣城縣雅山與蘄州同。太平縣生上睦臨睦與黃州同。杭州臨安於潛二縣生上目山與舒州同錢塘生天竺靈隱二寺睦州生桐廬縣山谷歙州生婺源山谷與衡州同。

潤州蘇州又下。

潤州江寧縣生傲山蘇州長洲縣生洞庭山與金州蘄州梁州同。

劍南以彭州上。

生九隴縣馬鞍山至德寺棚口與襄州同。

綿州蜀州次。

綿州龍安縣生松嶺關與荊州同其西昌昌明神泉縣西山者並佳有過松嶺者不堪採蜀州青城縣生丈人山與綿州同青城縣有散茶木茶。

邛州次。雅州下。

雅州百丈山名山瀘州。瀘州者與金州同也。

眉州漢州又下。

眉州丹棱縣生鐵山者。漢州綿竹縣生竹山者與潤州同

浙東以越州上。

餘姚縣生瀑布泉嶺曰仙茗大者殊異。小者與襄縣同。

明州婺州次。

明州鄞縣生榆莢村婺州東陽縣東目山與荊州同。

台州下。

台州曹縣生赤城者與歙州同。

黔州生恩州播州費州夷州。江南生鄂州袁州吉州嶺南生福州泉州韶州象州

福州生閩方山山陰縣也。

其恩播費夷鄂袁吉福建泉韶象十一州未詳往往得之其味極佳。

九之略

其造具若方春禁火之時。於野寺山園叢手而掇乃蒸乃春乃復以火乾之。則又棨樸焙貫棚穿青等七事皆廢。其煮器若松間石上可坐則具列廢用槁薪鼎櫪之屬則風爐灰承炭撾火筴交牀等廢若瞰泉臨澗則水方滌方漉水囊廢若五人已下茶可味而精者則羅廢若援藟躋嵒引絙入洞於山口炙而末之或紙包合貯則碾拂末等廢旣瓢盌筴札熟盂醆筥悉以一筥盛之則都籃廢但城邑之中王公之門。二十四器闕一則茶廢矣。

十之圖

以絹素或四幅或六幅分布寫之陳諸座隅則茶之源之具之造之器之煮之飲之事之出之略目擊而存於是茶經之始終備焉。

煎茶水記

張又新

故刑部侍郎劉公諱伯芻於又新丈人行也爲學精博顔有風鑒稱較水之與茶宜者凡七等。

揚子江南零水第一。

無錫惠山寺石水第二。

蘇州虎丘寺石水第三。

丹陽縣觀音寺水第四。

揚州大明寺水第五。

吳淞江水第六。

淮水最下第七。

斯七水余嘗俱瓶於舟中。親挹而比之。誠如其說也。客有熟於兩浙者言搜訪未盡。余嘗志之及刺永

嘉過桐廬江至嚴子瀨溪色至清水味甚冷家人皆用陳黑壞茶潑之皆至芳香又以煎佳茶不可名

其鮮馥也又愈於揚子南零殊遠及至永嘉取仙巖瀑布用之亦不下南零以是知客之說信矣夫顯

理鑒物今之人信不逮於古人蓋亦有古人所未知而今人能知之者元和九年春子初成名與同年

生期於薦福寺余與李德垂先至憩西廂元鑒室會適有楚僧至置囊有數編書余偶抽一通覽焉文

細密皆雜記卷末又一題云煑茶記云代宗朝李季卿刺湖州至維揚逢陸處士鴻漸李素熟陸名有

傾蓋之歡因之赴郡泊揚子驛將食李曰陸君善於茶蓋天下聞名矣況揚子南零水又殊絶今者二

妙千載一遇何曠之乎命軍士謹信者挈瓶操舟深詣南零陸利器以俟之俄水至陸以杓揚其水曰

江則江矣非南零者似臨岸之水使曰某櫂舟深入見者累百敢虛紿乎陸不言既而傾諸盆至半陸

遽止之又以杓揚之曰自此南零者矣使蹶然大駭伏罪曰某自南零齎至岸舟蕩覆半至懼其尠挹

岸水堦之。處士之鑒神鑒也其放隱焉李與賓從數十人皆大駭愕李因問陸既如是所歷經處之水。

優劣精可判矣陸曰楚水第一晉水最下李因命筆口授而次第之。

廬山康王谷水簾水第一。

無錫縣惠山寺石泉水第二。

蘄州蘭溪石下水第三。

峽州扇子山下有石突然洩水獨清冷狀如龜形俗云蝦蟆口水第四。

蘇州虎丘寺石泉水第五。

廬山招賢寺下方橋潭水第六。

揚子江南零水第七。

洪州西山西東瀑布泉第八。

唐州柏巖縣淮水源第九。淮水本佳。

廬州龍池山嶺水第十。

丹陽縣觀音寺水第十一。

揚州大明寺水第十二。

漢江金州上游中零水第十三。水苦

歸州玉虛洞下香溪水第十四。

商州武關西洛水第十五。未嘗泥。

吳淞江水第十六。

天台山西南峯千丈瀑布水第十七。

柳州圓泉第十八。

桐廬嚴陵灘水第十九。

雪水第二十。用雪不可太冷。

此二十水余嘗試之。非繫茶之精麤過此不之知也。夫茶烹於所產處無不佳也蓋水土之宜離其處水功其半然善烹潔器全其功也李實諸司馬遇有言茶者卽示之又新刺九江有客李滂門生劉魯封言嘗見說茶余醒然思往歲僧室獲是書因盡篋書在焉古人云瀉水置甁中焉能辨淄澠此言不必可判也萬古以爲信然蓋不疑矣豈知天下之理未可言至古人硏精固有未盡強學君子孜孜不懈豈止思齊而已哉此言亦有裨於勸勉故記之。

十六湯品

蘇廙

湯者茶之司命若名茶而濫湯則與凡末同調矣煎以老嫩言者凡三品注以緩急言者凡三品以器

標者共五品以薪論者共五品。

第一得一湯。火績已儲。水性乃盡。如斗中米。如稱上魚。高低適平。無過不及爲度。蓋一而不偏雜者也。天

得一以淸地得一以寧湯得一可建勳。

第二嬰湯。薪火方交。水釜纔熾。急取旋傾。若嬰兒之未孩。欲責以壯夫之事難矣哉。

第三百壽湯。人過百息。水踰十沸。或以話阻。或以事廢。始取用之。湯已失性矣。敢問皤鬢蒼顏之大老還

可報弓抹矢以取中乎。還可登閬步以邁遠乎。

第四中湯。亦見夫鼓琴者也。聲合中則失妙。亦見磨墨者也。力合中則失濃。聲有緩急則琴亡。力有緩急

則墨喪。注湯有緩急則茶敗。欲湯之中臂任其責。

第五斷脈湯。茶已就膏。宜以造化成其形者。手顫臂䤼惟恐其深瓶嘴之端若存若亡。湯不順通故茶不

勻粹。是猶人之百脈氣血斷續欲壽奚可得邀宜逃。

第六大壯湯。力士之把針耕夫之握管所以不能成功者傷於麤也。且一甌之茗多不二錢茗盞量合宜

下湯不過六分萬一快瀉而深積之茶安在哉。

第七富貴湯以金銀爲湯器惟富貴者具焉所以榮功建湯業貧賤者有不能遂也湯器之不可捨金銀。

猶琴之不可捨桐墨之不可捨膠。

第八秀碧湯石凝結天地秀氣而賦形者也琢以爲器秀猶在焉其湯不良未有之也。

第九壓一湯貴欠金銀賤惡銅鐵則瓷瓶有足取焉幽士逸夫品色尤宜豈不爲瓶中之壓一乎然勿與

誇珍衒豪臭公子道。

第十纏口湯猥人俗靠煉水之器豈暇深擇銅鐵鉛錫取熱而已夫是湯也腥苦且澀飲之逾時惡氣繞

口而不得去。

第十一減價湯無油之瓦滲水而有土氣雖御膳宸羞且將敗德銷聲諺曰茶瓶用瓦如乘折腳駿登高。

好事者幸誌之。

第十二法律湯凡木可以煑湯不獨炭也惟沃茶之湯非炭不可在茶家亦有法律水忌停薪忌薰犯律

踰法湯乖則茶殆矣。

第十三一面湯或柴中之歘火或焚餘之虛炭木體雖盡而性且浮性浮則湯有終嫩之嫌炭則不然實

湯之友。

第十四宵人湯茶本靈草餉之則敗糞火雖熱惡性未盡作湯泛茶減耗香味。

第十五賊湯。一名賤湯竹篠樹梢風日乾之燃鼎附瓶顏甚快意然體性虛薄無中和之氣爲茶之殘賊也。

第十六魔湯調茶在湯之淑慝而湯最惡烟燃柴一枝濃烟蔽室又安有湯耶又安有茶耶所以爲大魔焉。

採茶錄

温庭筠

辨

代宗朝李季卿刺湖州至維揚逢陸鴻漸抵揚子驛將食李曰陸君別茶開揚子南泠水又殊絕今者二妙千載一遇命軍士謹慎者深入南泠陸利器以俟俄而水至陸以杓揚水曰江則江矣非南泠似臨岸者使者曰某棹舟深入見者累百敢有紿乎陸不言旣而傾諸盆至半陸遽止之又以杓揚之曰自此南泠者矣使者顯然馳白某自南泠齎至岸舟蕩覆過半懼其尠把岸水增之處士之鑒神鑒也某其敢隱焉。

李約汧公子也一生不近粉黛性辨茶嘗曰茶須緩火炙活火煎活火謂炭火之有焰者當使湯無妄沸。庶可養茶始則魚目散布微微有聲中則四邊泉湧纍纍連珠終則騰波鼓浪水氣全消謂之老湯三沸之法非活火不能成也。

後。

甫里先生陸龜蒙嗜茶舜置小園於顧渚山下歲入茶租薄爲甌犧之費自爲品第書一篇繼茶經訣之

易

白樂天方齋禹錫正病酒。禹錫乃饋菊苗虀蘆菔鮓換取樂天六班茶二囊以自醒酒。

苦

王濛好茶人至輒飲之士大夫甚以爲苦每欲候濛必云今日有水厄。

致

劉琨與弟羣書吾體中憒悶常仰眞茶汝可信致之。

茶錄　　　　　　　　　　　　　蔡　襄

茶論

色

茶色貴白而餅茶多以珍膏油[去聲]其面。故有靑黃紫黑之異。善別茶者正如相工之視人氣色也。隱然察

之於內以肉理潤者為上旣已末之黃白者受水昏重青白者受水詳明故建安人鬭試以青白勝黃白。

香

茶有眞香而入貢者微以龍腦和膏欲助其香建安民間試茶皆不入香恐奪其眞若烹點之際又雜珍果香草其奪益甚正當不用。

味

茶味主於甘滑惟北苑鳳凰山連屬諸焙所產者味佳隔溪諸山雖及時加意製作色味皆重莫能及也。

又有水泉不丹能損茶味前世之論水品者以此。

藏茶

茶宜蒻葉而畏香藥喜溫燥而忌溼冷故收藏之家以蒻葉封裹入焙中兩三日一次用火常如人體溫。

溫則禦溼潤若火多則茶焦不可食。

炙茶

茶或經年則香色味皆陳於淨器中以沸湯漬之刮去膏油一兩重乃止以鈐箝之微火炙乾然後碎碾。

若當年新茶則不用此說。

碾茶

碾茶先以淨紙密裹搥碎然後熟碾其大要旋碾則色白或經宿則色已昏矣。

羅茶

羅細則茶浮麤則沫浮。

候湯

候湯最難未熟則沫浮過熟則茶沈前世謂之蟹眼者故熟湯也沈瓶中煑之不可辨故曰候湯最難。

熁盞

凡欲點茶先須熁盞令熱冷則茶不浮。

點茶

茶少湯多則雲脚散湯少茶多則粥面聚。建人謂之雲脚粥面鈔茶一錢匕先注湯調令極勻又添注入環迴擊拂湯上盞可四分則止視其面色鮮白著盞無水痕為絕佳建安鬪試以水痕先者為負耐久者為勝故較勝負之說曰相去一水兩水。

器論

茶焙

茶焙織竹爲之裹以蒻葉蓋其上以收火也隔其中以有容也納火其下去茶尺許常温温然所以養茶

色香味也。

茶籠

茶不入焙者宜密封裹以蒻籠盛之置高處不近溼氣。

砧椎

砧椎蓋以砧茶砧以木爲之椎或金或鐵取於便用。

茶鈐

茶鈐屈金鐵爲用以炙茶。

茶碾

茶碾以銀或鐵爲之黃金性柔銅及砳石皆能生鉎星不入用。

茶羅

茶羅以絕細爲佳羅底用蜀東川鵝溪畫絹之密者投湯中揉洗以冪之。

茶盞

茶色白宜黑盞建安所造者紺黑紋如兔毫其坯微厚熺之久熱難冷最爲要用出他處者或薄或色紫。皆不及也其靑白盞鬪試自不用。

茶匙

茶匙要重擊拂有力黃金為上人間以銀鐵為之竹者輕建茶不取。

湯瓶

瓶要小者易候湯又點茶注湯有準黃金為上人間以銀鐵或瓷石為之。

試茶錄

序　　　　　　　　　　　子安

隙督七閩山川特異峻極迴環勢絕如甌其陽多銀銅其陰孕鉛鐵厥土赤墳厥植惟茶會建而上蔡益秀迎抱相向草木叢條水多黃金茶生其間氣味殊美豈非山川重複土地秀粹之氣鍾於是而物得以宜獻北苑西距建安之洞溪二十里而近東至東宮百里而遙。

姬名有三十六東宮其一也。

過洞溪踰東宮則僅能成餅耳獨北苑連屬諸山者最勝北苑前枕溪流北涉數里茶皆氣弇然也。

尤薄惡況其遠者乎亦猶橘過淮為枳也近蔡公作茶錄亦云隔溪諸山雖及時加意製造色味皆重矣。

今北苑焙風氣亦殊先春朝隮常雨霽則霧露昏蒸晝午猶寒故茶宜之茶宜高山之陰而喜日陽之早。

自北苑鳳山南直苦竹園頭東南屬張坑頭皆高遠。先陽處歲發常早芽極肥乳。非民間所比次出壑源
嶺高土決地茶味甲於諸焙丁謂亦云鳳山高不百丈無危峯絕巘而岡阜環抱氣勢柔秀宜乎嘉植靈
卉之所發也又以建安茶品甲於天下疑山川至靈之卉天地始和之氣盡此茶矣又論石乳出壑源斷
崖缺石之間蓋草木之仙骨丁謂之記錄建溪茶事詳備矣至於品載止云北苑壑源及總記官私諸
焙千三百三十六耳近蔡公亦云唯北苑鳳凰山連屬諸焙所產者味佳故四方以建茶爲目皆曰北苑。
壑源爲疑今書所異者從二公紀土地勝絕之目具疏園隴百名之異香味精粗之別庶知茶於草木爲
靈最矣去畝步之間別移其性又以佛嶺葉源沙溪附見以質二焙之美故曰東溪試茶錄自東宮西溪。
南焙北苑皆不足品第今略而不論。

　　　總敍焙名

北苑諸焙或還民間或隸北苑前書未盡今始終其事。
舊記建安郡官焙三十有八自南唐歲率六縣民採造大爲民間所苦我宋建隆以來環北苑近焙歲取
上供外焙俱還民間而裁稅之至道年中始分游坑臨江汾常西濛州西小豐大熟六焙隸劍南又免五
縣茶民專以建安一縣民力裁足之而除其口率泉慶曆中取蘇口曾坑石坑重院還屬北苑焉又丁氏

舊錄云官私之焙千三百三十有六而獨記官焙三十二東山之焙十有四北苑龍焙一乳橘內焙二乳

橘外焙三重院四壑嶺五渭源六范源七蘇口八東宮九石坑十連溪十一香口十二開山十

四。南溪之焙十有二下瞿一濛州東二汾東三南溪四斯源五小香六際會七謝坑八沙龍九南鄉十中

瞿十一黃熟十二西溪之焙四慈善西一慈善東二慈惠三船坑四北山之焙二慈善東一豐樂二。

北苑　<small>曾坑石坑附</small>

建溪之焙三十有二北苑首其一而園別為二十五苦竹園頭甲之鼯鼠窠次之張坑頭又次之苦竹園

頭連屬窠坑在大山之北園植北山之陽大山多修木叢林鬱蔭相及自焙口達源頭五里地遠而益高

以園多苦竹故名曰苦竹以高遠居眾山之首故曰園頭直西定山之隈土石迴向如窠然南挾泉流積

陰之處而多飛鼠故曰鼯鼠窠其下曰小苦竹園又西至於大園絕山尾疎竹翁翳昔多飛雉故曰雞藪

窠又南出壤園麥園言其土壤沃宜麰麥也自青山曲折而北嶺勢屬如貫魚凡十有二又隈曲如窠巢

者九其地利為九窠十二壠隈深絕數里曰廟坑坑有山神祠焉又焙南直東嶺極高峻曰教練壠東入

張坑南距苦竹帶北岡勢橫直故曰坑又北出鳳凰山其勢中跱如鳳之首兩山相向如鳳之翼因取

象焉鳳凰山東南至於袁雲壠又南至於長坑又南最高處曰張坑頭言昔有袁氏張氏居於此因名其

地焉出袁雲之北平下故曰平園絕嶺之表曰西際其東為東際焙東之山縈紆如帶故曰帶園其中曰

中歷坑。東又曰馬鞍山又東黃淡窠謂山多黃淡也。絕東為林園又南曰柢園又有蘇氏焙與北苑不相

屬昔有蘇氏居之其園別為四其最高處曰曾坑際上又曰尼園又北曰官坑上園下坑園慶曆中始入

北苑蒸貢有曾坑上品一斤叢出於此曾坑山淺土薄苗發多紫復不肥乳氣味殊薄今歲貢以苦竹園

茶充之而蔡公茶錄亦不云曾坑者佳又石坑者涉溪東北距焙僅一舍諸焙絕下慶曆中分屬北苑園

之別有十一曰大畬二曰石雞望三曰黃園四曰石坑古焙五曰重院六曰彭坑七曰蓮湖八曰嚴曆九

曰烏石高。十曰高尾山多古木修林今為本焙取材之所園焙歲久今廢不開二焙非產茶之所今附見

之。

壑源　葉源　附

建安郡東𡎝北苑之南山叢然不秀高峙數百丈。如郛郭焉。

民間所謂捍火山也。

其絕頂西南下視建之地邑。

民間謂之望州山。

山起壑源口诉四周抱北苑之羣山逶迤南絕其尾歸然山阜高者為壑源頭言壑源嶺山自此首也。大

山南北以限沙溪其東曰壑水之所出水出山之南東北合為建溪壑源口者在北苑之東北南徑數里。

有僧居曰承天。有圍隴北稅官山。其茶甘香特勝。近焙受水。則渾然色重淡而無澤。道山之南。又西至於章歷。章歷西曰後坑。西曰連焙。南曰焙山。又南曰新宅。又西曰嶺根。言北山之根也。茶多植山之陽。其土尺埴。其茶香少而黃白。嶺根有流泉。清淺可涉。涉泉而南。山勢回曲。東去如鉤。故其地謂之嶐嶺坑頭。茶爲勝絕處。又東別爲大窠坑頭。至大窠爲正嶐嶺。實爲南山。土皆黑埴。茶生山陰。厥味甘香。厥色青白。及受水。則淳淳光澤。

民間謂之冷粥面。

視其面渙散如粟。雖去社芽葉過老。色益青明。氣益鬱然。其止則苦去而甘至。

民間謂之草木大而味大是也。

他焙芽葉過老。色益青濁。氣益勃然。甘至。則味去而苦留爲異矣。大窠之東。山勢平盡曰嶐嶺尾。茶生其間。色黃而味多土氣。絕大窠南山。其陽曰林坑。又西南曰嶐嶺根。其西曰嶐嶺頭。道南山而東曰穿欄焙。又東曰黃際。其北曰李坑。山漸平下。茶色黃而味短。自嶐嶺尾之東南溪流繚遶岡阜不相連附。極南塢。中曰長坑。踰流爲葉源。又東爲梁坑。而盡於下湖。葉源者。土赤多石。茶色其中色多黃青。無粥面粟紋而

佛嶺

顏明爽復性重喜沈爲次也。

佛嶺連接葉源下湖之東而在北苑之東南隔谿源谿水道自章阪東際爲丘坑坑口西對谿源亦曰谿

口其茶黃白而味短東南曰曾坑。其正東曰後歷曾坑之陽曰佛嶺又東至於張坑又東曰李坑又

有硬頭後洋蘇池滃源郭源南源苦竹坑岐頭槎頭皆周環佛嶺之東南茶少廿而多苦色亦重濁。

小梨皆屬沙溪茶大率氣味全薄其輕而浮淳淳如土色製造亦殊谿源者不多留膏蓋以去膏盡則味

又有箕源　晉臘沫　石門江源白沙皆在佛嶺之東北茶泛然縹塵色而不鮮明味短而香少爲劣耳。
　　　　　詳此字

沙溪去北苑西十里山淺土薄茶生則葉細芽不肥乳自溪口諸焙色黃而土氣自襲漆南曰挺頭又西

曰章坑又南曰永安西南曰南坑漆其西曰砰溪又有周坑范源溫湯漆厄源黃坑石龜李坑章坑章村。

故多苦而少甘。

少而無澤也。

茶之面無光澤也。

　　茶名

　　茶之名類殊別故錄之。

茶之名有七一曰白葉茶民間大重出於近歲園焙時有之地不以山川遠近發不以社之先後芽葉如

紙民間以為茶瑞，取其第一者為鬭茶，而氣味殊薄，非食茶之比。今出壑源之大竊者六。（葉仲元。葉世萬。葉勇。葉）壑源嚴下一（世儲。葉相）源頭二（葉務）壑源後坑（葉歐）壑源嶺根三品（葉公。葉居）林坑黃漈一（容游）丘坑一（游用）畢

源一（王大。一照）佛嶺尾一（生游道）沙溪之大梨漈上一（謝）高石嚴一（阮）大梨一（呂）次有甘葉

茶樹高丈餘，徑頭七八寸，葉厚而圓，狀類柑橘之葉，其芽發卽肥乳，長二寸許，為食茶之上品。三曰早茶，

亦類柑葉，發常先春，民間採製為試焙者。四曰細葉茶，葉比柑葉細薄，樹高者五六尺，芽短而不乳，今生

沙溪山中，蓋土薄而不茂也。五曰稽茶，葉細而厚密，芽晚而青黃。六曰晚茶，蓋雞茶之類，發比諸茶晚生，

於社後。七曰叢茶，亦曰蘗茶，叢生高不數尺，一歲之間發者數四，貧民取以為利。

採茶

辨茶須知製造之始故次。

建溪茶比他郡最先，北苑壑源者尤早，歲多暖則先驚蟄十日卽芽，歲多寒則後驚蟄五日始發，先芽者

氣味俱不佳，唯過驚蟄者最為第一，民間常以驚蟄為候，諸焙後北苑者半月，去遠則益晚。凡採茶必以

晨興，不以日出，日出露晞，為陽所薄，則使芽之膏腴內耗於內，茶及受水而不鮮明，故常以早為最。凡斷

芽必以甲，不以指，以甲則速斷不柔，以指則多溫易損，擇之必精，濯之必潔，蒸之必香，火之必良，一失其

度俱為茶病。

心一堂　飲食文化經典文庫

民間常以春陰為採茶得時。日出而採則芽葉易損建人謂之採摘不鮮是也。

茶病

試茶辨味必須知茶之病故又次之。

芽擇肥乳則甘香而粥面著盞而不散。土瘠而芽短則雲腳渙亂。去盞而易散藥梗半則受水鮮白葉梗

短則色黃而泛。

梗謂芽之身除去白合處茶民以茶之色味俱在梗中。

烏帶白合茶之大病不去烏帶則色黃黑而惡。不去白合則味苦澀。

丁謂之論備矣。

蒸芽必熟去膏必盡蒸芽未熟則草木氣存。

適口則知。

去膏未盡則色濁而味重受烟則香奪壓黃則味失此皆茶之病也。

受烟謂過黃時火中有烟使茶香盡而烟臭不去也壓去膏之時久留茶黃未造使黃經宿香味俱失。

飲然氣如假雞卵臭也。

大觀茶論

宋徽宗

序

嘗謂首地而倒生。所以供人求者。其類不一。穀粟之於饑。絲枲之於寒。雖庸人孺子皆知常須而日用不以時歲之舒迫而可以與廢也。至若茶之爲物。擅甌閩之秀氣。鍾山川之靈稟。祛襟滌滯。致清導和。則非庸人孺子可得而知矣。冲澹閒潔。韻高致靜。則非遑遽之時。可得而好尚矣。本朝之興。歲修建溪之貢龍團鳳餅。名冠天下。而壑源之品。亦自此而盛。延及於今。百廢俱舉。海內晏然。垂拱密勿。幸致無爲縉紳之士。韋布之流。沐浴膏澤。薰陶德化。盛以雅尚相推。從事茗飲。故近歲以來。采擇之精。製作之工。品第之勝。烹點之妙。莫不盛造其極。且物之興廢。固自有時。然亦係乎時之汙隆。時或遑遽。人懷勞瘁。則向所謂常須而日用。猶且汲汲營求。惟恐不獲。飲茶何暇議哉。世既累洽。人恬物熙。則常須而日用者。固久厭飫狼籍。而天下之士。勵志清白。競爲閒暇修索之玩。莫不碎玉鏘金。啜英咀華。較筐篋之精。爭鑒裁之別。雖下士於此時。不以蓄茶爲羞。可謂盛世之清尚也。嗚呼。至治之世。豈惟人得以盡其材。而草木之靈者。亦得以盡其用矣。偶因暇日。研究精微。所得之妙。後人有不自知爲利害者。敘本末別於二十篇。號曰茶論。

地產

植產之地崖必陽圃必陰蓋石之性寒其葉抑以癉其味疏以薄必資陽和以發之土之性敷其葉疏以暴其味疆以肆必資陰蔭以節之

　今圃家皆植木以資茶之陰

　陰陽相濟則茶之滋長得其宜

天時

茶工作於驚蟄尤以得天時為急輕寒英華漸長條達而不迫茶工從容致力故其色味兩全若或時暘鬱燠芽甲奮暴促工暴力隨槁舉刻所迫有蒸而未及壓壓而未及研研而未及製茶黃留積其色味所失已半故焙人得茶天為慶

采擇

攝茶以黎明見日則止用爪斷芽不以指揉慮氣汗薰漬茶不鮮潔故茶工多以新汲水自隨得芽則投諸水凡芽如雀舌穀粒者為鬭品一鎗一旗為揀芽一鎗二旗為次之餘斯為下茶之始芽萌則有白合既擷則有烏帶白合不出害茶味烏帶不去害茶色

蒸壓

茶之美惡尤係於蒸芽壓黃之得失蒸太生則芽滑故色清而味烈過熟則芽爛故茶色赤而不膠壓久

則氣竭味漓不及則色暗味澀蒸芽欲及熟而香壓黃欲盡頭止如此則製造之功十已得七八矣。

製造

滌芽惟潔濯器惟淨蒸壓惟其宜研膏惟熱焙火惟良飲而有少砂者滌濯之不精也文理燥赤者焙火之過熟也夫造茶先度日暴之短長均工力之衆寡會采擇之多少使一日造成恐茶過宿則害色味。

鑒辨

茶之範度不同如人之有首面也膏稀者其膚蹙以文膏稠者其理斂以實即日成者其色則青紫越宿製造者其色則慘黑有肥凝如赤蠟者末雖白受湯則黃有縝密如蒼玉者末雖灰受湯愈白有光華外暴而中暗者有明白內備而表質者其首面之異同難以槩論要之色瑩徹而不駁質縝繹而不浮舉之凝結碾之則鏗然可驗其爲精品也有得於言意之表者可以心解又有貪利之民購求外焙已采之芽假以製造碎已成之餅易以範模雖名氏采製似之其膚理色澤何所逃於鑒賞哉。

白茶

白茶自爲一種與常茶不同其條敷闡其葉瑩薄崖林之間偶然生出雖非人力所可致有者不過四五家生者不過一二株所造止於二三胯而已芽英不多尤難蒸焙湯火一失則已變而爲常品須製造精微運度得宜則表裏昭徹如玉之在璞它無與倫也淺焙亦有之但品不及。

羅碾

碾以銀爲上，熟鐵次之，生鐵者非掏揀槌磨所成，間有黑屑藏於隙穴，害茶之色尤甚。凡碾爲製，槽欲深而峻，輪欲銳而薄。槽深而峻，則底有準而茶常聚；輪銳而薄，則運邊中而槽不戛。羅欲細而面緊，則絹不泥而常透。碾必力而速，不欲久，恐鐵之害色。羅必輕而平，不厭數，庶已細者不耗。惟再羅則入湯輕泛，粥面光凝，盡茶之色。

盞

盞色貴青黑，玉毫條達者爲上，取其煥發茶采色也。底必差深而微寬，底深則茶宜立而易以取乳，寬則運筅旋徹不礙擊拂。然須度茶之多少，用盞之大小。盞高茶少則掩蔽茶色，茶多盞小則受湯不盡。盞惟熱則茶發立耐久。

筅

筅以觔竹老者爲之，身欲厚重，筅欲疏勁，本欲壯而末必眇，當如劍脊之狀。蓋身厚重則操之有力而易於運用，筅疏勁如劍脊，則擊拂雖過而浮沫不生。

瓶

瓶宜金銀，小大之制，惟所裁給。注湯害利，獨瓶之口嘴而已。嘴之口差大而苑直，則注湯力緊而不散。嘴

之末。欲圓小而峻削。則用湯有節。而不滴瀝。蓋湯力緊則發速有節不滴瀝則茶面不破。

杓

杓之大小當以可受一盞茶爲量過一盞則必歸其餘。不及則必取其不足。傾杓煩數茶必冰矣。

水

水以清輕甘潔爲美。輕甘乃水之自然獨爲難得。古人品水雖曰中零惠山爲上。然人相去之遠近似不常得。但當取山泉之清潔者。其次則井水之常汲者爲可用。若江河之水。則魚鼈之腥。泥濘之汙雖輕甘無取。凡用湯以魚目蟹眼連繹迸躍爲度。過老則以少新水投之。就火頃刻而後用。

點

點茶不一。而調膏繼刻以湯注之。手重筅輕無粟文蟹眼者。謂之靜面點。蓋擊拂無力。茶不發立。水乳未浹。又復增湯色澤不盡英華淪散茶無立作矣。有隨湯擊拂手筅俱重。立又泛泛。謂之一發點。蓋用湯已故指腕不圓粥面未凝茶力已盡雲霧雖泛。水脚易生於此者。量茶受湯。調如融膠。環注盞畔。勿使侵茶勢不欲猛先須攪動茶膏漸加擊拂。手輕筅重指遶腕旋。上下透徹如酵蘗之起麵疏星皎月燦然而生。則茶之根本立矣。第二湯自茶面注之。周回一線急注急上茶面不動擊拂既力。色澤漸開。珠璣磊落。三湯多寘。如前擊拂漸貴輕勻。周環旋復。表裏洞徹粟文蟹眼泛結雜起。茶之色十已得其六七。四湯尚

盞欲轉稍寬而勿速。其清眞華彩。既已煥發。則擊以作之。發立已過。則拂以斂之。結浚靄結凝雪。茶色盡矣。六湯以觀立作乳點勃結。則以筅著之緩拂遶勁而已。七湯以分輕清重濁相稀稠得中。可欲則止。乳霧洶湧。溢盞而起。周迴凝而不動。謂之咬盞。宜勻其輕清浮合者飲之。桐君錄曰。茗有餑。飲之宜人。雖多不爲過也。

味

夫茶以味爲上。香甘重滑。爲茶之全。惟北苑壑源之品兼之。其味醇而乏風骨者蒸壓太過也。茶鎗乃條之始萌者。木性酸。鎗過長則初甘重而終微澀。茶旗乃葉之方敷者。葉味苦。旗過老則初雖留舌而飲徹反甘矣。此則芽胯有之。若夫卓絕之品眞香靈味自然不同。

香

茶有眞香。非龍麝可擬。要須蒸及熟而壓之。及乾而研。研細而造。則和美具足。入盞則馨香四達。秋爽灑然。或蒸氣如桃人夾雜。則其氣酸烈而惡。

色

點茶之色。以純白爲上眞。青白爲次。灰白又次之。黃白又次之。天時得於上。人力盡於下。茶必純白。天時暴喧。芽萌狂長。采造留積。雖白而黃矣。青白者蒸壓微生。灰白者蒸壓過熟。壓膏不盡則色青暗。焙火太烈。

則色昏赤。

藏焙

數焙則首面乾而香減失焙則雜色剝而味散要當新芽初生即焙以去水陸風濕之氣焙用熟火置爐中以靜炭擁合七分露火三分亦以輕灰糝覆良久即置焙簍上以逼散焙中潤氣然後列茶於其中盡展角焙未可蒙蔽候火速徹覆之火之多少以焙之大小增減探手爐中火氣雖熱而不至逼人手者為良時以手按茶體雖甚熱而無害欲其火力通徹茶體爾或曰焙火如人體溫但能燥茶皮膚而已內之淫潤未盡則復蒸喝矣焙畢即以用久竹漆器中緘藏之陰潤勿開終年再焙色常如新。

品名

名茶各以聖產之地葉如耕之平園台星岩葉剛之高峯青鳳髓葉思純之大嵐葉嶼之屑山葉五崇柎之羅漢上水桑芽葉堅之碎石窠石臼窠〔一作穴巢〕葉瓊葉輝之秀皮林葉師復師貺之虎岩葉椿之無又岩芽葉懋之老窠園葉各擅其美未嘗混淆不可縷舉後相爭相鬻互為剝竊參錯無據不知茶之美惡在於製造之工拙而已豈岡地之虛名所能增減哉焙人之茶固有前優而後劣者昔負而今勝者是亦園地之不常也。

外焙

世稱外焙之茶。樹小而色駁。體耗而味淡。方之正焙。昭然則可近之好事者筴笥之中。往往半之蓄外焙
之品。蓋外焙之家。久而益工製之妙。咸取則於壑源倣像外爲正殊不知其樹雖等而葉殊。風骨色
澤雖潤而無藏蓄。體雖實而縝密乏理。味雖重而澀滯乏香。何所逃乎外焙哉。雖然有外焙者。有淺焙者。
蓋淺焙之茶。去壑源爲未遠。製之能工則色亦瑩白。擊拂有度。則體亦立湯味甘重香滑之味。稍遠於正
焙耳。于治外焙。則迥然可辨。其有甚者。又至於採柿葉桴欖之萌。相雜而造。味雖與茶相類。點時隱隱如
輕絮。泛然茶面粟文不生。乃其驗也。桑苧翁曰。雜以卉莽飲之成病。可不細鑒而熟辨之。

宣和北苑貢茶錄

熊　蕃

序

　陸羽茶經裴汶茶述者皆不第建品說者但謂二字未嘗至建。而不知物之發也。固自有時。蓋昔者山川
尚閟。靈芽未露。至於唐末然後北苑出爲之最。是時僞蜀詞臣王文錫作茶譜。亦第言建有紫筍而臘
面乃產於福。五代之季。屬建南唐。歲率諸縣民采茶北苑。初造研膏。繼造臘面。旣又製其佳者。號曰京鋌。
聖朝開寶末。下南唐。太平興國初。特置龍鳳模。遣使卽北苑造團茶。以別庶飲，龍鳳茶蓋始於此。又一種，
茶叢生石崖。枝葉尤茂。至道初。有詔造之。別號石乳。又一號的乳。又一種號白乳。蓋自龍鳳與京石的白

四種紹出而腴面降爲下矣。蓋龍鳳等茶皆太宗朝所制。至咸平初。丁晉公曹闓始載之於茶錄慶曆中。

蔡君謨將漕創小龍團以進被旨仍歲貢之。自小團出而龍鳳遂爲次矣。元豐間。有旨造密雲龍其品又、

加於小龍團之上。紹聖間改爲瑞雲翔龍。至大觀初今上親製茶論二十篇以白茶者與常茶不同偶然

出非人力可致。於是白茶遂爲第一。既又製之已細茶及試新銙貢新銙自三色細第出。而瑞雲翔龍顧

爲下矣。凡茶芽數品最上曰小芽如雀舌鷹爪以其勁直纖挺故號芽茶。次曰揀芽乃一芽帶一葉者號

一銙一旗次曰中芽乃一芽帶兩葉號一銙兩旗其帶三葉四葉皆漸老矣。芽茶早春極少景德中建守

周絳爲補茶經言芽茶只作早茶馳奉萬乘嘗之可矣。如一鎗一旗號揀芽最

爲挺特光正矣。舒王送入閩中詩云新茗齋中試一旗謂揀芽也。或者乃謂茶芽未展爲鎗已展爲旗指舒

王此詩爲誤蓋不知有所謂揀芽也。夫揀芽猶貴重如此。而況芽茶以供天子之新嘗者乎芽茶絕矣。至

於水芽則曠古未之聞也。宣和庚子歲漕臣鄭公可問始創爲銀線水芽蓋將已揀熟芽再剔去祇取其

心一縷用珍器貯清泉漬之光明瑩潔若銀線然以製方寸新銙有小龍蜿蜒其上號龍團勝雪又廢白

的石乳鼎造花銙二十餘色初貢茶皆入龍腦至是慮奪真味始不用焉蓋茶之妙。至勝雪極矣。故合爲

首冠然猶在白茶之次者以白茶上之所好也。異時郡人黃儒撰品茶要錄極稱當時靈芽之富謂使陸

羽數之見之。必爽然自失蕃亦謂使黃君而閱今日則前此者未足記焉。然龍焙初與貢數殊少累增至

於元符。以斤計者一萬八千。視初已加數倍而猶未盛。今則為四萬七千一百斤有奇矣。此數見范逵所著龍焙羨戌茶錄。

遠也。茶
官也。白茶勝雪以次厥名實繁今列於左使好事者得以觀焉。

貢新銙。大觀二年造。　試新銙。政和二年造。

白茶。政和二年造。　龍團勝雪宣和二年造。

御苑玉芽大觀二年造。　萬壽龍芽大觀二年造。

上林第一宣和二年造。　乙夜清供宣和二年造。

承平雅玩宣和二年造。　龍鳳英華宣和二年造。

玉除清賞宣和二年造,　啓沃承恩宣和二年造。

雪英宣和二年造。　雲葉宣和二年造。

蜀葵宣和二年造。　金錢宣和三年造。

玉華宣和二年造。　寸金宣和三年造。

無比壽芽大觀四年造。　萬春銀葉宣和二年造。

宜年寶玉宣和三年造。　玉清慶雲宣和二年造。

無疆壽龍宣和二年造。　玉葉長春宣和四年造。

瑞雲翔龍紹聖二年造。

長壽玉圭政和二年造。

興國巖銙

香口焙銙

上品揀芽紹興二年造。

新收揀芽

太平嘉瑞政和二年造。

龍苑報春宣和四年造。

南山應瑞宣和四年造。

興國巖揀芽

興國巖小龍。

興國巖小鳳。已上號絹色。

揀芽。

小鳳。

小龍。

大鳳。已上號粗色。

大龍。

又有瓊林毓粹浴雪呈祥壑源供季篚推先價倍南金賜谷先春壽巖却勝延平石乳清白可鑒風韻甚高凡十色皆宣和二年所製越五歲省去

右歲分十餘綱惟白茶與勝雪自驚蟄前興役浹日乃成飛騎疾馳不出仲春已至京師號為頭綱玉芽。

以下即先後以次發逮貢足時夏過半矣歐陽文忠公詩曰建安三千五百里京師三月嘗新茶蓋異時

如此以今較昔又為最早因念草木之微有瓊奇卓異亦必逢時而後出而況為上者哉昔昌黎先生感

二鳥之蒙采擢。而悼其不如。今蔣於是茶也焉敢效昌黎之感。始務自醫而堅其守。以待時而已。

貢新銙竹圈銀模方一寸二分。

試新銙竹圈同上。

龍團勝雪竹圈銀模同上。

白茶銀圈銀模徑一寸五分。

御苑玉芽銀圈銀模徑一寸五分。

萬壽龍芽銀圈銀模同上。

上林第一方一寸二分。

乙夜清供竹圈同上。

承平雅玩。

龍鳳英華。

玉除清賞。

啓沃承恩同上。

雪英横長一寸五分。

興國巖鎗竹圈方一寸二分。

長壽玉圭銀模直長三寸。

瑞雲翔龍銀模銅圈徑二寸五分。

玉葉長春竹圈直長三寸六分。

無疆壽龍銀模竹圈直長一寸。

玉清慶雲銀模銀圈方一寸八分。

宜年寶玉銀圈銀模直長三寸。

萬春銀葉銀模銀圈兩尖徑二寸二分。

無比壽芽銀模竹圈同上。

寸金竹圈方一寸二分。

玉華銀模橫長一寸五分。

金錢銀模同上。

蜀葵徑一寸五分。

雲葉同上。

香口焙銙竹圈同上。

上品揀芽銀模銅圈

新收揀芽銀模銀圈同上。

太平嘉瑞銀圈徑一寸五分。

龍苑報春徑一寸七分。

南山應瑞銀模銀圈方一寸八分。

興國巖揀芽銀模徑三寸。

小龍。

小鳳銀模銅圈同上。

大龍銀模銅圈

大鳳銀模銅圈。

大龍銀模銅圈。

先人作茶錄賞貢品極勝之時。凡有四千餘色紹興戊寅歲克攝事北苑。閱近所貴皆仍舊其先後之序亦同惟躋龍團勝雪於白茶之上。及無興國巖小龍小鳳蓋建炎南渡有旨罷貢三之一而省去之也先人但著其名號克今更寫其形製庶覽之無遺恨焉先是任之春漕司再攝茶政越十三載乃復舊額且

用政和故事補種茶二萬株。正和周曹種三萬株。此年益虔貢職遂有創增之目仍改京鋌爲大龍團由是大龍多

於大鳳之數凡此皆近事或者猶未之知也三月初吉男克北苑寓舍書。

北苑貢茶最盛然前輩所錄止於慶曆以上自元豐後瑞龍相繼挺出制精於舊而未有好事者記焉但

於詩人句中及大觀以來增創新銙亦猶用揀芽蓋水芽至宣和始名顧龍團勝雪與白茶角立歲元首

貢自御苑玉芽以下厥名實繁先子觀見時事悉能記之成編具存今閩中漕臺所刊茶錄未備此書庶

幾補其闕云。淳熙九年冬十二月四日朝散郎行秘書郎國史編修官學士院權直熊克謹記。

品茶要錄

序

黃儒

說者常怪陸羽茶經不第建安之品蓋前此茶事未甚與靈芽真筍往往委翳消腐。而人不知惜自國初

已來士大夫沐浴膏澤詠歌升平之日久矣夫身世灑落神觀沖淡惟茲茗飲爲可喜園林亦相與摘英

誇異制捲鬻新而趨時之好故殊異之品始得自出於蓁莽之間。而其名遂冠天下借使陸羽復起閱其

金餅味其雲腴當爽然自失矣因念草木之材一有負瓖偉詭特者未嘗不遇時而後興況於人乎然士

大夫間爲珍藏精試之具非伺雅好真未嘗輒出其好事者又常論其采制之出入器用之宜否較試之

68

湯火。圓於縑素傳玩於時。獨未有補於賞鑒之明耳。蓋園民射利啗油其面。色品味易辨而難詳予因閱

收之暇爲原采造之得失較試之低昂次爲十說以中其病題曰品茶要錄云。

一采造過時

茶事起於驚蟄前其采芽如鷹爪。初造曰試焙。又曰一火其次曰二火。二火之茶已次一火矣。故市茶芽

者惟同出於三火前者爲最佳尤善薄寒氣候陰不至凍。

芽發時尤畏霜有造於一火二火皆過霜而三火霜齊則三火之茶勝矣。晴不至於暄則穀芽含養約

勒而滋長有漸采工亦優爲矣凡試時泛色鮮白隱於薄霧者得於佳時而然也。有造於積雨者其色昏。

或氣候暴暄茶芽蒸發采工汗手薰漬揀摘不給則製造雖多皆爲常品矣試時色非鮮白水腳微紅者。

過時之病也。

二白合盜葉

茶之精絕者曰鬥曰亞鬥其次揀芽茶芽鬥品雖最上園戶或止一株蓋天材間有特異非能皆然也。且

物之變勢無常而人之耳目有盡故造鬥品之家有昔優而今劣前負而後勝者雖人工有至有不至亦

造化推移不可得而擅也。其造一火曰鬥二火曰亞鬥不過十數銙而已。揀芽則不然徧園隴中擇其精

英者耳。其或貪多務得又滋色澤往往以白合盜葉間之。試時色雖鮮白其味澀淡者間白合盜葉之病

也。

一鷹爪之芽有兩小葉抱而生者白合也新條葉之初生而白者盜葉也造揀芽常剔取鷹爪而白合不用況盜葉乎

三入雜

物固不可以容偽況飲食之物尤不可也故茶有入他草者建人號爲入雜鈐列入柿葉常品入桴欖葉二葉易致又滋色澤園民欺售直而爲之試時無粟紋甘香盞面浮散隱如微毛或星星如纖絮者入雜一之病也善茶品者側盞視之所入之多寡從可知矣鈴上下品有之近雖鈐列亦或勾使

四蒸不熟

穀芽初采不過盈筐而已趣時爭新之勢然也旣采而蒸旣蒸而研蒸有不熟之病有過熟之病蒸不熟自雖精芽所損已多試時色青易沈味爲桃仁之氣者不蒸熟之病也唯正熟者味甘香

五過熟

茶芽方蒸以氣爲候視之不可以不謹也試時色黃而粟紋大者過熟之病也然雖過熟愈於不熟甘香之味勝也故君謨論色則以靑白勝黃白余論味則以黃白勝靑白

六焦釜

茶蒸不可以逾久久而過熟又久則湯乾而焦釜之氣出茶工有注新湯以益之是致蒸損茶黄試時色

多昏黯氣焦味惡者焦釜之病也。建人謂熱鍋氣。

七壓黄

茶已蒸者爲黄黄細則已入捲模制之矣蓋清潔鮮明則香色如之故采佳品者常於半曉間衝蒙雲霧

或以罐汲新泉懸胸間得必投其中蓋欲鮮也其或曰氣烘爍茶芽暴長工力不給其采芽已色不鮮明。

薄如壤卵氣者壓黄之病也。

八潰膏

茶餅光黄又如蔭潤者榨不乾也榨欲盡去其膏膏盡則有如乾竹葉乏意味唯飾首面者故榨不欲乾。

以利易售試時色雖鮮白其味帶苦者潰膏之病也。

九傷焙

夫茶本以芽葉之物就之捲模既出捲上笪焙之用火務令通熱卽以灰覆之虛其中以熟火氣然茶民

不喜用實炭號爲冷火以茶餅新濕欲乾以見售故用火常帶煙焰煙焰既多稍失看候以故薰損茶餅。

試時其色昏紅氣味帶焦者傷焰之病也。

十辨壑源沙溪

壑源沙溪。其地相背而中隔一嶺。其去無數里之遠。然茶產頓殊有能出力移植之。亦為士氣所化竊

嘗惟茶之為草一物爾其勢必猶得地而、後異豈水絡地脈。偏鍾粹於壑源豈御焙占此大岡巍隴神物

伏護得其餘蔭耶何其甘芳精至。而美擅天下也。觀夫春雷一驚筍籤纔起。售者已擔簦挈橐於其門。或

先期而散留金錢或茶纔入笪。而爭酬所直故壑源之茶常不足容所求其有桀滑之園民陰取沙溪茶

黃雜就家捲而製之人耳其規模之相若不能原其實者蓋有之矣。凡壑源之茶售以十。則沙溪

之茶售以五其直大率倣此然沙溪之園民亦勇於覓利或雜以松黃飾其首面凡肉理怯薄體輕而色

黃賦時雖鮮白而不能久泛香薄而味短者沙溪之品也凡肉理實厚體堅而色紫賦時泛盞凝久香滑而

味長者壑源之品也。

後論

今嘗論茶之精絕者其白合未開其細如麥蓋得青陽之輕清者也又其山多帶砂石而號佳品者皆在

山南蓋得朝陽之和者也余嘗事閒乘暑景之明淨適軒亭之蕭灑一一皆取品試既而神水生於華池

愈甘而新其有助乎然建安之茶散人下者不為也而得建安之精品者亦不能辨或

不善於烹試矣或非其時尤不善也況非其實乎然未有主賢而賓愚者也夫惟知此然後盡茶之事昔

者陸羽號為知茶然羽之所知者皆今之所謂茶草何哉如鴻漸所論蒸筍并葉畏流其膏蓋草茶味短

而淡。故恐去膏建茶力厚而甘故惟欲去膏又論屬建爲未詳往往得之其味極佳由是觀之鴻漸未
嘗到建安歟。

北苑別錄

<div style="text-align:right">無名字</div>

序

建安之東三十里有山曰鳳凰其下直北苑旁聯諸焙厥土赤壤厥茶惟上上太平興國中初爲御焙歲
模龍鳳以羞貢篚蓋表珍異慶曆中漕臺益重其事品數日增制度日精厥今茶自北苑上者獨冠天下。
非人間所可得也方其春蟲震蟄蠶夫雷動一時之盛誠爲大觀故建人謂至建安而不詣北苑與不至
者同侯同攝事遂得研究其始末姑摭其大槩修爲十餘類目曰北苑別錄云。

御園

九窠十二隴。	麥窠。	壤園。	
龍游窠。	小苦竹。	苦竹裏。	
雞藪窠。	苦竹。	苦竹源。	
鼯鼠窠。	教練隴。	鳳凰山。	

大小焊。橫坑。猿游隴。

張坑。帶園。焙東。

中厯。東際。西際。

官平。石碎窠。上下官坑。

虎膝窠。樓隴。蕉窠。

新園。天樓基。院坑。

曾坑。黃際。馬安山。

林園。和尚園。黃淡窠。

吳彥山。羅漢山。水桑窠。

銅場。師姑園。靈滋。

苑馬園。高畬。大窠頭。

小山。

右四十六所廣袤三十餘里。自官平而上爲內園官坑而下爲外園。方春靈芽萌坼。先民焙十餘日。如九窠十二隴龍游窠小苦竹張坑西際又爲禁園之先也。

開焙

驚蟄節萬物始萌。每歲常以前三日開焙。遇閏則後之。以其氣候少遲故也。

采茶

采茶之法須是清晨。不可見日。晨則夜露未晞。茶芽斯潤。見日則為陽氣所薄。使芽之膏腴內耗。至受水而不鮮明。故每日常以五更撾鼓集羣夫於鳳凰山。山有打鼓亭。監采官人給一牌入山。至辰刻則復鳴鑼以聚之。恐其踰時貪多務得也。大抵采茶亦須習熟。募夫之際必擇土著及諳曉之人。非特識茶發早晚所在。而於采摘亦知其指要。蓋以指而不以甲則多溫而易損。以甲而不以指則速斷而不柔。從舊說也。故采夫欲其習熟政為是耳。采夫日役二百二十二人。

揀茶

茶有小芽。有中芽。有紫芽。有白合。有烏蔕。不可不辨。小芽者其小如鷹爪。初造龍團勝雪白茶以其芽先次蒸熟置之水盆中。剔取其精英僅如針小謂之水芽。是小芽中之最精者也。中芽古謂之一鎗二旗是也。紫芽葉之紫者是也。白合乃小芽有兩葉抱而生者是也。烏蔕茶之蔕頭是也。凡茶以水芽為上。小芽次之。中芽又次之。紫芽白合烏蔕皆在所不取。使其擇焉而精則茶之色味無不佳。萬一雜之以所不取。則首面不均。色濁而味重也。

蒸茶

茶芽再四洗滌取令潔淨然後入甑俟湯沸蒸之然蒸有過熟之患有不熟之患過熟則色黃而味淡不熟則色青易沈而有草木之氣唯在得中爲當。

榨茶

茶既熟謂茶黃須淋洗數過。欲其冷。方入小榨以去其水又入大榨出其膏。水芽。則以高壓壓之。先是包以布帛束以竹皮然後入大榨壓之至中夜取出揉勻復如前入榨謂之翻榨徹曉奮擊必至於乾淨而後已蓋建茶之味遠而力厚非江茶之比江茶畏沈其膏建茶唯恐其膏之不盡則色味重濁矣。

研茶

研茶之具以柯爲杵以瓦爲盆。分團酌水亦皆有數。上而勝雪白茶以十六水下而揀芽之水六小龍鳳四大龍鳳二其餘皆一十二焉。自十二水而上曰研一團。自六水而下曰研三團至七團每水研三必至於水乾茶熟而後已。水不乾則茶不熟茶不熟則首面不勻。故研夫尤貴於彊有力者也嘗謂天下之理未有不須而成者有北苑之芽而後有龍井之水。龍井之水清而且甘盡夜酌之而不竭。凡茶自北苑上者皆資焉亦猶錦之於蜀江膠之於阿井詎不信然。

造茶

造茶舊分四局匠者起好勝之心彼此相鎊不能無弊迨併爲二焉故茶堂有東局西局之名茶鎊有東

作西作之號凡茶之初出研盆盪之欲其勻操之欲其膩然後入圈製鎊隨笪過黃有方故鎊有花鎊有

大龍有小龍品色不同其名亦異隨綱繋之於貢茶云。

　　過黃

茶之過黃初入烈火焙之次過沸湯爁之凡如是者三而後宿一火至翌日逐過煙焙之火不欲烈烈則

面炮而色黑又不欲煙煙則香盡而味焦但取其溫溫而已凡火之數多寡皆視其鎊之厚薄鎊之厚者

有十火至於十五火鎊之薄者八火至於六火火數既足然後過湯上出色出色之後置之密室急以扇

扇之則色澤自然光瑩矣。

　　綱次

　　細色第一綱

　　龍焙貢新

　　細色第二綱

　　龍焙試新

水芽十二水十宿火正貢三十鎊創添二十鎊。

水芽。十二水十宿火正貢一百銙創添五十銙。

細色第三綱

龍團勝雪

水芽。十六水十二宿火正貢三十銙續添二十銙創添二十銙。

白茶

水芽。十六水七宿火正貢三十銙續添五十銙創添八十銙。

御苑玉芽

小芽。十二水八宿火正貢一百片。

萬壽龍芽

小芽。十二水八宿火正貢一百片。

上林第一

小芽。十二水十宿火正貢一百銙。

乙夜清供

小芽。十二水十宿火正貢一百銙。

小芽。十二水十宿火正貢一百銙。

承平雅玩

小芽。十二水。十宿火。正貢一百銙。

龍鳳英華

小芽。十二水。十宿火。正貢一百銙。

玉除清賞

小芽。十二水。十宿火。正貢一百銙。

啓沃承恩

小芽。十二水。十宿火。正貢一百銙。

雪英

小芽。十二水。七宿火。正貢一百片。

雲葉

小芽。十二水。七宿火。正貢一百片。

蜀葵

小芽。十二水。七宿火。正貢一百片。

小芽。十二水。七宿火。正貢一百片。

金錢

小芽。十二水七宿火正貢一百片。

寸金

小芽。十二水九宿火正貢一百銙。

細色第四綱

龍團勝雪

水芽十六水十二宿火正貢一百五十銙。

無比壽芽

小芽。十二水十五宿火正貢五十銙創添五十銙。

萬春銀葉

小芽。十二水十宿火正貢四十片創添六十片。

宜年寶玉

小芽。十二水十宿火正貢四十片創添六十片。

玉清慶雲

小芽。十二水。十五宿火。正貢四十片。創添六十片。

小芽。十二水。十五宿火。正貢四十片。創添六十片。

無疆壽龍

小芽。十二水。十五宿火。正貢四十片。創添六十片。

玉葉長春

小芽。十二水。七宿火。正貢一百片。

瑞雲翔龍

小芽。十二水。九宿火。正貢一百八片。

長壽玉圭

小芽。十二水。九宿火。正貢二百片。

興國巖銙

中芽。十二水。十宿火。正貢一百七十銙。

香口焙銙

中芽。十二水。十宿火。正貢五十銙。

上品揀芽

小芽。十二水十宿火正貢一百片。

新收揀芽

中芽。十二水十宿火正貢六百片。

細色第五綱

小芽。十二水九宿火正貢三百片。

太平嘉瑞

龍苑報春

小芽。十二水九宿火正貢六十片創添六十片。

南山應瑞

小芽。十二水十五宿火正貢六十銙創添六十銙。

興國巖揀芽

中芽。十二水十宿火正貢五百十片。

興國巖小龍

中芽。十二水十五宿火正貢七百五片。

興國巖小鳳

中芽。十二水十五宿火正貢五十片。

先春兩色

太平嘉瑞

已見前。正貢二百片。

長壽玉圭

已見前。正貢一百片。

續入額四色

御苑玉芽

已見前。正貢一百片。

萬壽龍芽

已見前。正貢一百片。

無比壽芽

已見前。正貢一百片。

已見前。正貢一百片。

瑞雲翔龍

巳見前。正貢一百片。

麤色第一綱

　正貢

不入腦子上品揀芽小龍一千二百片。六水。十宿火。

入腦子小龍七百片。四水。十五宿火。

　增添

不入腦子上品揀芽小龍一千二百片。

入腦子小龍七百片。

建寧府附發小龍茶八百四十片。

麤色第二綱

　正貢

不入腦子上品揀芽小龍六百四十片。

入腦子小龍六百七十二片。

入腦子小鳳一千三百四十片。四水十五宿火。

入腦子大龍七百二十片。二水十五宿火。

入腦子大鳳七百二十片。二水十五宿火。

增添

不入腦子上品揀芽小龍一千二百片。

入腦子小龍七百片。

建寧府附發小鳳茶一千三百片。

麤色第三綱

正貢

不入腦子上品揀芽小龍六百四十片。

入腦子小龍六百四十片。

入腦子小鳳六百七十二片。

入腦子大龍一千八百片。

入腦子大鳳一千八百片。

增添

不入腦子上品揀芽小龍一千二百片。

入腦子小龍七百片。

建寧府附發大龍茶四百片大鳳茶四百片。

　細色第四綱

　正貢

不入腦子上品揀芽小龍六百片。

入腦子小龍三百三十六片。

入腦子小鳳三百三十六片。

入腦子大龍一千二百四十片。

入腦子大鳳一千二百四十片。

建寧府附發大龍茶四百片大鳳茶四百片。

　細色第五綱

　正貢

入腦子大龍一千三百六十八片。

入腦子大鳳一千三百六十八片。

京鋌改造大龍一千六百片。

建寧府附發大龍茶八百片。大鳳茶八百片。

麤色第六綱

正貢

入腦子大龍一千三百六十片。

入腦子大鳳一千三百六十片。

京鋌改造大龍一千六百片。

建寧府附發大龍茶八百片。大鳳茶八百片。

京鋌改造大龍一千二百片。

麤色第七綱

正貢

入腦子大龍一千二百四十片。

入腦子大鳳一千二百四十片。

京鋌改造大龍二千三百二十片。

建寧府附發大龍茶二百四十片，大鳳茶二百四十片。

京鋌改造大龍四百八十片。

　　細色五綱

貢新爲最上後開焙十日入貢龍團爲最精而建人有直四萬錢之語夫茶之入貢圈以箬葉內以黃斗。

盛以花箱護以重篚花箱內外又有黃羅冪之可謂十襲之珍矣。

　　麤色七綱

揀芽以四十餅爲角小龍鳳以二十餅爲角大龍鳳以八餅爲角圈以箬葉束以紅縷包以紅紙緘以蒡綾。惟揀芽俱以黃焉。

　　開畬

草木至夏益盛。故欲嗇生長之氣以滲雨露之澤。每歲六月與工。虛其本培其末滋蔓之草過鬱之木悉用除之政所以導生長之氣而滲雨露之澤也此之謂開畬。惟桐木則留焉桐木之性與茶相宜而又茶至冬則畏寒桐木望秋而先落茶至夏而畏日桐木至春而漸茂理亦然也。

外焙

石門。乳吉。香口。

右三焙常後北苑五七日與工。每日採茶蒸榨以其黃悉送北苑併造。

茶譜

顧元慶

序

余性嗜茗弱冠時識吳心遠於陽羨。識過養拙於琴川二公極於茗事者也。授余收焙烹點法顧爲簡易。及閱唐宋茶譜茶錄諸書法用熟碾細羅爲末爲餅。所謂小龍團尤爲珍重。故當時有金易得而龍餅不易得之語。嗚呼豈士人而能爲此哉。頃見友蘭翁所集茶譜其法於二公顏合。但收探古今篇什太繁甚失譜意。余暇日刪校仍附王友石竹爐。即苦節君像。并分封六事於後重梓於大石山房常與有玉川之辯者共之也。

茶略

茶者。南方嘉木自一尺二尺至數十尺。其巴峽有兩人抱者伐而掇之。樹如瓜蘆葉如梔子花如白薔薇。實如栟櫚蔕如丁香根如胡桃。

茶品

茶之產於天下多矣。若劍南有蒙頂石花。湖州有顧渚紫筍。峽州有碧澗明月。卭州有火井思安渠江有薄片。巴東有眞香。福州有柏巖洪州有白露常之陽羨婺之舉巖丫山之陽坡龍安之騎火黔陽之都濡高株瀘川之納溪梅嶺之數者其名皆著品第之則石花最上紫筍次之又次則碧澗明月之類是也惜皆不可致耳。

藝茶

藝茶欲茂法如種瓜三歲可採陽崖陰林紫者爲上綠者次之。

採茶

團黃有一旗二鎗之號言一葉二芽也凡早取爲茶晚取爲荈穀雨前後收者爲佳麤細皆可用惟在採摘之時。天色晴明炒焙適中盛貯如法。

藏茶

茶宜蒻葉而畏香藥喜溫燥而忌冷溼故收藏之家以蒻葉封裹入焙中。兩三日一次用火當如人體溫。溫則去溼潤若火多則茶焦不可食。

花茶諸法、

橙茶將橙皮切作細絲一斤以好茶五斤焙乾入橙絲間和用密麻布襯墊火箱罿茶於上烘熱淨綿被罨之三兩時隨用建連紙袋封裹仍以被罨焙乾收用。

蓮花茶於日未出時將半含蓮花撥開放細茶一撮納滿蕊中以麻皮略縶令其經宿次早摘花傾出茶葉。用建紙包茶焙乾再如前法又將茶葉入別蕊中如此者數次取其焙乾收用不勝香美。

木樨、茉莉、玫瑰、薔薇、蘭蕙、橘花、梔子、木香、梅花皆可作茶諸花開時摘其半含半放蕊之香氣全者量其茶葉多少摘花爲茶花多則太香而脫茶韻花少則不香而不盡美三停茶葉一停花始稱假如木樨花須去其枝蔕及塵垢蟲蟻用磁罐一層茶一層花投間至滿紙箬紮固入鍋重湯煮之取出待冷用紙封裹罿火上焙乾收用諸花倣此。

煎茶四要

一擇水

凡水泉不甘能損茶味之嚴。故古人擇水最爲切要。山水上。江水次。井水下。山水乳泉漫流者爲上。瀑湧湍激勿食食久令人有頸疾。江水取去人遠者。井水取汲多者。如蟹黃混濁鹹苦者皆勿用。

二洗茶

凡烹茶先以熱湯洗茶葉去其麈垢冷氣烹之則美。

三候湯

凡茶須緩火炙活火煎。活火謂炭火之有焰者。常使湯無妄沸。庶可養茶。始則魚目散布。微微有聲。二則

四邊泉湧纍纍連珠。終則騰波鼓浪。水氣全消。謂之老湯。三沸之法非活火不能成也。

凡茶少湯多則雲腳散。湯少茶多則乳面聚。

四擇品

凡瓶甌小者易候湯。又點茶注湯有應。若瓶大啜存。停久味過則不佳矣。茶銚茶瓶。銀錫爲上。瓷石次之

耳。

茶色白宜黑盞。建安所造者紺黑紋。如兔毫。其坯微厚�之久熱難冷。最爲要用。出他處者。或薄坯色異。

皆不及也。

茶三要

一滌器

茶瓶茶盞茶匙生鉎致損茶味。必須先時洗潔則美。

二熁盞

凡點茶先須熁盞令熱則茶面聚乳。冷則茶色不浮。

三擇果

茶有眞香有佳味，有正色烹點之際。不宜以珍果香草雜之。奪其香者。松子、柑橙、杏仁、蓮心、木香梅花茉莉、薔薇、木樨之類是也。奪其味者牛乳、番桃荔枝圓眼、水梨、枇杷之類是也。奪其色者柿餅膠棗火桃楊梅橙橘之類是也。凡飲佳茶去果方覺淸絕雜之則無辨矣若必曰所宜核桃榛子瓜仁藻仁菱米欖仁、栗子、雞豆、銀杏、山藥、筍乾芝麻莒蒿蔍莒芹菜之類精製或可用也。

茶效

人飲眞茶能止渴消食。除痰少睡。利水道明目益思。除煩去膩人固不可一日無茶。然或有忌而不飲每食已輒以濃茶漱口煩膩旣去而脾胃健旺凡肉之在齒間者得茶漱滌之乃盡消縮不覺脫去不煩剌挑也。而齒性便苦緣此漸堅密蠹毒自已矣然率用中下茶。
〔出蘇文。〕

茶錄

　　馮時可

總敍

茶一名檟又名蔎名茗檟苦茶也蔎則西蜀語茗則晚取者本草檟甘檟苦羽經則稱檟甘荈苦茶荈爲經自陸羽始羽經稱茶味至寒探不時造不精雜以卉莾飲之成疾若探造得宜便與醍醐甘露抗

衡。故知茶全貴採造蘇州茶飲徧天下專以採造勝耳徽郡向無茶近出松蘿茶最爲時尚是茶始比丘

大方大方居虎丘最久得採造法其後於徽之松蘿結庵採諸山茶於庵焙製遠邇爭市價倏翔湧人因

稱松蘿茶實非松蘿所出也是茶比天池茶稍麤而氣甚香味更清然於虎丘能稱仲不能伯也松郡余

山亦有茶與天池無異顧採造不如近有比丘來以虎丘法製之味與松蘿等老衲亟逐之曰無爲此山

開孽徑而置火坑蓋佛以名爲五欲之一名媒利利媒禍物且難容況人乎

鴻漸伎倆磊塊著是茶經以逃名也示人以處其小無志於大也意亦與韓康市藥事相同不知者乃

謂其宿名夫羽惡用名者且經六經而經茶乎張步兵有云使我有身後名不如生前一杯酒夫

一杯酒之可以逃名也又惡知一杯茶之欲以逃名也

芘莉一曰籯篣茶籠也犧木杓也瓢也永嘉中餘姚人虞洪入瀑布山採茗遇一傄眞道士云吾丹丘子

祈子他日甌犧之餘乞相遺也故知神仙之貴茶久矣

茶經用水以山爲上江爲中井爲下山勿太高勿多石勿太荒遠蓋潛龍虺蜮所蓄毒多於斯也又有瀑

湧湍激者氣最悍食之令頸疾惠泉最宜人無前患耳

江水取去人遠者井取汲多者其沸如魚目微有聲爲一沸緣邊如湧泉連珠爲二沸騰波鼓浪爲三沸。

過此水老不可食也沫餑湯之華也華之薄者曰沫厚者曰餑省茶經中語大抵畜水惡其停費水惡其

老皆於陰陽不適故不宜人耳。

羅岕茶記

七則

熊明遇

産茶處山之夕陽勝於朝陽廟後山西向故稱佳總不如洞山南向受陽氣特專稱仙品。

茶産平地受土氣多故其質濁岕茗産於高山渾是風露清虛之氣故爲可尚。

茶以初出雨前者佳惟羅岕立夏開園吳中所貴梗麤葉厚有蕭箬之氣還是夏月六七日如雀舌者佳。

最不易得。

藏茶宜箬葉而畏香藥喜溫燥而忌冷濕收藏時先用青箬以竹絲編之醱器四週焙茶俟冷貯器中以

生炭火煅過烈日中暴之令滅亂插茶中封固罌口覆以新磚置高爽近人處霉天雨候切忌發覆須於

晴明取少許別貯小瓶空缺處即以箬填滿封置如故方爲可久或夏至後一焙或秋分後一焙

烹茶水之功居大無泉則用天水秋雨爲上梅雨次之秋雨冽而白梅雨醇而白雪水天地之精也色不

能白養水須置石子於甕不惟益水而白石清泉會心亦不在遠。

茶之色重味重香重者俱非上品松蘿香重六安味苦而香與松蘿同天池亦有草萊氣龍井如之至雲

霧則色重而味濃矣。嘗啜虎丘茶色白而香似嬰兒肉眞精絕。

茶色貴白然白亦不難泉清瓶潔葉少水洗旋烹旋啜其色自白然眞味抑鬱徒爲日食耳若取靑綠則

天池松蘿及岕之最下者雖冬月色亦如衣何足爲妙莫若余所收洞山茶自穀雨後五日者以湯薄

瀹貯甖久其色如玉至冬則嫩綠味甘色淡韻淸氣醇亦作嬰兒肉香而芝芬浮蕩則虎丘所無也。

茶寮記

陸樹聲

總叙

園居敬小寮於嘯軒埠垣之西中設茶竈凡瓢汲罌注濯沸之具咸庇擇一人稍通茗事者主之一人佐

炊汲客至則茶烟隱隱起竹外其禪客過從余者每與余相對結跏趺坐啜茗汁舉無生話終南僧明亮

者近從天池來餉余天池苦茶授余點法甚細余嘗受其法於陽羨士人大率先火候其次候湯所謂

蟹眼魚目參沸沫浮沈以驗生熟者法皆同而僧所烹點味絕淸乳面不黟是具人淸淨味中三昧者要

之此一味非眠雲跂石人未易領略余方遠俗雅意禪棲安知不因是遂悟入趙州耶時秒秋旣望適園

無諍居士與五臺僧演鎭終南僧明亮同試天池茶於茶寮中。

雲脚乳面

心一堂　飲食文化經典文庫

凡茶少湯多則雲腳散湯少茶多則乳面浮。

茗戰

建人謂鬭茶爲茗戰。

茶名

一曰茶二曰檟三曰蔎四曰茗五曰荈揚雄注云蜀西南謂茶曰蔎郭璞云早取爲茶晚取爲茗又爲荈。

候湯三沸

茶經凡候湯有三沸如魚眼微有聲爲一沸四向如湧泉連珠爲二沸騰波鼓浪爲三沸則湯老。

祕水

唐祕書省中水最佳故名祕水。

火前茶

蜀雅州蒙山頂上火前茶最好謂焚火以前採者後者謂之火後茶。

五花茶

蒙頂又有五花茶其房作五出。

文火長泉

顧況論茶云。煎以文火細煙。小鼎長泉。

報春鳥

顧渚山茶記山中有鳥。每至正月二月鳴云春起也。至三月四月云春去也採茶者咸呼爲報春鳥。

酪蒼頭

謝宗論茶豈可爲酪蒼頭。便應代酒從事。

漚花

又曰筷蝀背之芳香觀蝦目之沸湯故緗漚花泛浮餑雲騰昏俗塵勞一啜而散。

換骨輕身

陶弘景云苦茶換骨輕身昔丹丘山黃山服之。

花乳

劉禹錫試茶歌欲知花乳清泠味須是眠雲跂石人。

瑞草魁

杜牧茶山詩云山實東吳秀茶稱瑞草魁。

白泥赤印

劉禹錫試茶歌云。何況蒙山顧渚春。白泥赤印走風塵。

　　茗粥

茗古不聞食晉宋已降吳人採葉煮之曰茗粥。

茶疏

　　産茶

許次紓

天下名山必産靈草江南地暖故獨宜茶大江以北則稱六安然六安乃其郡名其實産霍山縣之大蜀山也茶生最多名品亦振於南山陜人皆用之南方謂其能消垢膩去積滯亦甚寶愛顧彼山中不善製造就以食鐺大薪炒焙未及出釜業已焦枯詎堪用哉兼以竹造巨笥乘熱便貯雖有綠枝紫筍輒就萎黄僅供下食矣摘品闘江南之茶唐人首稱陽羨宋人最重建州於今貢茶兩地獨多陽羨僅有其名建茶亦非最上惟有武夷雨前最勝近日所尚者爲長興之羅岕疑即古人顧渚紫筍也介於山中謂之岕羅氏隱焉故名羅岕然岕故有數處今惟洞山最佳姚伯道云明月之峽厥有佳茗是名上乘要之採之以時製之盡法無不佳者其韻致清遠滋味甘香清肺除煩尼稱仙品此自一種也若在顧渚亦有佳者人但以水口茶名之全與岕別矣若歙之松蘿吳之虎丘錢塘之龍井香氣穠郁並可與岕頏行次甫亦稱

黃山黃山亦在歙中。然去松蘿遠甚。士人皆貴天池天池產者飲之略多令人脹滿。自余始下其品向多非之。近來賞奇者始信余言矣浙之產又曰天台之鴈宕括蒼之大盤東陽之金華紹興之日鑄皆與武夷相爲伯仲然雖有名茶而土人之製造不精收藏無法一行出山香味色俱減錢塘諸山產茶甚多南山盡佳北山次之北山勤於用糞蓄雖易茁氣韻反薄夷夷之外有泉州之清源倘以好手製之亦與武夷亞匹惜多焦枯令人意盡楚之產曰寶慶滇之產曰五華此皆表表有名猶在鴈茶之上其他名山所產當不止此余不及論。

　　採摘

清明穀雨摘茶之候也。清明太早立夏太遲穀雨前後。其時適中若肯再遲一二日。期待其氣力完足香烈尤倍易於收藏梅雨不蒸雖稍長大。故是嫩枝柔葉也杭俗喜於盂中撮點。故貴極細理煩散鬱未可遽非吳松人極貴吾鄉龍井背以重價購雨前細者狃於故常未解妙理憒中之人非夏前不摘初試摘者謂之開園探自正夏謂之春茶其地稍寒。故須待夏此又不當以太遲病之往日無有於秋日摘茶者。近乃有之秋七八月重摘一番謂之早春其品甚佳。不嫌少薄他山射利多摘梅茶梅茶澀苦止堪作下食且傷秋摘佳產戒之。

　　炒茶

生茶初摘。香氣未透，必借火力以發其香然性不耐勞炒不宜久多取入鐺，則手力不勻久於鐺中過熟

而香散矣甚且枯焦不堪烹點炒茶之器最嫌新鐵鐺腥一入不復有香大忌脂膩害甚於鐵須豫取一

鐺專用炊飲無得別作他用炒茶之薪僅可樹枝不用幹葉幹則火力猛熾葉則易燄易滅鐺必磨瑩旋

摘旋炒一鐺之內僅容四兩先用文火焙頓次用武火催之手加木指急急鈔轉以半熟為度微俟香發

是其候矣急用小扇鈔置被籠純綿大紙襯底燥焙積多候冷入瓶收藏人力若多數鐺數籠人力即少

僅一鐺二鐺亦須四五竹籠蓋炒速而焙遲燥濕不可相混混則大減香力。一葉稍焦全鐺無用然火雖

忌猛尤嫌鐺冷則枝葉不柔以意消息最難最難。

岕中製法

岕之茶不妙飯中蒸熟然後烘焙綠其摘遲枝葉微老炒亦不能使輭徒枯碎耳亦有一種極細炒卵乃

采之他山炒焙以欺好奇者彼中甚愛惜茶决不忍乘嫩摘探以傷樹本余意他山所產亦稍遲探之待

其長大。如岕中之法蒸之似無不可但未試嘗不敢漫作。

收藏

收藏宜用瓷甕大容一二十斤四圍厚箬中則貯茶須極燥極新專供此事久乃愈佳不必歲易茶須築

實仍用厚箬填緊甕口再加以箬以真皮紙包之以苧麻緊扎壓以大新磚勿令微風得入可以接新。

置頓

茶惡濕而喜燥畏寒而喜溫忌蒸鬱而喜清涼置頓之所須在時時坐臥之處逼近人氣則常溫不寒必在板房不宜土室板房則燥土室則蒸又要透風勿置幽隱之處尤易蒸濕兼恐有失點檢其閤皮之方宜磚底數層四圍磚砌形若火爐愈大愈善勿近土牆頓甕其上隨時取竈下火灰候冷簇於甕傍半尺以外仍隨時取灰火簇之令裹灰常燥一以避風一以避濕卻忌火氣入甕則能黄茶世人多用竹器貯茶雖復多用箸譐然箸性峭勁不甚安帖最難緊實能無滲罅風易侵多故無益也其不燥地貯頓萬萬不可人有以竹器盛茶置被籠中用火焙黄除火卽潤忌之忌之。

取用

茶之所忌上條備矣然則陰雨之日豈宜擅開如欲取用必候天氣晴明融和高朗然後開缶庶無風濕先用熱水濯水麻就拭燥缶口內箸別置燥處另取小罌貯所取茶量日幾何以十日爲限去茶盈寸則以寸箸補之仍須碎剪茶日漸少箸日漸多此其要也焙燥築黄包緊如前。

包裹

茶性畏紙紙於水中成受水氣多也紙裹一夕隨紙作氣盡矣雖次中焙出少頃卽潤鴈宕諸山首坐此病每以紙帖寄遠安得復佳。

102

日用頓置

日用所須。貯小器中箬包苧紮。亦勿見風宜即置之案頭。勿頓巾箱書簏。尤忌與食器同處。並香藥則染香藥海味則染海味。其他以類而推不過一夕黃色變矣。

茶箋

聞龍

製法

茶初摘時。須揀去枝梗老葉。惟取嫩葉。又須去尖與柄恐其易焦此松蘿法也炒時須一人從傍扇之以袪熱氣否則黃色香味俱減子所親試扇者色翠不扇色黃炒起出鐺時置大瓷盤中仍須急扇令熱氣稍退以手重揉之再散入鐺文火炒乾入焙蓋揉則其津上浮點時香味易出田子藝以生曬不炒不揉者為佳亦未之試耳

經云焙鑿地深二尺闊一尺五寸長一丈。上作短牆高二尺。泥之以木構於焙上縆木兩層高一尺以焙茶之半乾昇下棚全乾昇上棚恐謂令人不必全用此法予嘗構一焙室高不踰尋方不及丈縱廣正等四圍及頂綿紙密糊無小罅隙置三四火缸於中安新竹篩於缸內預洗新麻布一片以襯之散所炒茶於篩上闔戶而焙。上面不可覆蓋茶葉尚潤一覆則氣悶罨黃須焙二三時俟潤氣盡然後覆以竹箕

焙極乾出缸。待冷入器收藏後。再焙亦用此法色香與味不致大減。

諸名茶法多用炒。惟羅岕宜於蒸焙味真蘊藉世競珍之卽顧渚陽羨密邇洞山不復倣此想此法偏宜

於岕未可槩施他茗。而經已云蒸之焙之則所從來遠矣。

吳人絕重岕茶往往雜以黃黑箬大是闕事余每藏茶必令樵靑入山探竹箭箬拭淨烘乾護器四週半

用剪碎拌入茶中經年發覆靑翠如新。

吾鄉四陸省山泉水在在有之然省嶔而不廿獨所謂宕泉者其源出自四明瀉淺洞歷大闔小皎諸名

齜迴溪百折幽洞千支沿洞漫衍不舍晝夜鄞令王公元偉築埭宕山以分注江河自洞抵埭不下三

數百里水色蔚藍素砂白石黝黝見底淸寒甘滑甲於郡中。余愧不能爲浮家泛宅。送老于斯。每一臨泛。

浹旬忘返攜茗就烹鮮特甚洵源泉之最勝甌犠之上味矣以僻在海陬圖經是漏故又新之記囿聞。

季疵之杓莫及遂不得與谷簾諸泉齒譽獪遁吉人滅影貞士直將逃名世外亦且永托知稀矣。

山林隱逸水銚用銀尙不易得何況鍰乎若用之恆而卒歸於鐵也。

茶具滌畢覆於竹架俟其自乾爲佳其拭巾只宜拭外切忌拭內蓋布帨雖潔一經水手極易作氣縱器

不乾。亦無大害。

吳興姚叔度言茶葉多焙一次。則香味隨減一次予驗之良然。但於始焙極燥。多用炭箬。如法封固。卽梅

雨連旬燥固自若。惟開罐頻取。所以生潤不得不再焙耳。自四五月至八月。極宜致謹九月以後天氣漸

蕭便可僻嚴矣雖然能不弛懈尤妙尤妙。

東坡云。蔡君謨嗜茶老病不能飲。日烹而玩之者幾希矣。因憶老友周文甫自少至老茗椀薰爐無時蹔廢飲

云年老耽彌甚脾寒量不勝去烹而玩之者幾希矣。因憶老友周文甫自少至老茗椀薰爐無時蹔廢飲

茶日有定期旦明晏食禺中餔時下舂黃昏凡六舉其僮僕烹點不與焉壽八十五無疾而卒非宿植清

麗鳥能與世安享視好而不能飲者所得不旣多乎家中有製舂壺摩挲寶愛不啻掌珠用之旣久外類

紫玉內如碧雲眞奇物也後以殉葬。

按經云第二沸留熱以貯之以備育華救沸之用者名曰雋永五人則行三盌七八人則行五盌若遇六人。

但闕其一正得五人卽行三盌以雋永補所闕人故不必別約盌數也。

茶解

十二則

羅廩

按唐氏產茶地僅僅如季疵所稱而今之虎丘羅岕、天池顧渚松蘿龍井、鴈宕武夷靈山大盤日鑄朱溪

諸名茶無一與焉乃知靈草在在有之但培植不嘉或疏探製耳。

茶地南向爲佳向陰者遂劣故一山之中美惡大相懸也。

茶固不宜加以惡木惟桂梅辛夷玉蘭玫瑰蒼松翠竹與之間植足以蔽覆霜雪掩映秋陽其下可植芳蘭幽菊清芬之物最忌菜畦相逼不免滲漉淬厭清眞。

凡貯茶之器始終貯茶不得移爲他用。

烹茶須甘泉次梅水梅雨如膏萬物賴以滋養其味獨甘梅後便不堪飮大甕滿貯投伏龍肝一塊卽竈中心乾土也乘熱投之。

貯水甕須置陰庭覆以沙石使承星露則英華不散靈氣常存假令壓以木石封以紙箬暴於日中則外耗其神內閉其氣水神敝矣。

李南金謂當用背二涉三之際爲合量此眞賞鑒之言而羅鶴林㰢湯老欲於松楓潤水後移抵去火少待沸止而瀹之此語亦未中窾殊不知湯旣老矣雖去火何挍哉。

茶煨或瓦或竹大小與湯銚稱。

採茶制茶最忌手汗膻氣口臭多涕不潔之人及月信婦人又忌酒氣蓋茶酒性不相入故製茶人切忌沾醉。

茶性淫易於染著無論腥穢及有氣息之物不宜近卽名香亦不宜近。

山堂夜坐。汲泉煮茗。至水火相戰。如聽松濤清芬滿杯。雲光艷瀲。此時幽氣故難與俗人言矣。

茶色白味甘鮮香觸鼻。乃為精品茶之精者淡亦白濃亦白初潑白少頃亦白味甘色白其香自溢者得

則俱得也。近來好事者或虛其色重注之湯投茶數片味固不足香亦竇然終不免水厄之諸矣。然尤

貴擇水香以蘭花上蠶荳花次之水以山上石池泉旋汲用之斯良丙舍在城夫豈易得故宜多汲貯以

大甕但忌新器為其火氣未退易於敗水亦易生蟲久用則善最嫌他用水性忌木松杉為甚木桶貯水。

其害滋甚挈瓶為佳耳。

考槃餘事 　　　　　　　　　　　　　　　　　　　屠隆

茶品

與茶精稍異今烹製之法亦與蔡陸諸前人不同。

虎丘

最號精絕為天下冠惜不多產皆為豪右所據寂寞山家無由獲購矣。

天池

青翠芳馨啜之賞心嗅亦消渴誠可稱仙品諸山之茶尤當退舍。

陽羨

俗名羅岕。浙之長興者佳。荊溪稍下。細者其價兩倍天池。惜乎難得。須親自采收方妙。

六安

品亦精。入藥最效。但不善炒。不能發香而味苦。茶之本性實佳。

龍井

不過十數畝外此有茶似皆不及。大抵天開龍泓美泉。山靈特生佳茗以副之耳。山中僅有一二家炒法甚精。近有山僧焙者亦妙。眞者天池不能及也。

天目

爲天池龍井之次。亦佳品也。地誌云山中寒氣早嚴。山僧至九月卽不敢出。冬來多雪。三月後方通行茶之萌芽較晚。

采茶

不必太細。細則芽初萌而味欠足。不必太青。青則茶已老而味欠嫩。須在穀雨前後。覓成梗帶葉微微綠色。而團且厚者爲上。更須天色晴明。采之方妙。若閩廣嶺南多瘴癘之氣。必待日出山霽霧障嵐氣收淨采之可也。穀雨日晴明采者能除痰嗽療百疾。

日曬茶

茶有宜以日曬者青翠香潔。勝於火炒。

焙茶

茶采時先自帶銚籠入山別租一室擇茶工之尤良者倍其雇直。戒其搓摩。勿使生硬。勿令過焦。細細炒燥扇冷方貯罌中。

藏茶

茶宜箬葉而畏香藥。喜溫燥而忌冷濕。故收藏之家。先於清明時收買箬葉揀其最青者預焙極燥以竹絲綯之每四片編為一塊聽用。又買宜興新堅大罌可容茶十斤以上者洗淨焙乾聽用。山中焙茶回復焙一番。去其茶子老葉枯焦者及梗屑。以大盆埋伏生炭。覆以籠中鼓細赤火。既不生烟又不易過罌茶焙下焙之。約以二斤作一焙。別有炭火入大爐內。將罌懸架其上。至燥極而止。以縐箬襯於罌底茶燥者扇冷方先入罌茶之燥。以拈起即成末爲驗。隨焙隨入。既滿又以箬葉覆於罌上。每茶一斤約用箬二兩。口用尺八紙焙燥封固。約六七層。壓以方厚白木板一塊。亦取焙燥者。然後於向明淨室高閣之用時以新燥宜與小瓶取出。約可受四五兩隨即包整夏至後三日再焙一次秋分後三日又焙一次。一陽後三日又焙之。連山中共五焙。直至交新色味如一罌中用淺更以燥箬葉貯滿之則久而不湮。

又法以中罐盛茶十斤一瓶。每瓶燒稻草灰入於大桶。將茶瓶坐桶中。以灰四面填桶上覆灰築實。每用撥開瓶取茶些少。仍覆灰。再無蒸壞。次年換灰。又法空樓中懸架。將茶瓶口朝下放。不蒸綠蒸氣自天而下也。

諸花茶

蓮花茶，於日未出時半含白蓮花撥開。放細茶一撮納滿蕊中。以麻皮略紮令其經宿。次早摘花傾出茶葉。用建紙包茶焙乾。再如前法隨意以別蕊製之焙乾收用。不勝香美。

橙茶將橙皮切作細絲一斤。以好茶五斤焙乾。入橙間和用密廂布襯襯火廂。置茶於上。以淨綿被罨罨之。

三兩時。隨用建連紙袋封裹。仍以被罨烘乾收用。

木樨玫瑰薔薇蘭蕙橘花梔子木香梅花皆可作茶。諸花開時。摘其半含半放蕊之香氣全者。量其茶多少。摘花爲伴。花多則太香而脫茶韻。花少則不香而不盡美三停茶葉一停花。始稱假如木樨花須去其枝蔕及塵垢蟲蟻。用瓷罐一層茶一層花投間至滿紙箬紮固入鍋重湯煮之。取出待冷。用紙封裹。置火上焙乾收用。則花香滿頰。茶味不減。諸花倣此以上俱平等細茶拌之。可也。茗花入茶。本色香味尤嘉。

茉莉花以熟水半杯放冷。鋪竹紙一層。上穿數孔。晚時采初開茉莉花綴於孔內。上用紙封不令泄氣。明晨取花簪之水。香可點茶。

擇水

天泉。秋水爲上梅水次之秋水白而冽梅水白而甘甘則茶味稍奪冽則茶味獨全。故秋水較差勝之。春冬二水春勝於冬皆以和風甘雨得天地之正施者爲妙惟夏月暴雨不宜或因風雷所致實天之流怒也。

龍行之水暴而霪者旱而凍者腥而墨者皆不可食雪爲五穀之精取以煎茶幽人清況。

地泉。取乳泉漫流者如梁溪之惠山泉爲最勝。

取清寒者泉不難於清而難於寒石少土多沙膩泥凝者必不清寒且瀾峻流駛而清嚴與陰積而寒者亦非佳品。

取山脈逶迤者山不停處水必不停若停即無源者矣旱必易涸往往有伏流沙土中者挹之不竭即可食。不然則滲瀦之淥耳雖淸勿食。

有瀑湧湍急者勿食食久令人有頸疾。如廬山水簾洪州天台瀑布誡山居之珠箔錦幕以供耳目則可。

入水品則不宜矣。

有溫泉下生硫黃故然有同出一壑半溫半冷者皆非食品。

有流遠者遠則味薄取深潭停蓄其味迺復。

有不流者食之有害博物志曰山居之民多癭腫。由於飲泉之不流者泉上有惡木則葉滋根潤能損甘香甚者能釀毒液尤宜去之如南陽菊潭損益可驗。

江水　取去人遠者揚州南泠夾石淳淵特入首品。

長流　亦有通泉竇者必須汲貯候其澄澈可食。

井水　脈暗而性滯味鹹而色濁有妨茗氣試煎茶一甌隔宿視之則結浮膩一層他水則無此其明驗矣。雖然汲多者可食終非佳品或平地偶穿一井適通泉穴味甘而澀大旱不涸與山泉無異非可以井水例觀也若海濱之井必無佳泉蓋潮汐近地斥鹵故也。

靈水　上天自降之澤如上池天酒甜雪香雨之類世或希覯人亦罕識乃仙飲也。

丹泉　名山大川仙翁修煉之處水中有丹其味異常能延年却病尤不易得凡不淨之器甚不可汲。如新安黃山東峯下有硃砂泉可點茗春色微紅此自然之丹液也臨沅廖氏家世壽後掘井人得丹砂數十粒。西湖葛洪井中有石甕淘出丹數枚如芡實啖之無味棄之有施漁翁者拾一粒食之壽一百六歲。

洗茶

養水　取白石子入甕中。能養其味。亦可澄水不淆。

凡烹茶先以熱湯洗茶去其塵垢冷氣烹之則美。

候湯

凡茶須緩火炙活火煎活火謂炭火之有焰者以其去餘薪之烟雜穢之氣且使湯無妄沸庶可養茶始如魚目微有聲爲一沸緣邊湧泉連珠爲二沸奔濤濺沫爲三沸三沸之法非活火不成如坡翁云蟹眼已過魚眼生颼颼欲作松風聲盡之矣若薪火方交水生釜熾急取旋傾水氣未消謂之嫩若人過百息水踰十沸或以話阻事廢始取用之湯已失性謂之老老與嫩皆非也。

注湯

茶已就膏宜以造化成其形若手顫臂軃惟恐其深瓶嘴之端若存若亡湯不順通則茶不勻粹是謂緩注一甌之茗不過二錢茗盞量合宜下湯不過六分萬一快瀉而深積之則茶少湯多是謂急注緩與急皆非中湯欲湯之中臂任其責。

擇器

凡瓶要小者易候湯又點茶注湯有應若瓶大啜存停久味過則不佳矣所以策功建湯業者金銀爲優。貧賤者不能具則瓷石有足取焉瓷瓶不奪茶氣幽人逸士品色尤宜石凝結天地秀氣而賦形琢以爲器秀猶在焉其湯不良未之有也然勿與誇珍衒豪臭公子道銅鐵鉛錫腥苦且澀無油瓦瓶滲水而有

土氣用以煉水飲之逾時惡氣纏口而不得去亦不必與猥人俗輩言也。

宜廟時有茶齋料精式雅質厚難冷瑩白如玉可試茶色。最爲要用蔡君謨取建盞其色紺黑似不宜用。

滌器

茶甌茶盞茶匙生鉎致損茶味。必須先時洗潔則美。

熁盞

凡點茶必須熁盞令熱則茶面聚乳冷則茶色不浮。

擇薪

凡木可以煮湯不獨炭也。惟調茶在湯之淑慝。而湯最惡烟非炭不可。若暴炭膏薪濃烟蔽室實爲茶魔。

或柴中之麩火焚餘之虛炭風乾之竹篠樹梢燃鼎附瓶顏甚快意然體性浮薄無中和之氣亦非湯友。

擇果

茶有眞香。有眞味。有正色。烹點之際。不宜以珍果香草奪之奪其香者松子、柑橙、木香梅花、茉莉、薔薇、木

樨之類是也。奪其味者番桃、楊梅之類是也。凡飲佳茶去果方覺清絕雜之則無辨矣若必曰所宜核桃、

榛子、杏仁、欖仁、菱米、粟子、雞豆銀杏、新筍蓮肉之類精製或可用也。

茶効

人飲眞茶能止渴消食除痰少睡利水道明目益思除煩去膩人固不可一日無茶然或有忌而不飲每

食已輒以濃茶嗽口煩膩既去而脾胃自清凡肉之在齒間者得茶滌之乃盡消縮不覺脫去不煩刺挑

也而齒性便苦緣此漸堅密蠹毒自去矣然率用中下茶。

人品

茶之爲飲最宜精形修德之人兼以白石清泉烹煮如法不時廢而或與能熟習而深味神融心醉覺與

醍醐甘露抗衡斯善賞鑒者矣使佳茗而飲非其人猶汲泉以灌蒿萊罪莫大焉有其人而未識其趣一

吸而盡不暇辨味俗莫甚焉司馬溫公與蘇子瞻嗜茶墨公云茶與墨正相反茶欲白墨欲黑茶欲重墨

欲輕茶欲新墨欲陳蘇曰奇茶妙墨俱香公以爲然唐武墨博學有著述才性惡茶因以詆之其略曰釋

滯消壅一日之利暫佳瘠氣侵精終身之害斯大獲益則收功茶力貽患則不爲茶災豈非福近易知禍

遠難見。

李德裕侈過求在中書不飲京城水悉用惠山泉時謂之水遞清致可嘉有損盛德。

傳稱陸鴻漸閉門著書誦詩擊木性甘茗味狎漚灩淸風雅趣膽炙古今嗜茶者至陶其形置煬突間。

祀爲茶神可謂崇之極矣嘗考蠻甌志云陸羽采越江茶使小奴子看焙奴失睡茶燋爍不可食羽怒

以鐵索縛奴而投火中殘忍者此其餘不足觀也已矣。

茶具

苦節君。　湘竹風鑪。

建城。　蒻茶箬籠。

湘筥焙。　焙茶箱蓋其上。以收火氣也。隔其中以有容也。納火其下去茶尺許。所以養茶色香味也。

雲屯。　泉缶。

烏府。　盛炭籃。

水曹。　滌器桶。

鳴泉。　煮茶罐。

品司。　編竹爲籃收貯各品葉茶。

沈垢。　古茶洗。

分盈。　水杓卽茶經水則每兩升用茶一兩。

執權。　準茶秤每茶一兩用水二升。

合香。　藏日支茶瓶以貯司品者。

歸潔。　竹筅箒用以滌壺。

滌塵。　洗茶匜。

醎象。　古石鼎。

遞火。　銅火斗。

降紅。　銅火筯不用聯索。

國風。　湘竹扇。

注春。　茶壺。

靜沸。　竹架爲茶經支腹。

運鋒。　鑱果刀。

啜香。　茶甌。

揾雲。　竹茶匙。

甘鈍。　木碪墩。

納敬。　湘竹茶素。

易持。　納茶雕漆祕閣。

受汚。　拭抹布。

本草綱目

李時珍

釋名

蘇頌曰郭璞云早采爲茶。晚采爲茗。一曰荈蜀人謂之苦茶。陸羽云其名有五。一茶二檟三蔎四茗五荈。

李時珍曰楊愼丹鉛錄云茶卽古茶字。晉途詩云誰謂茶苦。其甘如薺是也。顏師古云漢時茶陵始轉途音

爲宅加切。或言六經無茶字。未深考耳。

集解

神農食經曰茶茗生益州及山陵道旁凌冬不死三月三日采乾蘇恭曰茗生山南澤中山谷爾雅云檟

苦茶。郭璞註云樹小如梔子冬生葉。可煮作羹飲蘇頌曰今閩浙蜀江湖淮南山中皆有之通謂之茶春

中始生嫩葉蒸焙去苦水末之乃可飲與古所食殊不同也陸羽茶經云茶者南方嘉木自一尺二尺至

數十尺其巴州峽山有兩人合抱者伐而掇之。木如瓜蘆。葉如梔子花如白薔薇實如栟櫚蔕如丁香根

如胡桃其上者生爛石中生礫壤下者生黃土藝法如種瓜三歲可采陽岸陰林紫者上綠者次筍者上

芽者次葉卷者上舒者次在二月三月四月之間茶之筍者生於爛石之間長四五十莟蕨之始抽凌露

采之茶之芽者發於叢薄之上有三枝四枝五枝於枝顚采之采得蒸焙封乾有千類萬狀也略而言之。

如胡人鞾者蹙縮然。如犎牛臆者廉沾然。出山者翰困然。拂水者涵澹然。皆茶之精好者也。如竹籜、如霜

荷者茶之瘠老者也。其別者有石南芽枸杞芽枇杷葉皆治風疾又有皂莢芽槐芽、柳芽、乃上春摘其芽。

和茶作之。故今南人輶官茶往往雜以泉藥惟茅蘆竹筍之類不可入之。餘山中草木芽葉皆可和椿

梆尤奇。虔茶性冷惟雅州蒙山出者溫而袪疾毛文錫茶譜云蒙山有五頂。上有茶園其中頂曰上清峯、

昔有僧人病冷且久遇一老父謂曰蒙之中頂茶當以春分之先後多構人力俟雷發聲幷手采擇三日

而止若獲一兩以本處水煎服。卽能祛宿疾二兩當眼前無疾三兩能固肌骨四兩卽為地仙矣。其僧如

說獲一兩餘服之未竟而疾瘳。其四頂茶園朵摘不廢惟中峯草木繁密雲霧蔽虧鷙獸時出故人跡不

到矣。近歲稍貴此品製作亦精於他處。陳承曰。近世蔡襄遂闢茶梅備惟建州北苑數次產者性味與諸

方略不同。今亦獨名臘茶上供御用碾治作餅曰曬得火愈良其他者或為芽或謂末收貯若微見火便

硬不可久收。色味俱敗。惟鼎州一種芽茶性味略纇建茶今汴中及河北京西等處磨為末亦冒蠟茶者。

是也。寇宗奭曰苦茶卽今茶也。陸羽有茶經。丁謂有北苑茶錄。毛文錫有茶譜。蔡宗顏有茶對皆甚詳然

古人謂茶為雀舌麥顆言其至嫩也。又有新芽一發便長寸餘其粗如針最為上品其根幹水土力皆有

餘故也。雀舌麥顆又在下品前人未知爾李時珍曰茶有野生種生者用子其子大如指頂而圓黑色

其仁入口初甘後苦。最蝕人喉。而閩人以榨油食用二月下種一坎百顆乃生一株蓋空殼者多故也。

古今茶事

畏水與日最宜坡地陰處清明前采者上穀雨前者次之此後皆老茗爾采蒸揉焙修造皆有法詳見茶

譜茶之稅始於唐德宗盛於宋元及於明朝乃與西番互市易焉夫茶一木爾下爲民生日用之資上爲

朝廷賦稅之助其利博哉昔賢所稱大約謂唐人尙茶茶品衆有雅州之蒙頂石花露芽穀芽爲第一

建寧之北苑龍鳳團爲上供蜀之茶則有東川之神泉獸目硤州之碧澗明月夔州之眞香卭州之火井

思安黔陽之都濡嘉定之峨嵋瀘州之納溪玉壘之沙坪楚之茶則有荆州之仙人掌湖南之白露長沙

之鐵色䖰州蘄門之團面壽州霍山之黃芽廬州之六安英山武昌之（缺）山岳州之巴陵辰州之漵浦

湖南之寶慶茶陵吳越之茶則有湖州顧渚之紫筍臨州方山之生芽洪州之白露雙井之白毛廬山之

雲霧常州之陽羨池州之九華丫山之陽坡袁州之界橋睦州之鳩坑宣州之陽坑金華之舉岩會稽之

日鑄。茶有名者其他猶多。而猥雜更甚。按陶隱居註苦茶云。餘物並冷利。又巴東縣有眞茶。火焙作卷結爲飲亦

人。凡所飲物。有茗及木葉天門冬苗菝葜葉皆益人。西陽武昌廬江晉陵皆有好茗。飲之宜

令人不眠。俗中多烹檀葉及大皂李葉作茶飲。並冷利。南方有瓜蘆木。亦似茗也。今人采儲槇山蘗。南燭。

烏藥諸葉。皆可爲飲以亂茶云。

　　葉

　　氣味

苦甘微寒。無毒。

陳藏器曰苦寒久食令人瘦去人脂。使人不睡。飲之宜熱冷則聚痰。

胡洽曰。與榧同食令人身重。

李廷飛曰。大渴及酒後飲茶水入腎經。令人腰脚膀胱冷痛兼患水腫攣痺諸疾。大抵飲茶宜熱宜少不飲尤佳空腹最忌之。

李時珍曰。服威靈仙土茯苓者忌飲茶。

主治

神農食經曰。瘦癢利小便。去痰熱止渴令人少睡。有力悅志。

蘇恭曰。下氣消食作飲加茱萸葱薑良。

陳藏器曰。破熱氣除瘴氣利大小腸。

王好古曰。清頭目治中風昏憒多睡不醒。

陳承曰治傷暑合醋治泄痢甚效。

吳瑞曰。炒煎飲治熱毒赤白痢同芎窮葱白煎飲止頭痛。

李時珍曰濃煎吐風熱痰涎。

發明

王好古曰茗茶氣寒味苦入手足厥陰經。治陰證湯藥內入此。去格拒之寒及治伏陽大意相似經云苦

以泄之其體下行。所以能清頭目機曰頭目不清熱熏上也以苦泄其熱則上清矣且茶體清浮采摘之

時芽蘖初萌正得春升之氣味雖苦而氣則薄乃陰中之陽可升可降利頭目蓋本諸此汪穎曰一人好

燒鵝炙煿日常不缺人咸防其生癰疽後卒不病訪知其人每夜必啜涼茶一椀乃知茶能解炙煿之毒

也楊士瀛曰蒙茶治痢竈助陽茶助陰並能消暑解酒食毒且一寒一熱調平陰陽不問赤白冷熱用之

皆良生薑細切與真茶等分新水濃煎服之蘇東坡以此治文潞公有効李時珍曰茶苦而寒陰中之陰

沈也降也最能降火火為百病火降則上清矣然火有五火有虛實若少壯胃健之人心肺脾胃之火多

盛故與茶相宜溫飲則火因寒氣而下降熱飲則茶借火氣而升散又兼解酒食之毒使人神思闓爽不

昏不睡此茶之功也若虛寒及血弱之人飲之既久則脾胃惡寒元氣暗損土不制水精血潛虛成痰飲

成痞脹成痿痹成黃瘦成嘔逆成洞瀉成腹痛成疝瘕種種內傷此茶之害也民生日用蹈其弊者往往

皆是而婦嫗受害更多習俗移人自不覺耳況雜茶更多其為患也又可勝言哉人有嗜茶成

癖者時時咀啜不止久而傷營傷精血不華色黃瘁痿弱抱病不悔尤可嘆惋晉干寶搜神記載武官周

時病後啜茗一斛二升乃止纔減升合便為不足有客令更進五升忽吐一物狀如牛脾而有口澆之以

茗。盞一觔二升再澆五升卽溢出矣人途謂之觔茗痕嗜茶者觀此可以戒矣陶隱居雜錄言丹丘子黃

山君服茶輕身換骨壺公食忌言苦茶久食羽化者皆方士謬言誤世者也按唐補闕毋炅茶序云釋滯

消擁一日之利暫佳瘠氣侵精終身之累斯大獲益則功歸茶力貽患則不謂茶災豈非福近易知禍遠

難見乎又宋學士蘇軾茶說云除煩去膩世故不可無茶然暗中損人不少空心飲茶入鹽直入腎經且

冷脾胃乃引賊入室也惟飲食後濃茶漱口既去煩膩而脾胃不知且苦能堅齒消蠹深得飲茶之妙古

人呼茗爲酪奴亦賤之也時珍早年氣盛每飲新茗必至數椀輕汗發而肌骨淸頗覺痛快中年胃氣稍

損飲之卽覺爲害不痞悶嘔惡卽腹冷洞泄故備述諸說以警同好焉又濃茶能令人吐乃酸苦涌泄爲

陰之義非其性能升也。

附方

氣虛頭痛用上春茶末調成膏罝瓦盞內覆轉以巴豆四十粒作二次燒煙熏之曬乾乳細每服一字別

入好茶末食後煎服立效。醫方大成

熱毒下痢諗曰赤白下痢以好茶一斤炙擣末濃煎一二盞服久患痢者亦宜服之直指用蠟茶赤痢

以密水煎服白痢以連皮自然薑汁同水煎服二三服卽愈經驗良方用蠟茶二錢湯點七分入麻油一

蜆殼和服須臾腹痛大下卽止一少年用之有效一方蠟茶末以白梅肉和丸赤痢甘草湯下白痢烏梅

古今茶事

湯下各百丸。一方。建茶合醋煎服。即止大便下血榮衛氣虛或受風邪或食生冷或啖炙煿或飲食過度。

積熱腸間使脾胃受傷精粗不聚大便下利清血臍腹作痛裏急後重及酒毒一切下血並皆治之用細

茶半斤碾末用百藥煎五箇燒存性每服二錢米飲下日二服。普濟方

產後祕塞以葱涎調蠟茶末，九百丸，茶服自通不可用大黄利藥利者百無一生。郭稽中婦人方

久年心痛十年五年者。煎湖茶以頭醋和勻服之良。兵部手集

腰痛難轉。煎茶五合。投醋二合頓服。食療左詵

嗜茶成癖一人病此一方士令以新鞋盛茶令滿任意食盡再盛一鞋。如此三度。自不喫也。男用女鞋女

用男鞋用之果愈也。集簡方

解諸中毒芽茶白礬等分碾末冷水調下。簡便方

痘瘡作癢房中宜燒茶煙恆薰之。

陰囊生瘡用蠟面茶為末先以甘草湯洗後貼之妙。經驗方

脚椏濕爛茶葉嚼爛傅之有效。攝生方

蟺螻尿瘡初如穀粟漸大如豆更大如火焰漿𤷍疼痛至甚者速以草茶并蠟茶俱可以生油調傅藥至

痛乃止。勝金方

風痰顛疾。茶芽巵子各一兩。煎濃汁一椀服良久探吐。_方摘元

霍亂煩悶。茶末一錢煎水調乾薑末一錢服之即安。_{穗錄}聖濟方

月水不通茶清一瓶入沙糖少許露一夜服雖三個月胎亦通不可輕視。_氏鮑

痰喘咳嗽不能睡臥好末茶一兩白僵蠶一兩爲末放盌內蓋定傾沸湯一小盞臨臥再添湯點服。_方瑞竹堂

苦寒有毒

　　氣味

　　主治

李時珍曰喘急咳嗽去痰垢搗仁洗衣除油膩。

　　附方

上氣喘急時有咳嗽茶子百合等分爲末密丸梧子大每服七丸新汲水下。_方聖惠

喘嗽剝貽不拘大人小兒用糯米泔少許磨茶子滴入鼻中令吸入口服之。口咬竹筒少頃涎出如線不過二三次絕根廔驗。_{良方}輕殿

頭腦鳴響狀如虫蛀名大白蟻。以茶子爲末吹入鼻中取效。_方楊拱醫要

125

煮泉小品

田藝蘅

序

仁和趙觀撰

田子藝抱韜轢江山之氣。吐喬葩藻之才。夙厭塵囂。歷覽名勝。竊慕司馬子長之爲人。窮搜退討固嘗據該洽評品允當實泉茗之信史也。命予敍之。刻燭以竢予惟贊皇公之鑒水竟陵子之品茶猷以成癖矣。粵若子藝卿論水之宜茶者則又互有同異。近雲間徐伯臣氏作水品復略矣。李秀卿論水之宜茶者。泊丁公言茶圖顋論探造而未備蔡君謨茶錄詳於烹試而弗精劉伯芻李秀卿論水之宜茶者則又互有同異。昔人之所長得川原之雋味甚思冲以淡其才清以越。具可想也殆與泉茗相渾化者矣。不足以洗塵囂而謝舊綺乎。重遠嘉懇勉綴首簡第卽席撟辟愧不工耳。

飲泉覺爽唼茶忘喧。謂非審梁紈綺可語。愛著煮泉小品。與漱流枕石者商焉。頃於子讓所出以示予考

引

小小洞天居士

昔我田隱翁嘗自委曰泉石膏肓噫。夫以膏肓之病固神醫之所不治者也。而在於泉石則其病亦甚奇矣。余少患此病心已忘之。而人皆咎余之不治。然徧檢方書無對病之藥。偶居山中遇淡若叟向余曰。此病固無恙也。子欲治之。卽當煮清泉白石。加以苦茗服之久久雖辟穀可也。又何患於膏肓之病邪。余

敬頓首受之遂依法調飲自覺其效日著因廣其意條輯成編以付司鼎山童俾遇有同病之客來便以此薦之若有如煎金玉湯者來懼弗出之以取彼之鄙笑時嘉靖甲寅秋孟冬元日也。

品目

一源泉　二石流　三清寒　四甘香　五宜茶

六靈水　七異泉　八江水　九井水　十絡談

煮泉小品　　　　　　　明　武林子藝田藝蘅撰

源泉

積陰之氣為水水本曰源源曰泉水本作沴象衆水並流中有微陽之氣也省作水源本作原亦作灥從泉出厂下厂石岩之可居者省作原今作源泉本作眔象水流出成川形也知三字之義而泉之品思過半矣。

山下出泉曰蒙蒙穉也物穉則天全水穉則味全故鴻漸曰山水上其曰乳泉石池慢流者蒙之謂也其曰瀑湧湍激者則非蒙矣故戒人勿食

混混不舍皆有神以主之故天神引出萬物而漢書三神山嶽其一也。

源泉必重而泉之佳者尤重餘杭徐隱翁嘗為余言以鳳凰山泉較阿姥墩百花泉便不及五錢可見仙

源之勝矣。

山厚者泉厚。山奇者泉奇。山清者泉清。山幽者泉幽。皆佳品也。不厚則薄。不奇則蠢。不清則濁。不幽則喧。必無佳泉。

山不亭處。水必不亭。若亭卽無源者矣。旱必易涸。

石流

石山骨也。流水行也。山宣氣以產萬物氣宣則脉長。故曰山水上。博物志石者金之根甲石流精以生水。

又曰山泉者。引地氣也。

泉非石出者必不佳。故楚詞云飮石泉兮蔭松柏皇甫曾送陸羽詩幽期山寺遠野飯石泉淸梅堯臣碧

霄峰茗詩烹處石泉嘉又云小石冷泉留早味識可謂賞鑑矣咸感也山無澤則必崩澤感而山不應則

將怒而爲洪。

泉往往有伏流沙土中者挹之不竭卽可食不然則滲瀦之潦耳雖淸勿食流遠則味淡須深潭渟畜以

復其味乃可食。

泉不流者食之有害博物志山居之民多癭腫疾由於飮泉之不流者。

泉湧出曰濆在在所稀珍珠泉者皆氣盛而脉湧耳切不可食取以釀酒或有力。

泉有或湧而忽涸者氣之鬼神也。如劉禹錫詩沸井今無湧是也。否則徙泉喝水果有幻術邪。

泉縣出曰沃。暴溜曰瀑。皆不可食。而廬山水簾洪州天台瀑布皆入水品與陸經背矣。故張曲江廬山瀑

布詩吾聞山下蒙今乃林樹表。物性有詭激坤元曷紛矯猷然置此去變化誰能了。則識者固不食也。然

瀑布寶山居之珠箔錦幙也。以供耳目誰曰不宜。

清寒

清朗也靜也澄水之貌寒冽也。凍也覆冰之貌泉不難於清。而難於寒其瀨峻流駛而清岩與陰積而寒

者亦非佳品。

石少土多沙膩泥凝者必不清寒。

蒙之象曰果行。井之象曰寒泉。不果則氣瀦而光不澄不寒則性燥而味必嗇。

冰堅水也窮谷陰氣所聚。不浅則結。而為伏陰也。在地英明者惟水則冰則精而且冷是固清寒之極也。

謝康樂詩鑿冰煮朝飧拾遺記蓬萊山冰水飲者千歲。

下有石硫黃者發為溫泉。在在有之又有共出一壑半溫半冷者。亦在在有之皆非食品特新安黃山朱

砂湯泉可食圖經云黃山舊名黟山東峯下有朱砂湯泉可點茗。春色微紅此則自然之丹液也拾遺記。

蓬萊山沸水飲者千歲此又仙飲。

有黃金處水必清有明珠處水必媚有子鮒處水必腥腐有蛟龍處水必洞黑嫩惡不可不辨也

　甘香

甘美也，香芳也。尚書稼穡作甘黍甘爲香黍惟甘香故能養人泉惟甘香故亦能養人然甘易而香難未

有香而不甘者也。

味美者曰甘泉氣芳者曰香泉所在間有之

泉上有惡木則葉滋根潤皆能損其甘香甚者能釀毒液尤宜去之

甜水以甘稱也拾遺記員嶠山北甜水遠之味甜如蜜十洲記元洲玄澗水如蜜漿飲之與天地相畢又

曰生洲之水味如飴酪

水中有丹者不惟其味異常而能延年卻疾須名山大川諸仙翁修煉之所有之葛玄少時爲臨沅令此

縣廖氏家世壽疑其井水殊赤乃試掘井左右得古人埋丹砂數十斛西湖葛井乃稚川煉所在馬家園

後淘井出石匣中有丹數枚如芡實啖之無味棄之有施漁翁者拾一粒食之壽一百六歲此丹水尤不

易得凡不淨之器切不可汲

　宜茶

茶南方嘉木日用之不可少者品固有徵惡若不得其水且煮之不得其宜雖佳弗佳也

茶如佳人。此論雖妙。但恐不宜山林間耳。昔蘇子瞻詩。從來佳茗似佳人。曾茶山詩移人尤物羨談誇是

也。若欲稱之山林。當如毛女麻姑。自然仙風道骨。不湌烟霞可也。必若桃臉柳腰。宜亟屏之銷金帳中。無

俗我泉石。

鴻漸有云烹茶於所產處無不佳。蓋水土之宜也。此誠妙論。況旋摘旋瀹。及其新邪。故茶譜亦云蒙之

中頂茶若獲一兩以本處水煎服。即能祛宿疾是也。今武林諸泉。惟龍泓入品。而茶亦惟龍泓山為最。蓋

茲山深厚高大。佳麗秀越為兩山之主。故其泉清寒甘香。雅宜瀹茶虞伯生詩但見瓢中清翠影落羣帥。

烹煎黃金芽。不取穀雨後姚公綬詩品嘗顧渚風斯下零落茶經奈爾何則風味可知矣。又况為葛仙翁

煉丹之所哉。又其上為老龍泓寒碧倍之其地產茶。為南北山絕品鴻漸第錢唐天竺靈隱者為下品當

未識此耳。而郡志亦只稱寶雲香林白雲諸茶皆未若龍泓之清馥雋永也。余嘗一一試之。求其茶泉儔

絕兩浙罕伍云。

龍泓今稱龍井因其深也。郡志稱有龍居之非也。蓋武林之山皆發源天目以龍飛鳳舞之識故西湖之

山多以龍名非真有龍居之也。有龍則泉不可食矣泓上之閣亟宜去之浣花諸池尤所當浚。

鴻漸品茶又云。杭州下。而臨安於潛生於天目山與舒州同固次品也。葉清臣則云茂錢唐者以徑山稀。

今天目遠勝徑山而泉亦天淵也。洞霄次徑山。

嚴子瀨一名七里灘蓋砂石上曰瀨曰灘也總謂之漸江但潮汐不及而且深澄故入陸品耳余嘗清秋

泊釣臺下取囊中武夷金華二茶試之固一水也武夷則黃而燥冽金華則碧而清香乃知擇水常擇茶

也鴻漸以婺州為次而清臣以白乳為武夷之右今優劣頓反矣意者所謂離其處水功其半者耶

茶自浙以北者皆較勝惟閩廣以南，不惟水不可輕飲而茶亦當慎之昔鴻漸未詳嶺南諸茶仍云往往

得之其味極佳余見其地多瘴癘之氣染着草木北人食之多致成疾故謂人當慎之要須採摘得宜待

其曰出山露收嵐淨可也。

茶之團者片者皆出於礙碨之末。既損真味復加油垢卽非佳品總不若今之芽茶也蓋天然者自勝耳

曾茶山日鑄茶詩寶鈴自不乏山芽安可無蘇子瞻壑源試焙新茶詩要知玉雪心腸好不是膏油首面

新是也且末茶淪之有屑滯而不爽知味者當自辨之

芽茶以火作為次生曬者為上亦更近自然且斷烟火氣耳殊作人手器不潔火候失宜皆能損其香色

也生曬茶淪之甌中則旗槍舒暢清翠鮮明尤為可愛。

唐人煎茶多用薑鹽故鴻漸云初沸水合量調之以鹽味薛能詩鹽損添常戒薑宜着更誇蘇子瞻以為

茶之中等用薑煎信佳鹽則不可。余則以為二物皆水厄也若山居飲水少下二物以減嵐氣或可耳而

有茶則此固無須也。

今人薦茶類下茶果此尤近俗。是縱佳者能損眞味。亦宜去之且下果則必用匙。若金銀大非山居之器。

而銅又生腥皆不可也若舊稱北人和以酥酪蜀人入以白土此皆蠻飲固不足責。

人有以梅花菊花茉莉花薦茶者雖風韻可賞亦損茶味。如有佳茶亦無事此。

有水有茶不可無火。非無火也有所宜也前人云茶須緩火炙活火煎活火謂炭火之有焰者蘇軾詩活

火仍須活水烹是也。余則以爲山中不常得炭。且死火耳不若枯松枝爲妙若寒月多拾松實蓄爲煮茶

之具更雅。

紀。

湯嫩則茶味不出過沸則水老而茶乏。惟有花而無衣。乃得點淪之曉耳。

唐人以對花啜茶爲殺風景。故王介甫詩金谷千花莫漫煎其意在花非在茶也。余則以爲金谷花前信

不宜矣若把一甌對山花啜之當更助風景又何必羔兒酒也。

煮茶得宜。而飲非其人猶汲乳泉以灌蒿藋罪莫大焉飲之者一吸而盡不暇辨味俗莫甚焉。

靈水

靈神也。天一生水而精明不淆故上天自降之澤實靈水也古稱上池之水者非與要之皆仙飲也。

露者陽氣勝而所散也。色濃爲甘露凝如脂。美如飴。一名膏露。一名天酒。十洲記黃帝寶露洞冥記五色露皆靈露也。莊子曰姑射山神人不食五穀吸風飲露山海經。仙丘絳露仙人常飲之。博物志沃渚之野。民飲甘露拾遺記舍明之國承露而飲神異經西北海外人長二千里日飲天酒五斗楚詞朝飲木蘭之墜露是露可飲也。

雪者天地之積寒也。氾勝書雪爲五穀之精拾遺記穆王東至大樧之谷西王母來進嶂州甜雪是靈雪也。陶穀取雪水烹團茶而丁謂煎茶詩痛惜藏書篋堅留待雪天李虛己建茶呈學士詩試將梁苑雪煎勦建溪春是雪尤宜茶飲也處士列諸末品何邪意者以其味之燥乎若言太冷則不然矣。

雨者陰陽之和天地之施水從雲下輔時生養者也和風順雨明雲甘雨拾遺記香雲逼潤則成香雨皆靈雨也固可食若夫龍所行者暴而霖者旱而凍者腥而墨者及檐溜者皆不可食。

文子曰水之道上天爲雨露下地爲江河均一水也故特表靈品。

　　　異泉

異奇也水出地中與常不同皆異泉也亦仙飲也。
醴泉醴一宿酒也泉味甜如酒也聖王在上德蓍天地刑賞得宜則醴泉出食之令人壽考。
玉泉玉石之精液也。山海經密山出丹水中多玉膏其源沸湯黃帝是食十洲記瀛洲玉石高千丈出泉

如酒味甘名玉醴泉食之長生又方丈洲有玉石泉崑崙山有玉水尹子曰凡水方折者有玉。

乳泉石鍾乳山骨之膏髓也其泉色白而體重極甘而香若甘露也。

朱砂泉下產朱砂其色紅其性溫食之延年卻疾。

雲母泉下產雲母明而澤可煉為寶泉滑而甘。

茯苓泉山有古松者多產茯苓神仙傳松脂淪入地中千歲為茯苓也其泉或赤或白而甘香倍常又尤

泉亦如之非若杞菊之產於泉上者也。

金石之精草木之英不可殫述與瓊漿並美非凡泉比也故為異品。

江水

江公也眾水共入其中也水共則味雜故鴻漸曰江水中其曰取去人遠者蓋去人遠則澄深而無盪瀁之瀉耳。

泉自谷而溪而江而海力以漸而弱氣以漸而薄味以漸而鹹故曰水曰潤下潤下作鹹旨哉又十滴記。

扶桑碧海飫不鹹苦正作碧色甘香味美此固神仙之所食也。

潮汐近地必無佳泉蓋斥鹵誘之也天下潮汐惟武林最盛故無佳泉西湖山中則有之。

揚子固江也其南泠則夾石淳淵特入首品余嘗試之試與山泉無異若吳淞江則水之最下者也亦復

入品甚不可解。

井水

井清也泉之清潔者也通也物所通用者也法也節也法制居人令節飲食無窮竭也其清出於陰其通

入於消其法節由於不得已脈暗而味滯故鴻漸曰井水下其曰井取汲多者蓋汲多則氣通而流活耳。

終非佳品勿食可也。

市廛民居之井烟爨稠密汙穢滲漏特潰潦耳在郊原者庶幾。

深井多有毒氣葛洪方五月五日以雞毛試投井中毛直下無毒若迴四邊不可食淘法以竹篩下水方

可下浚。

若山居無泉鑿井得水者亦可食。

井味鹹色綠者其源通海舊云東風時鑿井則海通脈理或然也。

井有異常者若火井粉井雲井風井鹽井膠井不可枚舉而冰井則又純陰之寒沍也皆宜知之。

緒談

凡臨佳泉不可容易漱濯犯者每為山靈所憎。

泉坎須越月淘之革故鼎新妙運當然也。

山水固欲其秀。而蔭若叢惡則傷泉。今雖未能使瑤草瓊花披拂其上。而修竹幽蘭自不可少。

作屋覆泉。不惟殺盡風景。亦且陽氣不入能致陰損戒之戒之若其小者作竹罩以籠之防其不潔之侵。

勝屋多矣。

泉中有蝦蟹子蟲極能腥味亟宜淘淨之。僧家以羅濾水而飲雖恐傷生亦取其潔也。包幼圖淨律院詩

濾水滌新長。馬戴禪院詩濾泉侵月起。僧簡長詩花壺濾水添是也。于鵠過張老園林詩濾水夜澆花則

不惟僧家戒律為然而修道者亦所當爾也。

泉稍遠而欲其自入於山廚可接竹引之承之以奇石貯之以淨缸其聲尤琤琮可愛駱賓王詩剡木取

泉遙亦接竹之意。

去泉再遠者不能自汲須遣誠實山童取之以免石頭城下之偽蘇子瞻愛玉女河水付僧調水符取之。

亦惜其不得枕流焉耳故曾茶山謝送惠山泉詩舊時水遞費經營

移水而以石洗之亦可以去其搖盪之濁滓若其味則愈揚愈減矣。

移水取石子置瓶中雖養其味亦可澄水令之不淆黃魯直惠山泉詩錫谷寒泉撱石俱是也

擇水中潔淨白石帶泉煮之尤妙尤妙。

汲泉道遠必失原味唐子西云茶不問團銙要之貴新水不問江井要之貴活又云提瓶走龍塘無數千

古今茶事

步。此水宜茶不減清遠峽。而海道趨建安不數日可至矣。故新茶不過三月至矣。據所稱已非嘉賞蓋建

安皆碾磑茶且必三月而始得。不若今之芽茶於清明穀雨之前陟采而降煮也。數千步取塘水較之石

泉新汲左杓右鐺又何如哉。余嘗謂二難具辛。誠山居之福也。

山居之人固常惜水況佳泉更不易得尤常惜之。亦作福事也。章孝標松泉詩。注瓶雲母滑漱齒茯苓香。

野客偷煎茗。山僧惜淨淋夫言偷則誠貴言惜則不賤用矣。安得斯客斯僧也。而與之爲鄰耶。

山居宥泉數遠。若冷泉午月泉一勺泉皆可入品其視虎丘石水殆主僕未爲名流所賞也。泉亦有

幸有不幸邪要之隱於小山僻野。故不彰耳竟陵子可作便當煮一盃水相與蔭青松坐白石而仰視浮

雲之飛也。

後跋

子藝作泉品天下之泉也予問之曰盡乎子藝曰未也夫泉之名有甘有醴有冷有溫有廉有讓有君

子焉皆榮也。在廣有貪在柳有惠在狂國有狂。在安豐軍有咄在日南有淫雖孔子亦不飲者有益皆辱

也。予聞之曰有是哉。亦存乎其人爾天下之泉一也。惟和士飲之則爲甘辭士飲之則爲醴清士飲之則

爲冷厚士飲之則爲溫飲之於伯夷則爲廉飲之於虞舜則爲讓飲之於孔門諸賢則爲君子使泉雖惡

亦不得而汙之也。惡乎辱泉遇伯封可名爲貪遇宋人可名爲愚遇謝奕可名爲狂遇楚頊羽可名爲咄。

遇鄭衞之俗可名爲淫其遇躓也又不得不名爲盜使泉雖美亦不得而自濯也惡乎榮子藝曰噫予品泉矣子將彙品其人乎予山中泉數種請附其語於集且以貽同志者毋混飮以辱吾泉餘杭蔣灼題。

遵生八牋　茶

高濂

論茶品

茶之產於天下多矣。若劍南有蒙頂石花。湖州有顧渚紫筍。峽州有碧澗明月。邛州有火井思安渠江有薄片巴東有眞香福州有伯巖洪州有白露常之陽羨婺之舉巖丫山之陽坡龍安之騎火黔陽之都濡高株瀘川之納溪梅嶺之數者其名皆著品之。則石花最上紫筍次之又次則碧澗明月之類是也惜皆不可致耳若近時虎丘山茶亦可稱奇惜不多得若天池茶在穀雨前收細芽炒得法者清翠芳馨嗅亦消渴若眞岕茶其價甚重兩倍天池惜乎難得須用自己令人探收方妙又如浙之六合茶品亦精但不善炒不能發香而味苦茶之本性實佳如杭之龍泓即西茶眞者天池不能及也山中僅有一二家炒法甚精近有山僧焙者亦妙但出龍井者方妙而龍井之山不過十數畝此外有茶似皆不及附近假充猶之可也至於北山西溪俱充龍井即杭人識龍井茶味者亦少以亂眞多耳意者天開龍井美泉山靈特生佳茗以副之耳不得其遠者當以天池龍井爲最此外天竺靈隱爲龍井之次臨安於潛生於天目

山者與舒州同。亦次品也。茶自浙以北皆較勝。惟閩廣以南。不惟水不可輕飲。而茶亦宜慎昔鴻漸未詳

嶺南諸茶。乃云嶺南茶味極佳。孰知嶺南之地。多瘴癘之氣。染著草木北人食之。多致成疾故常慎之要

當採時待其日出山霽霧障山嵐收淨採之可也茶團茶片皆出碾磑大失眞味茶以日曬者佳其青翠

香潔更勝火炒多矣。

採茶

團黃有一旗一槍之號言一葉一芽也凡早取為茶晚取為荈穀雨前後收者為佳粗細皆可用惟在採

摘之時。天色晴明。炒焙適中盛貯如法。

藏茶

茶宜蒻葉而畏香藥喜溫燥而忌冷濕故收藏之家以蒻葉封裹入焙中兩三日一次用火當如人體溫

溫則去濕潤若火多則茶焦不可食矣又云以中罈盛茶十斤一瓶每年燒稻草灰入大桶茶瓶座桶中

以灰四面塡桶瓶上覆灰築實每用撥灰開瓶取茶些少仍復覆灰再無蒸壞次年換灰為之

又云空樓中懸架將茶瓶口朝下放。不蒸原蒸自天而下放。故宜倒放若上二種芽茶除以清泉烹外花香

雜果俱不容入人有好以花拌茶者此用平等細茶拌之焦茶味不減花香盫終不脫俗如橙茶蓮花

茶於日未出時將半含蓮花撥開放細茶一撮納滿藥中以麻皮略繫令其經宿次早摘花傾出茶葉用

建紙包茶焙乾。再如前法。又將茶葉入別藥中。如此者數次。取其焙乾收用不勝香美。

木樨茉莉玫瑰薔薇蘭蕙橘花梔子木香梅花皆可作茶。諸花開時。摘其半含半放藥之香氣全者量其

茶葉多少摘花爲拌花多則太香。而脫茶韻花少則不香而不盡美三停茶葉一停花始稱假如木樨花。

須去其枝蔕及塵垢蟲蟻用磁罐一層花一層茶投間至滿紙箬繫固入鍋重湯煮之取出待冷用紙封

裹。置火上焙乾收用諸花倣此。

　煎茶四要

　一　擇水

凡水泉不甘能損茶味。故古人擇水最爲切要。山水上江水次井水下山水乳泉漫流者爲上瀑湧湍激

勿食久令人有頸疾江水取去人遠者井水取汲多者如蟹黃混濁鹹苦者皆勿用若杭湖心水吳山

第一泉郭璞井虎跑泉龍井葛仙翁井俱佳。

　二　洗茶

凡烹茶先以熱湯洗茶葉去其塵垢冷氣烹之則美。

　三　候湯

凡茶須緩火炙活火煎活火謂炭火之有焰者當使湯無妄沸庶可養茶始則魚目散布微微有聲中則

四邊泉湧纍纍連珠。終則騰波鼓浪。水氣全消謂之老湯三沸之法非活火不能成也。最忌柴葉煙熏煎

茶爲此清異錄云五賊六魔湯也。

凡茶少湯多則雲脚散湯少茶多則乳面聚。

　四　擇品

凡瓶要小者易候湯又點茶注湯相應若瓶大啜存停久味過則不佳矣茶銚茶瓶磁砂爲上銅錫次之。

磁壺注茶砂銚煑水爲上清異錄云富貴湯當以銀銚煑湯佳甚銅銚煑水錫壺注茶次之。

茶盞惟宣窰壜盞爲最質厚白瑩樣式古雅有等宣窰印花白甌式樣得中而瑩然如玉次則喜窰心內

茶字小琖爲美欲試茶色黃白豈容青花亂之注酒亦然惟純白色器皿爲最上乘品餘皆不及。

　試茶三要

　一　滌器

茶瓶茶盞茶匙生鉎〔音星〕致損茶味。必須先時洗潔則美。

　二　熁盞

凡點茶。先須熁盞令熱則茶面聚乳冷則茶色不浮。

　三　擇果

心一堂　飲食文化經典文庫

草有眞香。有佳味。有正色。烹點之際。不宜以珍果香草雜之。奪其香者。薇木樨之類也。奪其味者牛乳番桃荔枝圓眼枇杷之類是也。奪其色者柿餅膠棗火桃楊梅橙橘之類是也凡飲佳茶去果方覺清絕雜之則無辨矣若欲用之所宜核桃榛子瓜仁杏仁欖仁粟子雞頭銀杏之類或可用也。

　　茶效

人飲眞茶能止渴消食除痰少睡利水道明目益思。出本草拾遺　除煩去膩。人固不可一日無茶。然或有忌而不飲每食已輒以濃茶漱口煩膩既去而脾胃不損凡肉之在齒間者得茶漱滌之乃盡消縮不覺脫去。不煩剌挑也。而齒性便苦緣此漸堅密蠹毒自已矣然率用中茶。

茶具十六器收貯於器局供役苦節君者故立名管之蓋欲歸統於一以其素有貞心雅操。而自能收之也。

商象。古石鼎也。用以煎茶。

歸潔。竹筅箒也。用以滌壺。

分盈。杓也。用以量水斤兩。

遞火。銅火斗也。用以搬火。

降紅。銅火筯也用以簇火。

執權。準茶秤也每杓水二斤用茶一兩。

團風。素竹扇也用以發火。

漉塵。茶洗也用以洗茶。

靜沸。竹架卽茶經支腹也。

注春。磁瓦壺也用以注茶。

運鋒。劖果刀也用以切果。

甘鈍。木礩墩也。

啜香。磁瓦甌也用以啜茶。

掩雲。竹茶匙也用以取果。

納敬。竹茶橐也用以放盞。

受汚。拭抹布也用以潔甌。

苦節君。煑茶竹爐也用以煎茶。

總貯茶器七具

建城。　以箬爲籠封茶以貯高閣。

雲屯。　磁瓶用以杓泉以供煑也。

烏府。　以竹爲籃用以盛炭爲煎茶之資。

水曹。　卽磁缸瓦缶用以貯泉以供火鼎。

器局。　竹編爲方箱用以收茶具者。

外有品司　竹編圓橦提合用以收貯各品茶葉以待烹品者也。

　　論泉水

田子藝曰。山下出泉爲蒙稺也，物稺則天全水稺則味全。故鴻漸曰。山水上。其曰乳泉石池慢流者蒙之謂也。其曰瀑湧湍激者則非蒙矣。宜戒人勿食。

混混不舍皆有神以主之。故天神引出萬物。而漢書三神山嶽其一也。

源泉必重而泉之佳者尤重。餘杭徐隱翁嘗爲余言以鳳凰山泉較阿姥墩百花泉便不及五泉。可見仙源之勝矣。

山厚者泉厚。山奇者泉奇。山淸者泉淸。山幽者泉幽。皆佳品也。不厚則薄。不奇則蠢。不淸則濁。不幽則喧。必無佳泉。

山不停處。水必不停。若停卽無源者矣。旱必易涸。

石流

石山骨也。水行也。山宣氣以產萬物。氣宣則脈長。故曰山水上。博物志曰石者金之根甲。石流精以生水。又曰山泉者。引地氣也。

泉非石出者必不佳。故楚詞云。飲石泉兮蔭松柏皇甫曾送陸羽詩幽期山寺遠。野汲石泉清梅堯臣碧霄峯茗詩。烹處石泉嘉。又云。小石冷泉留早味。誠可爲賞鑑者矣。

泉往往有伏流沙土中者。挹之不竭卽可食。不然則滲瀦之潦耳雖清勿食。

流遠則味淡。須深潭停畜以復其味乃可食。

泉不流者食之有害。博物志曰。山居之民多癭腫疾。由於飲泉之不流者。

泉湧出曰濆。在在所稱珍珠泉者皆氣盛而脈湧耳。切不可食。取以釀酒或有力。

泉縣出曰沃暴溜曰瀑皆不可食。而廬山水簾洪州天台瀑布皆入水品。與陸經背矣。故張曲江廬山瀑布詩吾聞山下蒙。今乃林巒表。物性有詭激坤元曷紛矯。默然置此去變化誰能了。則識者固不食也。然瀑布實山居之珠箔錦幕也。以供耳目誰曰不宜。

清湜

清。朗也。靜也。激水之貌也寒洌也凍也覆水之貌泉不難於清而難於寒其瀨峻流駛而清岩奥陰積而寒

者亦非佳品。

石少土多沙膩泥凝者必不清寒。

蒙之象曰果行井之象曰寒泉不果則氣滯而光不澄寒則性燥而味必嗇。

冰堅水也窮谷陰氣所聚不洩則結而爲伏陰也在地英明者惟水而冰則精而且冷是固清寒之極也。

謝康樂詩鑿冰糞朝殞拾遺記蓬萊山冰水飲者千歲。

砂湯泉可食圖經云黃山舊名黟山東峯下有朱砂湯泉可點茗春色微紅此則自然之丹液也拾遺記

蓬萊山沸水飲者千歲此又仙飲

下有石硫黃者發爲温泉在在有之又有共出一壑半温半冷者亦在在有之皆非食品特新安黃山朱

有黃金處水必清有明珠處水必媚有子鮒處水必腥腐有蛟龍處水必洞黑黲惡不可不辨也。

甘香

甘。美也香芳也尚書稼穡作甘黍甘爲香黍惟甘香故能養人泉惟甘香故亦能養人然甘易而香難未

有香而不甘者也

味善者曰甘泉氣芳者曰香泉所在間有之泉上有惡水則葉滋根潤皆能損其甘香甚者能釀毒液尤

古今茶事

147

宜去之。

甜水以甘稱也拾遺記員嶠山北甜水遶之味甜如蜜十洲記元洲元澗水如蜜漿飲之與天地相畢又曰生洲之水味如飴酪

水中有丹者。不唯其味異常。而能延年却疾須名山大川諸仙翁修煉之所有之葛元少時爲臨沅令此縣廖氏家世壽疑其井水殊赤乃試掘非左右得古人埋丹砂數十斛西湖葛井乃稚川煉丹所在馬家園後淘井出石甕中有丹數枚如芡實啖之無味棄之有施漁翁者拾一粒食之壽一百六歲此丹水尤不易得凡不淨之器切不可汲

煮茶得宜而飲非其人猶汲乳泉以灌蒿萊罪莫大焉飲之者一吸而盡不暇辨味俗莫甚焉。

靈水

靈神也天一生水。而精明不淆故上天自降之澤實靈水也古稱上池之水者非歟要之皆仙飲也

大甕收藏黃梅雨水雪水下放爲子石十數塊經年不壞用栗炭三四寸許燒紅投淬水中不生跳虫

靈者陽氣勝而所散也色濃爲甘露凝如脂美如飴一名膏露一名天酒是也

零者天地之積寒也氾勝書雪爲五穀之精拾遺記穆王東至大樹之谷西王母來進嶂州甜零是靈零也陶穀取雪水烹團茶而丁謂煎茶詩痛惜藏書篋堅留待雪天李虛己建茶呈學士詩試將梁苑零煎

勤建溪春是霽尤宜茶飲也處士列諸末品何耶意者以其味之燥乎若言太冷則不然矣。

雨者陰陽之和天地之施水從雲下輔時生養者也和風順雨明雲甘雨拾澄記香雲遍潤則成香雨皆

靈雨也固可食若夫龍所行者暴而霪者旱而凍者腥而墨者及簷溜者皆不可食潮汐近地必無佳泉

蓋斥鹵誘之也天下潮汐惟武林最盛故無佳泉西湖山中則有之揚子固江也其南泠則夾石渟淵特

入首品余嘗試之誠與山東無異若吳淞江則水之最下者也亦復入品甚不可解。

井水

非清也泉之清潔者也通也物所通用者也法也節也法制居人令節飲食無窮竭也其清出於陰其通

入於清其法節由於得已脈暗而味滯故鴻漸曰井水下其曰井取汲多者蓋汲多則氣通而流活耳終

非佳品養水取白石子入甕中雖養其味亦可澄水不淆。

高子曰井水美者天下知鍾冷泉矣然而焦山一泉余會味過數四不減鍾冷惠山之水味淡而清尤為

上品吾杭之水山泉以虎跑為最老龍井真珠寺二泉亦甘北山葛仙翁井水食之味厚城中之水以吳

山第一泉首稱予品不及施公井郭婆井二水清冽可茶若湖南近二橋中水清晨取之烹茶妙甚無伺

他求。

陽羨茗壺系洞山岕茶系

周高起

茗壺岕茶系序

吾鄉尚宜與岕茶尤尚宜與瓷壺陳貞慧秋園雜佩言之而不詳嘗檢宜與志考其緣始所載岕茶甚略。而論瓷壺則多引江陰周高起陽羨茗壺系及檢江陰新志周高起傳僅言其有讀書志而未及其他甲申在羊城書肆獲茗壺系鈔本一册今年春汪君芙生寄示粤刻叢書中有茗壺系後附洞山岕茶系一卷亦高起所撰惟粵板及前得鈔本均多訛舛無別本可校宜與志尚有吳騫陽羨名陶錄序云茗壺系多漏略復加增潤釐為二卷曰名陶錄今名陶錄亦不可得而江陰明人著述甚稀此二系亦譜錄中之雋逸者。高起弟榮起亦明諸生究心六書汲古閣刊板多其手校榮起女淑祜淑廙均工詩善畫尤為可訪求矣。姑就所知並宜與志所引茗壺系稍事訂正因合岕茶系彙梓叢書中其讀書志蓋無時所稱並附識之光緒十四年夏六月金武祥序於梧州。

江陰縣志忠義傳

周高起字伯高博聞強識工古文辭早歲饋於庠與徐邊湯同修縣志居由里山遊兵突至被執索貲怒嘗不屈死著有讀書志。

陽羨茗壺系　　　　　　　　　　明　江陰　周高起　伯高

壺於茶具用處一耳。而瑞草名泉。性情攸寄實仙子之洞天福地。梵王之香海蓮邦審厥尚焉非曰好事已也。故茶至明代不復碾屑和香製團餅此已遠過古人近百年中壺黜銀錫及閩豫甆而尚宜與陶。又近人遠過前人處也。陶曷取諸取諸其製以本山土砂能發眞茶之色香味。不但杜工部云傾金注玉驚人眼高流務以冤俗也至名手所作一壺重不數兩價重每一二十金能使土與黃金爭價世日趨華。抑足盛矣因考陶工陶土而爲之系。

創始

金沙寺僧久而逸其名矣聞之陶家云僧閒靜有致習與陶缸甕者處摶其細土加以澄練捏築爲胎規而圓之剡使中空踵傅口柄蓋的附陶穴燒成人逐傳用。

正始

供春學使吳頤山家靑衣也。頤山讀書金沙寺中供春於給役之暇竊仿老僧心匠。亦淘細土摶胚茶匙穴中指掠內外指螺文隱起可按必累按故腹半尙現節腠視以辨眞今傳世者栗色闇闇如古金鐵。敦廘周正允稱神明垂則矣世以其孫龔姓亦書爲龔春〔人皆證爲龔。予於吳冏卿家。見時大彬所仿。則刻供春二字。足折匡謬云。〕所仿。董翰號後谿始造菱花式已殫工巧。

趙梁多提梁式亦有傳爲名良者。

袁錫按袁姓據秋園雜佩更正。

時朋卽大彬父是爲四名家萬歷間人皆供春之後勁也董文巧而三家多古拙。

李茂林行四名養心製小圓式研在樸緻中尤爲名玩自此以往壺乃另作瓦甒閉入陶穴故前此名壺。

不免沾缸罈油淚。

大家

時大彬號少山或淘土或雜碙砂土諸款具足諸士色亦具足。不務研媚而樸雅堅栗妙不可思初自仿

供春得手喜作大壺後遊婁東聞眉公與琅琊太原諸公品茶施茶之論乃作小壺几案有一具生入閒

遠之思前後諸名家並不能及逐於陶人標大雅之遺擅空羣之目矣。

名家

李仲芳行大茂林子及時大彬門爲高足第一製度漸趨文巧其父督以敦古仲芳嘗手一壺視其父曰。

老兄這個如何俗因呼其所作爲老兄壺後入金壇卒以文巧相競今世所傳大彬壺亦有仲芳作之大

彬見賞而自署款識者時人語曰李大缾是大名。

徐友泉名士衡故非陶人也其父好大彬壺延致家塾一日強大彬作泥牛爲戲不卽從友泉奪其壺士

出門去。適見樹下眠牛將起。偶屈一足。注視揣塑盡厥狀。攜以視大彬。一見驚歎曰。如子智能異日必

出吾上。因學為壺變化其式仿古尊罍諸器。配合土色所宜。畢智窮工移人心目。予嘗博攷厥製有漢方、

扁觶、小雲雷提梁卣蕉葉蓮方菱花鵝蛋分襠索耳美人垂蓮大頂蓮一回角六子諸款泥色有海棠紅、

硃砂紫定窰白冷金黃淡墨沉香水石榴皮葵黃閃色梨皮諸名種種變異。妙出心裁。然晚年恒自歎曰，

吾之精終不及時之麤。

　　雅流

歐正春多規花草果物式度精妍。

邵文金仿時大彬漢方獨絕今尚壽。

邵文銀。

蔣伯荂名時英。四人並大彬弟子。蔣後客於吳陳眉公為改其字之敷為荂。因附高流諱言本業。然其所

作堅緻不俗也。

陳用卿與時同工而年技俱後負力尚氣嘗掛吏議在縲絏中俗名陳三獃子式尚工緻如蓮子湯婆缽

盂圓珠諸製不規而圓已極妍飭款仿鍾太傅帖意。

陳信卿仿時李諸傳器具有優孟叔敖處故非用卿族品其所作雖　　美遜之。而堅瘦工整雅自不羣貌

寐意率。自誇洪飲。逐貴游閒不務壹志盡技間多伺弟子造成。修削署款而已。所謂心計轉戾不復唱渭

城時也。

神品

閔魯生名賢製仿諸家漸入佳境人顔醋謹見傳器則虛心企擬不憚改爲技也進乎道矣。

陳光甫仿供春時大爲入室天奪其能早告一目相視口的不極端緻然經其手摹亦具體而徵矣。

陳仲美婺源人。初造瓷於景德鎭以業之者多不足成其名棄之而來好配壺土意造諸玩如香盒花盃、

獎貌爐瓶辟邪鎭紙重鎪疊刻細極鬼工壺象花果綴以草蟲或龍戲海濤伸爪出目至塑大士像莊嚴慈

惘神采欲生瓔珞花蔓不可思議智兼範眼道子心思殫竭以天天年。

沈君用名士良踵仲美之智而研巧悉敵壺式上接歐正春一派至尚象諸物製爲器用不尚正方圓而

筋縫不苟絲髮配土之妙色象天錯金石同堅自幼知名人呼之曰沈多梳。宜興垂髫之器 巧殫厥心以甲申四

月天。

別派

諸人見汪大心葉語附記中 休寧人。字體。號古鐵。

邵蓋周後谿邵二孫並萬歷間人。

陳俊卿。亦時大彬弟子。

周季山陳和之陳挺生承雲從沈君盛善仿友泉君用並天啓崇禎間人。

沈子澈崇禎時人所製壺古雅渾樸嘗為人製菱花壺銘之曰石根泉蒙頂葉漱齒鮮滌塵熱。<small>按。此係摹宜興舊志增入。</small>

陳辰字共之工鐫壺款近人多假手焉亦陶家之中書君也。

鐫壺款識即時大彬初倩能書者落墨用竹刀畫之或以印記後竟運刀成字書法閒雅在黃庭樂毅帖間人不能仿賞鑒家用以為別次則李仲芳亦合書法若李茂林朱書號記而已仲芳亦時代大彬刻款手法自遜規仿名壺日臨比於書畫家入門時。

陶肆謠曰壺家妙手稱三大謂時大彬李大仲芳徐大友泉也。<small>子</small>為轉一語曰明代良陶讓一時獨尊大彬固自匪佞。

相傳壺土初出時先有異僧經行村落日呼曰賣富貴人羣嗤之僧曰貴不要買買富何如因引村叟指山中產土之穴去及發之果備五色爛若披錦

嫩泥出趙莊山以和一切色土乃黏脂可築蓋陶壺之丞弼也。

石黃泥出趙莊山即未觸風日之石骨也陶之乃變硃砂色。

天青泥出蠡墅陶之變黯肝色。又其夾支有梨皮泥陶現梨皮凍色淡紅泥陶現松花色澄黃泥陶現豆碧

色蜜泥陶現輕赭色梨皮和白沙陶現淡黑色山靈勝絡陶治變化尚露種種光怪云。

老泥出團山陶則白沙星星按若珠琲以天青石黃和之成澄深古色。

白泥出大潮山陶鉼盎缸缶用之此山未經發用載目吾鄉白石山江陰泰望之出土諸山其穴往往善徙。東北支阜。

有素產於此忽又他穴得之者實山靈有以司之然皆深入數十丈乃得。

澄壺之家各穴門外一方地取色土篩搗部署訖入窰其中名曰養土取用配合各有心法祕不相授壺

成幽之以候極燥乃以陶甕庋五六器封閉不隙如鮮欠裂射油之患過火則老老不美觀欠火則稚稚

沙土氣若窰有變相匪夷所思傾湯貯茶雲霞綺閃直是神之所爲億千或一見耳。

陶穴瑓蜀山山原名獨東坡先生乞居陽羨時以似蜀中風景改名此山也祠祀先生於山椒陶煙飛染

祠宇盡墨按爾雅釋山云獨者蜀則先生之銳改厥名不徒桑梓殷懷抑亦考古自喜云爾。

壺供眞茶正在新泉活火雄淪旋啜以盡色聲香味之蘊故壺宜小不宜大宜淺不宜深壺蓋宜盎不宜

砥湯力茗香俾得團結氤氳宜傾竭即滌去厥滓乃俗夫強作解事謂時壺質地堅潔注茶越宿暑月

不餿不知越數刻而茶敗矣安俟越宿哉況眞茶如䔖脂柔即宜羹如笋味觸風隨劣悠悠之論俗不可

醫。

壺經用久滌拭日加自發闇然之光入手可鑒。此爲書房雅供若膩滓爛班。油光燦爛。是曰和尚光最爲

賤相。每見好事家藏列。顏多名製。而愛護垢染。舒袖摩挲。惟恐拭去曰。吾以寶其舊色爾。不知西子蒙不

潔堪充下陳否即以注眞茶是觀姑射山之神人安置烟霮地面矣豈不舛哉

壺之土色。自供春而下。及時大初年皆細土淡墨色。上有銀沙閃點迸硼砂和璞觳綴周身珠粒隱隱更

自奪目。

或問予以聲論茶是有說乎予曰竹鑪幽討。松火怒飛蟹眼徐窺鯨波乍起耳根圓通爲不遠矣然鑪頭

風雨聲銅餅易作不免湯腥砂銚亦嫌土氣惟純錫爲五金之母以製茶銚能益水德沸亦聲清白金尤

妙第非山林所辦爾。

壺宿雜氣滿貯沸湯傾即沒冷水中亦急出水寫之元氣復矣。

品茶用甌。白瓷爲良所謂素瓷傳靜夜芳氣滿閒軒也製宜弇口邃腸色浮浮而香味不散。

茶洗式如扁壺中加一盎鬲而細竅其底便過水漉沙茶藏以閉洗過茶者仲美若用各有奇製皆壺史

之從事也水杓湯銚亦有製之盡美者要以椰瓟錫器爲用之恆。

洞山岕茶系

明　江陰　周高起　伯高

唐李栖筠守常州日出僧進陽羨茶陸羽品爲芬芳冠世產可供上方遂置茶舍于罨畫谿去湖㳇一里。

所歲供萬兩許有穀詩云陸羽名荒舊茶舍。卻教陽羨置郵忙是也。其山名茶山亦曰貢山東臨罨畫谿。

修貢時。山中湧出金沙泉。杜牧詩所謂山實東南秀茶稱瑞草魁泉嫩黃金湧芽香紫壁栽者是也。山在

均山鄉縣東南三十五里又茗山在縣西南五十里永豐鄉。皇甫曾有送陸羽南山采茶詩千峯待逋客。

香茗復叢生采摘知深處烟霞羨獨行幽期山寺遠野飯石泉清寂寂燃燈夜相思磬一聲見時貢茶在

茗山矣又唐天寶中稠錫禪師名清晏卓錫南岳碣上泉忽迸石窟間字曰真珠泉師曰宜淪吾鄉桐廬

茶矣後來檄取山農苦之。故袁高有陰嶺茶未吐使者牒已頻之句。郭三益題南岳寺壁云古木陰森

厭典也有白蛇銜種茗側之異南岳產茶不絕修貢迨今方春采茶清明日縣令躬享白蛇于卓錫泉亭隆

梵帝家寒泉一勺試新茶官符星火催春焙卻使山僧怨白蛇全茶歌亦云天子須嘗陽羨茶百草不

敢先開花又云安知百萬億蒼生命墜顛厓受辛苦可見貢茶之苦民亦自古然矣至岕茶之尚于高流

雖近數十年中事而厥產伊始則自盧全隱居洞山種于陰嶺遂有茗嶺之目相傳古有漢王者栖遲茗

嶺之陽課童藝茶躡盧全幽致陽山所產香味倍勝茗嶺所以老廟後一帶茶猶唐朱根株也貢山茶今

已絕種羅岕去宜興而南踰八九十里浙宜分界只一山岡岡南卽長與山兩峯相阻介就夷曠者人呼

為岕〔廣其地始知古人制字有意〕今字書岕字但注云山名耳。　云有八十八處〔縣西南八十里〕前橫大礧水泉清駛漱潤茶根洩山土之肥澤故洞山為

諸岕之最自西氿溯張渚而入取道茗嶺甚險惡。　自東氿溯湖洑而入取道綿嶺稍夷才通車騎。

第一品

老廟後廟祀山之土神者瑞草叢鬱殆比茶星胗轡矣地不二三畝若溪姚象先與婿朱奇生分有之茶皆古本每年產不廿斤色淡黃不綠葉筋淡白而厚製成梗絕少入湯色柔白如玉露味廿芳香藏味中。空濛深水啜之愈出致在有無之外。

第二品 皆洞頂也

新廟後 棋盤頂 紗帽頂 毛巾條 姚八房 及吳江周氏地產茶亦不能多香幽色白味冷雋與老廟不甚別啜之差覺其薄耳總之品岕至此清如孤竹和如柳下並入聖矣今人以色濃香烈為岕茶。真耳食而睞其似也。

第三品

廟後洑沙 大衰頭 姚洞 羅洞 王洞 范洞 白石

第四品 皆平洞本岕也

下洑沙 梧桐洞 余桐 石場 丫頭岕 留青岕 黃龍 炭竈 龍池

不入品 山外

長潮 青口 筓莊 顧渚 茅山岕

貢茶

即南岳茶也天子所嘗不敢置品縣官修貢期以清明日入山蕭祭乃始開園採製視松蘿虎邱而色香

豐美自是天家清供名曰片茶初亦如岕茶製萬歷丙辰僧稠蔭游松蘿乃仿製爲片。

岕茶採焙定以立夏後三日陰雨又需之世人妄云雨前眞岕抑亦未知茶事矣。茶園既開入地相京高價

者日不下二三百石山民收製亂眞好事家躬往予租採焙幾視惟謹多被潛易眞茶去。

分買家不能二三斤近有採嫩葉除尖蒂抽細筋炒之亦曰片茶不去筋尖炒而復焙燥如葉狀曰攤茶。

並難多得又有俟茶市將闌採剩葉製之者名修山香味足而色差老若今四方新貨岕片多是南岳

片子署爲騙茶可矣本岕亦不可得噫安得起陸龜蒙于九京與之廣茶人詩

也。陸詩云天賦識靈草自然鍾野麥開來北山下似與東風期雨後採芳去雲間幽路危惟應報春鳥共

得此人知茶人皆有市心令予徒仰眞茶巳故予煩悶時每誦姚合乞茶詩一過嫩綠微黃碧澗春採時

開道斷葷辛不將錢買將詩乞借問山翁有幾人。

岕茶德全策勵惟歸洗控沸湯澆葉即起洗鬲斂其出液候湯可下指即下洗鬲排蕩沙沫復起併指控

乾。閉之茶藏候投蓋他茶。欲按時分投惟岕既經洗控神理綿綿止須上投耳。

傾湯滿壺後下葉子曰上投宜夏日傾湯及半下葉滿湯曰中投宜

春秋葉著臺底以湯浮之日下投宜冬日初春

第二輯　藝文

文

與兄子演書　　晉劉琨

吾體中憒悶時仰眞茶汝可信信致之。

荈賦　　杜毓

靈山惟岳奇產所鍾厥生荈草彌谷被崗承豐壤之滋潤受甘靈之霄降月惟初秋農功少休結偶同侶。是采是求水則岷方之注挹彼清流器澤陶簡出自東隅酌之以匏取式公劉惟茲初成沫沈華浮煥如積雪煜若春敷。

為田神玉謝茶表　　唐韓翃

臣某言中使至伏奉手詔兼賜臣茶一千五百串令臣分給將士以下聖慈曲被戴荷無階臣某_{中謝}臣智謝理戎功慙盪寇前恩未報厚賜仍加念以炎蒸恤其暴露榮分紫笋寵降朱宮味足蠲邪助其正直。

香堪愈病。沃以勤勞飲德相歡撫心是荷前朝饗士往典犒軍省是循常非聞特達顧幸忽被殊私。

吳主體賢方開置茗晉臣愛客纔有分茶豈如澤被三軍仁加十乘以欣以忭感戴無階臣無任云云。

顧況

茶賦

稽天地之不平分蘭何爲分早秀菊何爲分遲榮皇天既孕此靈物分厚地復糅之而萌惜下國之偏多。嗟上林之不至。如羅玳筵展瑤席凝藻思間靈液賜名臣留上客鷖轉宮女顏汎濃華漱芳津出恒品。先衆珍君門九重聖壽萬春此茶上達於天子也滋飯蔬之精素攻肉食之羶膩發當暑之清吟滌通宵之昏寐杏樹桃花之深洞竹林草堂之古寺乘槎海上來飛錫雲中至此茶下被於幽人也雅曰不知我者謂我何求可憐翠澗陰中有泉流舒鐵如金之鼎越泥似玉之甌輕烟細珠靄然浮爽氣淡烟風雨秋夢裏還錢懷中贈橘雖神祕而焉求。

為武中丞謝賜新茶表

臣某言中使竇某至奉宣旨賜臣新茶一斤者天睠忽臨時珍俯及捧載驚忭以喜以惶臣以無能謬司邦憲大明首出得親仰於雲霄渥澤逐行忽先霑於草木況茲靈味成自遠方照臨而甲拆惟新煦嫗而芬芳可襲調六氣而成美扶萬壽以效珍豈可賤徵膚此殊錫銜恩敢同以嘗酒滌慮方切於飲冰撫事循涯隕越無地臣不任感戴欣忭之至。

柳宗元

心一堂　飲食文化經典文庫

代武中丞謝新茶表

劉禹錫

伏以貢自外方名殊衆品效參藥石芳越椒蘭出自仙廚俯頒私室義同推食空荷於曲成責在素餐實懇於虛受臣無任云云。

又

伏以方隅入貢采擷至珍窵遠貢來以新爲貴捧而覩妙飲以滌煩顧蘭露而慙芳豈蔗漿而齊味旣榮凡口倍切丹心臣無任云云。

三月三日茶宴序

呂　溫

三月三日上巳祓飲之日也諸子議以茶酌而代焉乃撥花砌愛庭陰清風逐人日色留興臥措青靄坐攀香枝閒花近席而未飛紅藥拂衣而不散酒命酌香沫浮素杯殷凝琥珀之色不令人醉微覺清思雖五雲仙漿無復加也座右才子南陽鄒子高陽許侯與二三子頃爲塵外之賞而曷不言詩矣。

茶中雜詠序

皮日休

按周禮酒正之職辨四飲之物其三曰漿又漿人之職供王之六飲水漿醴涼醫酏入於酒府鄭司農云以水和酒也蓋當時人率以酒醴爲飲謂乎六漿酒之醨者也何得姬公製爾雅云檟苦茶即不撷而飲之豈聖人之純於用乎亦草木之濟人取舍有時也自周以降及以國朝茶事竟陵子陸季疵言之詳矣。

然季疵以前稱著飲者。必渾以烹之。與夫瀹蔬而啜者無異也。季疵始為經三卷。由是分其源。制其具。教

其造設其器。命其煑飲之者除痟而去癘雖疾醫之不若也。其為利也於人豈小哉。余始得季疵書以為

備之矣。後又獲其顧渚山記二篇。其中多茶事。後又太原溫從雲武威段碣之各補茶事十數節並存於

方册。茶之事由周至今竟無纖餘矣。昔晉杜育有荈賦。季疵有茶歌。余缺然於懷者謂有其具而不形於

詩。亦季疵之餘恨也。遂為十詠寄天隨子。

茶賦　　　　　　　　　　　　　　　　宋吳淑

夫其滌煩療渴。換骨輕身茶荈之利其功若神則有渠紅薄片西山白露雲垂綠脚香浮碧乳挹此霜華

却兹煩暑清文既傳於杜育精思亦聞於陸羽若夫擷此皇盧烹茲苦茶桐君之錄尤重仙人之掌難踰

豫章之嘉甘露。王肅之貪酪奴待檟旗而探摘。對鼎鑣以吹噓。則有療彼斛瘕困茲水厄擢彼陰林得以

爛石先火而造乘雷以摘吳主之憂韋曜初沐殊恩陸納之待謝安誠彰儉德別有產於玉壘造彼金沙。

三等為號。五出成花早春之來賓化横紋之出陽坡復開湘湖合膏之作龍安騎火之名柏巖號鶴嶺鳩

阮兮鳳亭嘉雀舌之纖嫩訛蟬翼之輕盈冬芽早秀麥顆先成或重西園之價或伴閭月之形並明目而

益思豈瘠氣而侵精又有蜀岡牛嶺洪雅烏程碧澗紀號紫笋為稱陟仙崖而花墜服丹丘而翼生至於

飛自獄中煎於竹裏效在不眠功存悅志或言詩為報或以錢見遺復云葉如梔子花若薔薇輕颺浮雲

心一堂　飲食文化經典文庫

之美。霜筍竹籜之差。唯芳茗之為用。蓋飲食之所資。

通商茶法詔

歐陽修

古者山澤之利與民共之。故民足於下。而君裕於上。國家無事。刑罰以清。自唐末流。始有茶禁。上下規利。垂二百年。如聞比來。為患益甚。民被誅求之困。日惟咨嗟。官受濫惡之入。歲以陳積。私藏盜販。犯者實繁。嚴刑峻誅。情所不忍。使田閭不安其業。商賈不通於行。鳴呼若茲。是於江湖間。幅員數千里。為陷阱以害吾民也朕心惻然念此久矣。閒遣使往就問之。而皆讙然願弛權法歲入之課以時上官。一二近臣件析其狀。朕嘉覽於再猶若慊然。又於歲輸裁成其數使得饒阜以相為生。剗去禁條俾通商賈歷世之弊。一旦以除著為經常弗復更制損上益下以休吾民。尚慮喜於立異之人緣而為姦之黨妄陳奏議以惑官司。必篤明刑用戒狂謬。布告遐邇體朕意焉。

龍茶錄後序

前　人

茶為物之至精。而小團又其精者。錄序所謂上品龍茶者是也。蓋自君謨始造而歲貢焉。仁宗尤所珍惜。雖輔相之臣未嘗輒賜。惟南郊大禮致齋之夕。中書樞密院各四人共賜一餅。宮人翦金為龍鳳花草貼其上。兩府八家分割以歸。不敢碾試。相家藏以為寶。時有佳客。出而傳玩爾。至嘉祐七年親享明堂齋夕。始人賜一餅。余亦忝預。至今藏之。余自以諫官供奉仗內。至登二府二十餘年。纔一獲賜。因君謨著錄。輒

古今茶事

165

附於後。庶知小團自君謨始而可貴如此。

南有嘉茗賦　　　　　　　　　　　　梅堯臣

南有山原兮不蓻不營乃產嘉茗兮叢此衆呡。土膏脈勤兮雷始發聲萬木之氣未通兮此已吐乎纖萌。一之曰雀舌露掇而製之以奉乎王庭二之曰鳥喙長撷而焙之以備乎公卿三之曰槍旗登攀而炕之。將求乎利贏四之曰嫩莖茂園而範之。來充乎賦征當此時也女廢蠶織男廢農耕夜不得息晝不得停。取之由一葉而至一掬輸之若百谷之赴巨溟華夷蠻貊固曰飲而無厭富貴貧賤亦時啜而不寧所以饒畜之牛羊犬豕而廿脆不遺調之辛酸鹹苦而五味適宜造之酒醴而讌饗之樹之果蔬而薦羞之於

小民冒險而競惜執謂峻法之與嚴刑嗚呼古者聖人爲之絲枲絺紵而民始衣播之禾麰菽粟而民不饑。

茲可謂備矣何彼茗無一勝焉而競進於今之時抑非近世之人體惰不勤飽食粱肉坐以生疾藉以靈蕣而消腑胃之宿陳若然則斯茗也不得不謂之無益於爾身無功於爾民也哉。

逑菱茶小品　　　　　　　　　　　　葉清臣

夫涓黍汾泉源之異稟江橘淮枳土地之或遷誠物類之有宜亦臭味之相感也若乃掇華掇秀多識草木之名激濁揚清能辨淄澠之品斯固好事之嘉尚博識之精鑒自非笑傲塵表逍遙林下樂追王濛之約不讓陸納之風其孰能與於此乎吳楚山谷間氣清地靈草木穎挺多孕茶蕣爲人採拾大率右於

心一堂　飲食文化經典文庫

武夷者爲白乳。甲於吳興者爲紫筍產禹穴者以天章顯茂錢塘者以徑山稀至於續盧之岩雲衡之麓

鴉山著於吳歙蒙頂傳於岷蜀角立差勝毛舉實繁然而天賦尤異性瀹俗諳苟制非其妙失於術雖

先雷而萌未雨而搢蒸焙以圓造作以經而泉不香水不甘釀之揚之若淤若滓予少得溫氏所著茶說。

嘗識其水泉之目有二十焉會西走巴峽經蝦蟆窟憩蕪城汲蜀岡井東遊故郡絕揚子江留丹陽酌觀

晉泉過無錫斟慧山水粉槍牙旗蘇蘭薪桂且鼎且缶以飲以歠莫不淪氣滌爐蕩病析酲祛鄙恡之生

心招神明而達親信乎物類之宜得臭味之所感幽人之佳尚前賢之精鑒不可及已噫紫華綠英均一

水也皆忘情於庶彙或求仲於知已不然煮薄之茅溝瀆之流亦笑以異哉遊鹿故宮依蓮盛府一命

受職再期服勞而虎丘之瀦沸松江之清泚復在封畛然然挹注是嘗所得以鴻漸之曰二十有七也。

昔酈道元善於水經未嘗知茶王肅辯於茗飲而言不及水表是二美吾無愧焉凡泉品二十列於右幅。

且使盡神方之四雨遂成其功代酒限於七升無忘真賞云南陽葉清臣述。

進茶錄序

　　　　　　　　　　　蔡　襄

臣前因奏事伏蒙陛下諭臣先任福建轉運使日所進上品龍茶最爲精好臣退念草木之微首辱陛下

知鑒若處之得地則能盡其材昔陸羽茶經不第建安之品丁謂茶圖獨論採造之本至於烹試曾未聞

有臣輒條數事簡而易明勒成二篇名曰茶錄伏惟清閑之晏或賜觀採臣不勝惶懼榮幸之至謹序。

古今茶事

葉嘉傳　　蘇軾

葉嘉閩人也。其先處上谷。曾祖茂先養高不仕。好游名山。至武夷悅之。遂家焉。嘗曰。吾植功種德。不爲時採然。遺香後世。吾子孫必盛於中土。嘗飲其惠矣。茂先葬郝源。子孫遂爲郝源民。至嘉少植節操。或勸之業武曰。吾當爲天下英武之精。一槍一旗。豈吾事哉。因而游。見陸先生。先生奇之。爲著其行錄傳於世。方漢帝嗜閱經史時。建安人爲謁者侍上。上讀其行錄而善之。曰。吾獨不得與此人同時哉。曰。臣邑人葉嘉。風味恬淡。清白可愛。頗負其名。有濟世之才。雖羽知猶未詳也。上驚敕建安太守召嘉。給傳遣詣京師。郡守始令採訪嘉所在。命齎書示之。嘉未就遣。使臣督促。郡守曰。葉先生方閉門制作。研味經史。志圖挺立。必不屑進。未可促之。親至山中爲之勸駕。始行登車。遇相者揖之曰。先生容質異常。矯然有龍鳳之姿。後當大貴。嘉以皂囊上封事。天子見之曰。吾久飫卿名。但未知其實耳。我其試哉。因顧謂侍臣曰。視嘉容貌如鐵。資質剛勁。難以遽用。必摘挺頓挫之。乃可。遂以言恐嘉曰。碪斧在前。鼎鑊在後。將以烹子。子視之如何。嘉勃然吐氣曰。臣山藪猥士。幸惟陛下採擇至此。可以利主。雖粉身碎骨。臣不辭也。上笑。命以名曹處之。又加樞要之務焉。因誡小黃門監之。有頃報曰。嘉之所爲。猶若粗疏然。上曰。吾知其才。第以獨學未經師耳。嘉爲之屑屑就師。頃刻就事。已精熟矣。上乃勑御史歐陽高。金紫光祿大夫鄭當時。甘泉侯陳平三人。與之同事。歐陽嫉嘉初進有寵。曰。吾屬且爲之下矣。計欲傾之。會天子御延英。促召四人。歐但熱中而

已。當時以足斃嘉。而平亦以口侵陵之。嘉雖見侮。爲之起立。顏色不變。歐陽悔曰。陛下以葉嘉見托吾譖

亦不可忽之也。因同見帝。陽稱嘉美。而陰以輕浮訾之。嘉亦訴於上。上爲責歐陽憐嘉。視其顏色久之曰。

葉嘉真清白之士也。其氣飄然若浮雲矣。遂引而宴之。少選間上鼓舌欣然曰。始吾見嘉。未甚好也。久味

之殊令人愛朕之精魄。不覺灑然而醒。書曰啓乃心沃朕心。嘉之謂也。於是封嘉爲鉅合侯。位尚書。曰尚

書朕喉舌之任也。由是寵愛日加。朝廷賓客。過會宴享。未始不推於嘉。上日引對。至於再三後因侍宴苑

中上飲踰度。嘉輒苦諫。上不悅曰卿司朕喉舌。而以苦辭逆我。我豈堪哉。遂唾之。命左右仆於地。嘉正色

曰陛下必欲甘辭利口然後愛耶。臣言雖苦。久則有效。陛下亦嘗試之。豈不知乎。上顧左右曰。始吾言嘉

剛勁難用。今果見矣。因含容之。然亦以是疎嘉。嘉既不得志。退去閩中。既而曰。吾未如之何也已矣。上以

不見嘉月餘。勞於萬幾。神蕭思困。顧思嘉。因命召至。喜甚。以平撫嘉曰。吾渴見卿久也。遂恩遇如故。

欲以兵革爲事。而大司農奏計國用不足。上深患之。以問嘉。嘉爲進三策。其一曰榷天下之利山海之資。

一切籍於縣官行之。一年。財用豐贍。上大悅。兵與有功而還。上利其財故榷法不罷。管山海之利。自嘉始

也。居一年嘉告老。上曰鉅合侯。可謂盡矣。遂得爵其子。又令郡守擇其宗支之良者。每歲貢焉嘉子

二人長曰摶。有父風。襲爵。次曰挺。抱黃白之術。比於摶。其志尤淡泊也。嘗散其資。拯鄉閭之困。人皆德之。

故鄉人以春伐鼓。大會山中。求之以爲常。贊曰今葉氏散居天下。皆不喜城邑。惟樂山居。氏於閩中者蓋

嘉之苗裔也。天下葉氏雖夥。然風味德馨爲世所貴。皆不及閩閩之居者又多。而郝源之族爲甲以衃

衣遇天子爵徹侯位八座。可謂榮矣。然其正色苦諫竭力許國。不爲身計。蓋有以取之。夫先王用於國有

節。取於民有制。至於山林川澤之利。一切與民。嘉爲策以權之。雖救一時之急。非先王之舉也。君子譏之。

或云管山海之利。始於鹽鐵丞孔僅桑弘羊之謀也。嘉之策未行於時。至唐趙贊始舉而用之。

煎茶賦　　　　黃庭堅

洶洶乎如澗松之發清吹。皓皓乎如春空之行白雲。賓主欲眠而同味。水茗相投而不渾。苦口利病。解膠

滌昏。未嘗一日不放箸。而策茗椀之勳者也。余嘗爲嗣直瀹茗。因錄其滌煩破睡之功。爲之甲乙。建谿如

割。雙井如挺。日鑄如燹。其餘苦則辛。甘則底滯。嗇嘔酸寒胃。令人失睡。亦未足與議。或曰無甚高論。敢問

其次涪翁曰。味江之羅山。嚴道之蒙頂。黔陽之都濡。高株。瀘川之納溪。梅嶺。夷陵之壓磚。臨邛之火井。不

得巳而去於三。則六者亦可。酌兔褐之甌。瀹魚眼之鼎者也。或者又曰寒中瘠氣。莫甚於茶。或濟之鹽勾

賊破家滑竅走水。又況雞蘇之與胡麻。涪翁於是酌岐雷之醴醲。參伊聖之湯液。斯附子如博投。以熬葛

仙之堊。去藙而用鹽。去橘而用薑。不奪茗味。而佐以草石之良。所以固太倉而堅作彊。於是有胡桃松實。

菴摩鴨脚。敦賀靡蕪。水蘇甘菊。既加臭味。亦厚賓客。前四後四。各用其一。少則美。多則惡。發揮其精神。又

益於咀嚼。蓋大匠無可棄之材。太平非一士之略。厭初貪味雋永速化湯餅。乃至中夜不眠。耿耿旣作溫

心一堂　飲食文化經典文庫

齊殊可壓歈。如以六經。濟三尺法雖有除治。與人安樂賓至則煎去則就榻不游軒石之華胥則化莊周

之胡蝶。

茶經序

<div style="text-align:right">陳師道</div>

陸羽茶經家傳一卷舉氏王氏書三卷張氏書四卷內外書十有一卷其文繁簡不同。王畢氏書繁雜意

其舊文。張氏書簡明與家書合而多脫誤。家書近古可考正月七之事其下乃合三書以成之錄爲二

篇藏於家夫茶之著書自羽始其用於世亦自羽始羽誠有功於茶者也。上自宮省下迨邑里外及夷戎

蠻狄賓祀燕享預陳於前山澤以成市商賈以起家又有功於人者也可謂智矣經曰茶之否臧存之口

訣則書之所載猶其廳也夫茶之爲藝下矣至其精微書有不盡況天下之至理而欲求之文字紙墨之

間其有得乎嗇者先王因人而教同欲而治凡有益於人者皆不廢也世八之說曰先王詩書道德而已。

此乃世外執方之論枯槁自守之行不可絜天下而居也史稱羽持具飲李季卿不爲賓主又著論以毀

之夫藝者君子有之德成而後及所以同於民也不務本而趨末故業成而下也學者謹之

鬪茶記

<div style="text-align:right">唐　庚</div>

政和二年三月壬戌二三君子相與鬪茶於寄傲齋予爲取龍塘水烹之而第其品以某爲上某次之某

閩人其所齎宜尤高而又次之然大較皆精絕蓋嘗以爲天下之物有宜得而不得不宜得而得之者富

貴有力之人。或有所不能致。而貧窮厄。流離遷徙之中。或偶然獲焉。所謂尺有所短。寸有所長。良不虛

也。唐相李衞公好飲惠山泉。置驛傳送。不遠數千里。而近世歐陽少師作龍茶錄序。稱嘉祐七年。親享明

堂。致齋之夕。始以小團分賜二府。人給一餅。不敢碾試。至今藏之時熙寧元年也。吾聞茶不問團錡要之

貴新水不問江井。要之貴活千里致水眞僞固不可知。就令識眞。已非活水。自嘉祐七年壬寅。至熙寧元

年戊申首尾七年。更閱三朝。而賜茶猶在此。豈復有茶也哉。今吾提瓶支龍塘無數十步。此水宜茶昔人

以爲不減淸峽。而海道趨建安。不數日可至。故每歲新茶不過三日至矣。罪戾之餘。上寬不誅。得與諸

公從容談笑於此。汲泉煑茗取一時之適。雖在田野。孰與烹數千里之泉。澆七年之賜茗也哉。此非吾君

之力歟。夫耕鑿食息。終日蒙福而不知爲之者。直愚民耳。豈吾儕謂耶。是宜有所紀述。以無忘在上者之

澤云。

謝傳尙書惠茶啓

楊萬里

遠餉新茗。當自攜大瓢。走汲溪泉。束澗底之散薪。燃折脚之石鼎。烹玉塵。啜香乳。以享天上故人之意魄

無俗中之書傳。但一味攪破菜園耳。

煮茶夢記

元　楊維楨

鐵龍道人臥石牀。移二更。月微明。及紙帳梅影。亦及半窗。鶴孤立不鳴。命小芸童汲白蓮泉。燃槁湘竹。授

以凌霄芽爲飮供。道人乃遊心太虛。雍雍涼涼若鴻濛。若皇芒會天地之未生。適陰陽之若亡。怳兮不知

入夢。途坐清眞銀暉之堂。堂上香雲麗拂地。中著紫桂楊綠璃几。看太初易一集。集內悉星斗文煥煜燼

熰。金流玉錯莫別。炙盪若烟雲日月。交麗乎中天。欻玉露涼月冷如冰入齒者易刻。因作太虛吟。吟曰道

無形兮兆無聲。妙無心兮一以貞。百象斯融兮太虛以清。歌已光飆起。林末激華氛。郁郁霏霏絢爛洴瑆。

心不行兮神不行。無而爲萬化清壽畢。紓徐而退。復令小玉環侍筆牘。遂書歌遺之曰。道可受兮不可傳。天

乃有縹絲衣若仙子者。從容來謁。云名淡香。小字綠花。乃捧太元盃。酌太淸神明之醴以壽予。侑以詞曰。

無形兮四時。以言妙乎天兮天天之先。天天之先復何仙。移間白雲微消。綠衣化煙月反明予內間予亦

悟矣。途冥神合元。月光尙隱隱於梅花間。小芸呼曰凌霄芽熟矣。

茶法

明　楊士奇

應天府批驗茶引所。直隸常州府宜興縣張渚批驗茶引所。浙江杭州府批驗茶引所。節次關去茶引退

引累催不繳。其故蓋因批驗所不置簿籍。附寫茶商姓名貫址。或不照茶商路引。聽其冒名開報。或將引

由成千成萬。賣與嗜利之徒。齎赴產茶地方。轉賣與人。如此欲得的確名籍。追繳引難矣。况茶貨出山。絕

過官司。旣不從公盤詰。又不依例批驗。縱有夾帶斤重。多是受財賣放。彼何畏憚而不停藏舊引影射私

茶哉。又如南直隸常州府。池州府。徽州府。浙江湖州府。嚴州府。衢州府。紹興府。江西南昌府。饒州府。南康

府九江府。吉安府。湖廣武昌府。寶慶府。長沙府。荊州府。四川成都府。保慶府。蘷州府。嘉定州。瀘州。雅州等

處俱係產茶地方。相去前項三批驗所遠者數千里。近亦不下數百里若照引內條例。聽茶商徑赴產茶

府州納課買引照茶。於人爲便理必樂從誰肯不買引由公犯茶禁。今却令茶商省來此三所買引路遠

寫遠往返不便。欲其一一遵依不作弊亦難矣。况批驗引由與之截角。及搜驗有無夾帶。乃批驗茶引

所之職所退引該典截角今照前項三所却管賣引不行批驗名實不稱有乖職掌合無請給聖旨榜文。

通行天下曉諭今後園戶賣茶及茶商與販茶貨告給引由與夫批驗納課等項務要遵引由內條例

數。仍惟買引一事免其納錢只照見行事例每引一道納鈔一貫中夾紙一張。仍令前項產茶府州斟酌

所管地方。每歲可出茶貨若干合用引由若干。預先具數差人赴本部關領前引回還收貯出榜集商中

買。仍要辦驗茶商引果無詐僞。即對其人姓名籍貫附簿將引給與。年終該府州各將賣給茶引造册。

就將收過紙鈔。差人一同解繳本部。鈔送該庫交收紙劄造引仍具數關領。次年合用引由各批驗所如

遇茶商經過引路。逐一批驗將引截角。如無夾帶便放行。若有夾帶。就連人茶拏送本處官司理問

終將批驗過客商姓名貫址並引數目及盤獲私茶起數線由造册申達合干上司轉繳本部查考。

一、茶引由內茶引一道納銅錢一千文照茶一百斤茶由一道納銅錢六百文。照茶六十斤見行事例。每

引由一道納鈔一貫中夾紙一張。

一、諸人但犯私茶與鹽法一體治罪。如將已批驗截角退引入山影射照茶者同私茶論。

一、客商與販茶貨先赴產茶府州具報所買斤重依律納課買引照茶出境發賣如至住賣去處賣畢隨即於所在官司繳納原引如或停藏影射者同私茶論。

一、山園茶主將茶賣與無引由客商與販者初犯笞三十仍追原價沒官再犯笞五十三犯杖八十俱倍

追原價沒官。

一、茶引不許相離有茶無引多餘夾帶並依私茶定論。

一、茶商販到茶貨經過批驗所須要依例批驗將引出截角別無夾帶方許放行違越者笞二十。

一、賣茶去處赴宣課司依例三十分抽一分芽茶葉茶各驗價值納課。

一、偽造茶引者處死籍沒當房家產告捉人賞銀二十兩,

一、販茶不拘地方欲令兩淮山東長蘆三運司將鹽引紙每張納鈔一貫。

請革芽茶疏　　　　曹　琥

臣聞天之生物。本以養人。未聞以其所以養人者害人也。歷觀古昔帝王忍嗜慾節貢獻或罷或卻詔戒丁寧蓋不欲以一人之奉而困天下之民以養人之物。而貽人之患此所以澤及生民法垂後世而王道成矣臣查得本府額貢芽茶歲不過二十斤邇年以來。額貢之外有寧王府之貢有鎮守太監之貢是二

貢者有芽茶之徵有細茶之徵，始於方春迄於首夏官校臨門急如星火農夫蠶婦各失其業奔走山谷

以應誅求者相對而泣因怨而怒殆有不可勝言者如鎮守之貢歲歲辦千有餘斤不知實貢朝廷者幾何

今歲太監黎安行取回京未及徵派而百姓相賀於道則往歲之為民病從可知已臣不容不為陛下悉

數之方春之時正值耕蠶而男婦廢業無以卒歲此其為害一也二麥未登民艱於食旦旦而促之民不

聊生此其為害二也及歸之官又揀擇去取十不一二逐使射利之家先期採集坐索高價此其為害三

也亦或採取過時括市殆取無所應計無所出則又科斂財物買求官校百計營求坐索高價此其為害

四也官校乘機私買貨賣遂使朝夕鹽米之小民相戒而不敢入市其為害五也凡此五不躋者皆切民之深

患致澗之本源今若不言後常有悔臣今竊祿署府目觀民患苟有所慮不敢不陳伏望陛下天地生

物之心惻閭閻窮苦之狀特降綸音罷此貢獻使方春之時農蠶不至於失期草木得全其生意民物欣

欣頌聲斯作實一方萬萬年無疆之福也。

茶德頌

周履靖

有嗜茗友生烹淪不論朝夕。沸湯在須臾波泉與燎火無暇踟躇長衢竹爐列牖獸炭陳爐全應讓陸羽

不知堪賤羽觴酒觚所貴茗碗茶壺一甌睡覺二碗飯餘遇醉漢渴夫山僧逸士聞馨嗅味欣然而喜乃

掀唇快飲潤喉嗽齒詩腸濯瀚妙思猛起友生詠句而嘲其酒槽我輩惡醪啜其湯飲猶勝啜精一吸懷

暢。再吸思陶心煩頃舒。神昏頓醒。喉能清爽而發高聲祕傳煎烹瀹啜眞形。始悟玉川之妙法追魯望之

幽情。

燃石鼎儗若翻浪傾磁甌葉泛如萍雖擬酒德頌不學古調詠鴟蛉。

詩

月夜啜茶聯句　　　　　　　　　　　　　　　　　　　　　　唐　顏眞卿

泛花邀坐客代飲引清言。居士　醸酒宜華席留僧想獨園。鷹　不須攀月桂何假樹庭萱御史秋風勁尚書

北斗會崔　流華淨肌骨疏瀹滌心源。眞卿　不似春醪醉何辭綠菽繁盡素瓷傳靜夜芳氣滿閑軒修士

答族姪僧中孚贈玉泉仙人掌茶序并　　　　　　　　　　　　　　　　李　白

余聞荊州玉泉寺近清谿諸山山洞往往有乳窟窟中多玉泉交流。中有白蝙蝠大如鴉按仙經蝙蝠

一名仙鼠千歲之後體白如雪棲則倒懸蓋飲乳水而長生也其水邊處處有茗草羅生枝葉如碧玉。

唯玉泉眞公常采而飲之年八十餘歲顏色如桃花。而此茗清香滑熟異于他者所以能還童振枯扶

人壽也余遊金陵見宗僧中孚示余茶數十片拳然重疊其狀如手號爲仙人掌茶蓋新出乎玉泉之

山曠古未覯因持之見遺兼贈詩要余答之途有此作後之高僧大隱知仙人掌茶發乎中孚禪子青

蓮居士李白也。

嘗聞玉泉山山洞多乳窟。仙鼠如白鴉。倒懸深谿月。茗生此中石。玉泉流不歇。根柯灑芳津采服潤肌骨。叢老卷綠葉枝枝相接連。曝成仙人掌似拍洪崖肩舉世未見之其名定誰傳宗英乃禪伯投贈有佳篇。清鏡燭無鹽。顧慙西子妍朝坐有餘與長吟播諸天。

喜園中茶生　　　　韋應物

潔性不可汙為飲滌塵煩此物信靈味本自出山原聊因理郡餘率爾植荒園嘉隨眾草長得與幽人言。

送陸鴻漸山人採茶　　　皇甫曾

千峯待逋客。春茗復叢生採摘知深處煙霞羨獨行幽期山寺遠野飯石泉清寂寂燃燈夜相思一磬聲。

過長孫宅與郎上人茶會　　錢起

偶與息心侶忘歸才子家。元談兼藻思綠茗代榴花岸幘看雲卷含毫任景斜松喬若逢此不復醉流霞。

與趙莒茶讌　　　　　前人

竹下忘言對紫金全勝羽客醉流霞塵心洗盡興難盡一樹蟬聲片影斜。

送陸鴻漸棲霞寺採茶　　皇甫冉

採茶非採菉遠遠上層崖布葉春風暖盈筐白日斜舊知山寺路時宿野人家借問王孫草何時泛椀花。

新茶味寄上西川相公　　盧綸

三獻蓬萊始一嘗。日調金鼎閱芳香。貯之玉合才半餅。寄與阿連題數行。

津染寺採新茶　　武元衡

靈卉碧巖下。蓁英初散芳。塗塗宿霜露。采采不盈筐。陰竇藏烟濕。單衣染焙香。幸將調鼎味。一爲奏明光。

巽上人以竹間自採新茶見贈酬之以詩　　柳宗元

芳叢翳湘竹。零露凝清華。復此雪山客。晨朝掇靈芽。燕烟俯石瀨。咫尺凌丹崖。圓方麗奇色。圭璧無纖瑕。呼兒爨金鼎。餘馥延幽遐。滌慮發眞照。還源蕩昏邪。猶同甘露飲。佛事熏毗邪。咄此蓬瀛侶。無乃貴流霞。

西山蘭若試茶歌　　劉禹錫

山僧後檐茶數叢。春來映竹抽新茸。宛然爲客振衣起。如傍芳叢摘鷹嘴。斯須炒成滿室香。便酌砌下金沙水。驟雨松聲入鼎來。白雲滿盌花徘徊。悠揚噴鼻宿醒散。清峭徹骨煩襟開。陽崖陰嶺各殊氣。未若竹下莓苔地。炎帝雖嘗未辨煎。相君有錄那知味。新芽連拳半未舒。自摘至煎俄頃餘。木蘭墜露香微似。瑤草臨波色不如。僧言靈味宜幽寂。采采翹英爲嘉客。不辭緘封寄郡齋。瓬井銅爐損標格。何况蒙山顧渚

嘗茶　　前人

春白泥赤印步風塵。欲知花乳清冷味。須是眠雲跂石人。

生拍芳茸鷹嘴芽老郎封寄謫仙家今宵更有湘江月照出霏霏滿盌花。

茶嶺

張籍

紫芽連白藥初向嶺頭生自看家人摘尋常觸露行。

走筆謝孟諫議寄新茶

盧仝

日高丈五睡正濃軍將打門驚周公口云諫議送書信白絹斜封三道印開緘宛見諫議面手閱月團三百片開道新年入山裏蟄蟲驚動春風起天子須嘗陽羨茶百草不敢先開花仁風暗結珠琲瓃先春抽出黃金芽摘鮮焙芳旋封裹至精至好且不奢至尊之餘合王公何事便到山人家柴門反關無俗客紗帽籠頭自煎喫碧雲引風吹不斷白花浮光凝碗面一碗喉吻潤兩碗破孤悶三碗搜枯腸惟有文字五千卷四碗發輕汗平生不平事盡向毛孔散五碗肌骨輕六碗通仙靈七碗喫不得唯覺兩腋習習清風生。

一言至七言詩

元稹

茶香葉嫩芽慕詩客愛僧家碾雕白玉羅織紅紗銚煎黃蕊色椀轉麴塵花夜後邀陪明月晨前命對朝霞洗盡古今人不倦將知醉後豈堪誇。

睡後茶興憶楊同州

白居易

昨晚飲太多鬼餓連宵醉今朝餐又飽爛漫移時睡睡足摩挲眼眼前無一事信脚遶池行偶然得幽致。

婆娑綠陰樹斑駮青苔地此處置繩牀傍邊洗茶器白瓷甌甚潔紅爐炭方熾沫下麴塵香花浮魚眼沸。

盛來有佳色燕罷餘芳氣不見楊慕巢誰人知此味。

謝李六郎中寄蜀茶詩　　　　　　前　人

麴塵不寄他人先寄我應綠我是別茶人。

故情周匝向交親新茗分張及病身紅紙一封書後信綠芽千片火前春湯添勺水煎魚眼末下刀圭攪

坐酌泠泠水看煎瑟瑟塵無由持一盌寄與愛茶人。

山泉煎茶有懷　　　　　　　　　前　人

蕭員外寄新蜀茶　　　　　　　　前　人

蜀茶寄到但驚新渭水煎來始覺珍滿甌似乳堪持翫況是春深酒渴人。

憶茗芽　　　　　　　　　　　李德裕

谷中春日暖漸憶啜茶英欲及淸明火能消醉客心松花飄鼎泛蘭氣入甌輕飲罷閒無事捫蘿溪上行。

茶嶺　　　　　　　　　　　　韋處厚

顧渚吳商絕蒙山蜀信稀千叢因此始含露紫英肥。

蜀茗茶　施肩吾

越椀初盛蜀茗新。薄煙輕處攬來勻。山僧問我將何比。欲道瓊漿却畏嗔。

寄楊工部聞虢陵舍弟自羆溪入茶山　姚合

采茶溪路好花時。漾影半浮沈畫舸。僧同上春山客共尋芳新生石際幽嫩在山陰色是春光染香驚日色侵。

試嘗應酒醒封進定恩深芳貼千里外怡怡太府吟。

乞新茶　前人

嫩綠微黃碧澗春採時聞道斷葷辛不將錢買將詩乞借問山翁有幾人。

題宜興茶山　杜牧

山實東吳秀茶稱瑞草魁剖符雖俗吏修貢亦仙才溪盡停蠻棹旗張卓翠苔柳郥穿罄窕松澗渡喧豗等級雲峯峻寬平洞府開拂天聞笑語特地見樓臺泉嫩黃金湧牙香紫璧裁拜章期沃日輕騎疾奔雷舞袖嵐侵潤歌聲谷靄迴磬音藏葉鳥雪艷照潭梅好是全家到兼為奉詔來樹陰香作帳花逕落成堆景物殘三月登臨惜一杯重遊難自剋俛首入塵埃。

謝劉相公寄天柱茶　薛能

兩串春園潑夜光名題天柱印維揚偸嫌曼倩桃無味搗覺嫦娥藥不香惜恐被分綠利市盡應難覓為

供堂粗官寄與眞抛卻。賴有詩情合得嘗。

蜀州鄭使君寄鳥嘴茶因以贈客八韻　　　　　　前　人

烏嘴撽渾牙精靈勝鎮錦。烹嘗方帶酒滋味更無茶。拒礦乾聲細撑封利穎斜。銜蘆齊勁實。啄木聚菁華。

鹽損添常誠嚣宜著。薑宜誇得來抛道藥攜去就僧家。旋覺前甌淺還愁後信賒。千巓故人意。此惠敵丹砂。

龍山人惠石廩方及團茶。　　　　　　　　　　李羣玉

客有衡岳隱。遺予石廩茶。自云凌煙露採掇春山芽。圭璧相壓疊。積芳莫能加。碾成黄金粉。輕嫩如松花。

紅爐炊霜枝越甌斟井華。灘聲起魚眼。滿鼎漂淸霞。凝澄坐曉燈。病眼如蒙紗。一甌拂昏寐。襟鬲開煩拏。

顧渚與方山諸人留品差持甌默吟咏。搖膝空咨嗟。

答友寄新茗　　　　　　　　　　　　　　　前　人

滿火芳香碾麹塵。吳甌湘水綠花新。槐君千里分滋味。寄與春風酒渴人。

西嶺道士茶歌　　　　　　　　　　　　　　温庭筠

乳竇濺濺通石脈。綠塵愁草春江色。澗花入井水味香。山月當人松影直。仙翁白扇霜烏翎。拂壇夜讀黃

庭經。疎香皓齒有餘味。更覺鶴心通杳冥。

茶山貢焙歌　　　　　　　　　　　　　　　李　郢

使君愛客情無已。客在金臺價無比。春風三月貢茶時。盡逐紅旌到山裏。焙中清曉朱門開筐箱漸見新芽來陵烟閣露不停採官家赤印連帖催朝飢暮餉誰與哀喧鬧競納不盈掬一時一餉還成堆燕之馥馥香勝梅研膏動雷如雷茶成拜表貢天子萬人爭噉春山摧驛騎鞭聲流電半夜驅夫誰復見十日玉程路四千到時須及清明宴吾君可謂納諫君諫官不諫何由聞九重城裏雖盰食天涯吏役長紛。使君憂民慘容色就焙嘗茶坐諸客幾回到口重咨嗟嫩綠鮮芳出何力山中有酒亦有歌樂營房屋皆仙家仙家十隊酒百斛金絲宴饌隨經過使君是日憂思多客亦無言徵綺殷勤繞焙復長嘆官府例成期如何吳民吳民莫憔悴使君作相期蘇爾。

美人嘗茶行　　　　崔　珏

雲鬟枕落因春泥玉郎為礪瑟瑟塵閑教鸚鵡啄窗響和嬌扶起濃睡人銀瓶貯泉水一掬松雨聲來乳花熟朱脣啜破綠雲時咽入香喉爽紅玉明眸漸開橫秋水手撥絲簧醉心起臺前卻坐推金箏不語思量夢中事。

故人寄茶　　　　曹　鄴

劍外九華英緘題下玉京開時微月上礪處亂泉聲半夜招僧至孤吟對月烹碧澄霞脚碎香泛乳花輕。六腑睡神去數朝詩思清用餘不敢費留伴吤書行。

茶　　　　　　鄭　愚

嫩芽香且靈吾謂草中英夜白和煙搗塞爐對雪烹催憂碧粉散常見綠花生最是堪珍重飽令睡思清

茶塢　　　　陸龜蒙

茗地曲隈回野行多繞繞向陽就中密背澗差還少遙盤雲髻慢亂簇香篝小何處好幽期滿巖春露曉。

茶人　　　　前人

天賦識靈草自然鍾野姿閑來北山下似與東風期雨後採芳去雲間幽路危唯應報春鳥得共斯人知。

茶筍　　　　前人

所孕和氣深時抽玉茗短輕煙漸結華嫩藥初成管尋來青靄曙欲去紅雲暖秀色自難逢傾筐不曾滿。

茶焙　　　　前人

左右擣凝膏朝昏布煙縷方圓隨樣拍次第依屑取山謠縱高下火候還文武見說焙前人時時炙花脯。

茶塢　　　　皮日休

閑尋堯氏山遂入深深塢種莜已成園栽葭寧記畝石窪泉似掬巖罅雲如縷好是夏初時白花滿烟雨。

茶筍　　　　前人

袞然三五寸生必依巖洞寒恐結紅鉛暖疑銷紫汞圓如玉軸光脆似瓊英凍每爲遇之疎南山挂幽夢。

茶舍

陽崖枕白屋幾口嬉嬉活。棚上汲紅泉。焙前蒸紫蕨。乃翁研茗後。中婦拍茶歌。相向掩柴屏。清香滿山月。

前　人

茶焙

鑿彼碧巖下。恰應深二尺。泥易帶雲根。燒難礙石脈。初能燥金餅。漸見乾瓊液。九里共杉林。相望在山側。

前　人

煮茶

香泉一合乳。煎作連珠沸。時看蟹目濺。乍見魚鱗起。聲疑松帶雨。餑恐烟生翠。儻把瀝中山。必無千日醉。

前　人

謝僧寄茶

空門少年初地堅。摘芳為藥除睡眠。匡山茗樹朝陽偏。暖萌如爪挐飛鳶。枝枝膏露凝圓參差失向兜。羅綿傾筐短甑蒸新鮮。白苧眼細勻于研。甌排古砌春苔乾。般勤寄我清明前。金槽無聲飛碧烟赤默呵。

李咸用

冰急鐵喧林風夕和真珠泉。半匙青粉攪澒淺。綠雲輕縐湘娥聲。嘗來縱使重支枕。蝴蝶寂寥空掩關。

採茶歌

天柱香芽露香發。爛研瑟瑟穿荻篾。太守憐才寄野人。山童碾破團圓月。倚雲便酌泉聲煮。獸炭潛然蚌珠吐。看著晴天早日明。鼎中颯颯篩風雨。老翠香塵下㧑熱。攪時繞筋天雲綠。妖書病酒兩多情。坐對甌

秦韜玉

甌睡先足洗我胷中幽思清。鬼神應愁歌欲成。

峽中嘗茶　　　鄭谷

篏篏新英摘露光。小江園裏火前嘗吳僧謾說雅山好。蜀叟休誇烏嘴香。入座半甌輕泛綠。開緘數片淺
含黃龍門病客不歸去酒渴更知春味長。

茗坡　　　陸希聲

二月山家穀雨天半坡芳茗露華鮮。春醒酒病兼消渴惜取新芽旋摘煎。

尚書惠蠟面茶　　　徐夤

武夷春暖月初圓採摘新芽獻地仙。飛鵲印成香蠟片啼猿餤走木蘭船。金槽和碾沈香末冰椀輕涵翠
縷烟分贈恩深知最異晚鐺宜煮北山泉。

東亭茶讌　　　鮑君徽

開朝向曉出簾櫳茗讌東亭四望通遠眺城池山色裏俯聆絲管水聲中幽篁映沼新抽翠芳槿低簷欲
吐紅坐久此中無限興更憐團扇起清風

煎茶　　　成彥雄

岳寺春深睡起時。虎跑泉畔思遲遲蜀茶倩箇雲僧碾自拾枯松三四枝。

與亢居士青山潭飲茶　　　僧靈一

野泉烟火白雲間坐飲香茶愛此山。嚴下縮舟不忍去清溪水流暮潺潺。

飲茶歌誚崔石使君

越人遺我剡溪茗採得金芽爨金鼎素瓷雪色飄沫香何似諸仙瓊蘂漿。一飲滌昏寐情思爽朗滿天地，

再飲清我神忽如飛雨灑輕塵三飲便得道何須苦心破煩惱此物清高世莫知世人飲酒徒自欺好看

畢卓甕間夜笑向陶潛籬下時崔侯啜之意不已狂歌一曲驚人耳孰知茶道全爾眞唯有丹丘得如此。

釋皎然

飲茶歌送鄭容

丹丘羽人輕玉食採茶飲之生羽翼名藏仙府世莫知骨化雲宮人不識雲山童子調金鐺楚人茶經盧

得名霜天半夜芳草折爛漫緗花噯又生常說此茶祛我疾使人胷中蕩憂慄日上香爐情未畢醉踏虎

溪雲。高歌送君出。

前　人

對陸迅飲天目山茶因寄元居士晟

喜見幽人會初開野客茶日成東井葉露採北山芽文火香偏勝寒泉味轉嘉投鐺湧作沫著椀聚生花。

稍與禪經近聊將睡網賒知君在天目此意日無涯。

前　人

和門下殷侍郎新茶二十韻

暖吹入春園新芽競粲然才敎廊岕坼未放雪花研荷杖青林下攜筐旭景前孕靈資雨露鍾秀自山川。

朱　徐鉉

礦後香彌遠。烹來色更鮮。名隨土地貴。味逐水泉遷。力籍流黃暖。形模紫筍圓。正當鑽柳火。遙想湧金泉，

任道時新物。須依古法煎。輕甌浮綠乳。孤竈散餘烟。甘荈非予匹。宮槐讓我先。竹空冉荷弱護田田。

解渴消殘酒。清神感夜眠。十漿何足饋。百榼盡堪捐。「采擷唯憂晚。營求不計錢。任公因焙顯。陸氏有經傳。

愛甚真成癖。嘗多合得仙。亭臺虛靜處。風月艷陽天。自可臨泉石。何仿雜管絃束山似蒙頂願得從諸賢。

恩賜龍鳳茶　　王禹偁

樣標龍鳳號題新。賜得還因作近臣。烹處豈期商嶺水。碾時空想建溪春。香于九晚芳蘭氣圓如三秋皓

月輪。愛惜不嘗惟恐盡除將供養白頭親。

茶園十二韻　　前人

勤王修歲貢。晚駕過郊原。蔽芾餘千本。青蔥共一園。芽新撐老葉土軟迸新根。舌小侔黃雀毛攣摘綠猿。

出蒸香更別入焙火微溫。採近桐華節生無穀雨痕。綴籐防遠道進獻趁頭番。待破華胥夢先經閶闔門。

汲泉鳴玉甃開宴壓瑤罇茂育知天意甄收荷主恩。沃心同直諫苦口類嘉言未復金鑾召年年奉至尊。

北苑茶　　丁謂

北苑龍茶著甘鮮的是珍。四方惟數此。萬物更無新。綿吐微茫綠初沾少許春。散尋縈樹偏急採上山頻。

宿葉寒猶在芳芽冷未申茅茨溪上焙籃籠雨中民。長疾勾萌坼開齊分雨勻帶煙蒸雀舌和露疊龍鱗。

作貢勝諸道先嘗祇一人。緘封瞻闕下郵傳渡江濱特旨留丹禁近臣。啜將靈藥助用與上尊親。

投進英華盡初烹氣味真細香勝卻辭淺色過於筍。顧渚慚投木宜都愧積薪年年號供御天產壯甌閩。

嘗茶次寄越僧靈皎

林逋

白雲峯下兩槍新。膩綠長鮮穀雨春。靜試卻如湖上雪對嘗兼憶刻中人餅懸金粉師應有筋點瓊花我

自珍。清話幾時搔首後顧和松色勸三巡。

茶

前人

石碾清飛瑟瑟塵。乳香烹出建谿春。世間絕品人難識。閒對茶經憶古人。

和伯恭自造新茶

余靖

郡庭無事即仙家。野圃裁成紫笋茶。疏雨半晴回暖氣輕雷初過得新芽烘褫精謹松齋靜採擷繁迂迴

路斜江水薄煎萍髣髴越甌新試霹交加。一槍試焙春尤早三盞搜腸句更嘉多謝彩箋貽雅貺想資詩

筆思無涯。

謝許少卿寄臥龍山茶

趙抃

越芽遠寄入都時。酬倡珍誇互見詩紫玉叢中觀兩腳。翠峯頂上摘雲旗啜多思爽都忘寐吟苦更長了

不知想到明年公進用臥龍春色自遲遲。

心一堂　飲食文化經典文庫

190

雙井茶　　歐陽修

西江水清江石老。石上生茶如鳳爪。窮臘不寒春氣早雙井茅生先百草白毛囊以紅碧紗十斤茶養一
兩芽長安富貴五侯家。一啜猶須三日誇寶雲日注非不精爭新棄舊世人情豈知君子有常德至寶不
隨時變易。君不見建谿龍鳳團不改舊時香味色。

送龍井與許道人　　前人

潁陽道士青霞客。來似浮雲去無蹤夜朝北斗太清壇。不道姓名人不識我有龍團古蒼壁九龍泉深一
百尺憑君汲井試烹之。不是人間香味色。

得雷太簡自製蒙頂茶　　梅堯臣

陸羽舊茶經。一意重蒙頂。比來唯建谿團片敵湯餅顧渚及陽羨又復下越茗近來江國人鷹爪奈雙井。
凡今天下品非此不覽省蜀茅久無味聲名謾馳騁因雷與改造帶露摘芽穎自煮至揉焙入碗只俄頃。
湯嫩乳花浮香新舌甘永初分翰林公豈數博士冷醉來不知惜悔已向醒重思朋友義果決在勇猛。
倏然乃於贈蠟囊收細梗吁嗟茗與鞭二物誠不幸我貧事事無得之似贅瘝。

呂晉叔著作遺新茶　　前人

四葉及三游共家原坂嶺歲摘建谿春爭先取晴景大窠有壯液所發必奇穎一朝團焙成價與黃金邅。

古今茶事

呂侯得鄉人分贈我已幸其贈幾何多。六色十五餅每餅包青蒻紅籤纏素縈屑之雲零輕啜已神魄惺。

會待嘉客來佐談當畫永。

李仲求寄建谿洪井茶七品云愈少愈佳未知嘗何如耳因偸而答之

忽有西山使始遺七品茶末品無水暈六品無枒粗五品散雲脚四品浮粟花三品若瓊乳二品罕所加。　前人

絕品不可議甘草焉等差一日嘗十甌六腑無昏邪夜枕不得嫌月樹間啼鴉憂來惟覺兩可驗唯齒牙。

勤搖有三四坊咀連左車髮亦足驚悚疎疎點霜華乃思平生遊但恨江路賒安得一見之賁泉相與誇。

答建州沈屯田寄新茶　　前人

春芽礦白膏夜火焙紫餅價與黃金齊包開青篛整礦爲玉色塵遠汲盧底井一啜同醉翁思君聊引領。

穎公遺碧霄峯茗　　前人

到山春已晚何更有新茶峯頂應多雨天寒始發芽採時林猶靜蒸處石泉嘉持作衣囊祕分來五柳家。

茶壟　　蔡襄

造化曾無私亦有意所嘉夜雨作春力朝雲護日車千萬碧天枝戰戰抽靈芽。

采茶　　前人

春衫逐紅旗散入青林下陰崖喜先至新苗漸盈把競攜篛籠歸更帶山雲寫。

心一堂　飲食文化經典文庫

造茶

前人

糜玉寸陰間摶金新範裏。規呈月正圓勢動龍初起。出焙幽花全爭誇火候是。

試茶

前人

兔毫紫甌新蟹眼清泉煮。雪凍作成花雲開未垂縷。顧渚池中波去作人間雨。

謝張和仲惠寶雲茶

王令

故人有意真憐我。靈芽封題寄篳門。與療文園消渴病。還招楚客獨醒魂。烹來似帶吳雲脚。摘處應無穀雨痕。果肯同嘗竹林下。寒泉猶有惠山存。

寄周安孺茶

蘇軾

大哉天宇內。植物知幾族。靈品獨標奇。迥超凡草木。名從姬旦始。漸播桐君錄。詠誰最先厥。傳惟杜育。唐人未知好。論著始於陸。常李亦清流。當年慕高躅。遂使天下士。嗜此偶於俗。豈但中土珍。兼之異邦鬻。鹿門有佳士。博覽無不賙。邂逅天隨翁。篇章互賡續。開園頤山下。屏迹松江曲。有與卽揮毫。燦然存簡牘。伊余素寡愛。嗜好本不篤。粵自少年時。低回客京轂。雖非曳裾者。庇蔭或華屋。頗見綺紈中。齒牙厭粱肉。小龍得屢試。糞土視珠玉。團鳳與葵花。碔砆雜魚目。貴人自矜惜。捧玩且緘櫝。未數日注卑。定知雙井辱。於茲自研討。至味識五六。自爾入江湖。尋僧訪幽獨。高人固多暇。探究亦頗熟。聞道早春時。漿纊赴初旭。

驚雷未破蕾。采采不盈掬旋洗肉泉蒸。芳馨豈停宿。須臾布輕縷火候謹盈縮。不憚頃間勞經時廣搜蓄。

綵筒淨無染筠籠勻且複。苦畏梅潤侵暖須人氣燠。有如剛耿性。不受纖芥觸又若廉夫心。難將穢稊瀆。

晴天斂虛府石碾破輕綠。永日遇閒賓乳泉發新馥，香奪蘭露色嫩欺秋菊。閩俗競傳誇豐腴面如粥。

自云葉家白顏勝中山醁好是一杯深。午窗春睡足清風擊兩腋。去欲凌鴻鵠嗟我樂何深。水經亦壞讀。

子咤中泠泉次乃康王谷蝦蟆培頭貴嘗瓶甖走僮僕。如今老且懶細事百不欲。美惡兩俱忘。誰能強追逐。

叢鹽拌白土稍稍從吾蜀尚欲徇心腹。由來薄滋味日飯止脫粟外慕既已矣。胡爲此羈束。

昨日散幽步偶上天峯麓山圖正春風蒙茸萬旗簇呼兒爲佳客。采製聊亦復地僻誰我從。包藏置廚簏。

何嘗較優劣但喜破睡速況此夏日長人間正炎毒人無一事午飯飽蔬菽困臥北窗風。風微動窗竹。

乳甌十分滿人世真局促爽飄欲仙頭輕快如沐昔人固多辟我辟良可贖爲問劉伯倫。胡然枕糟麴。

試院煎茶

前人

蟹眼已過魚眼生颼颼欲作松風鳴。蒙茸出磨細珠落眩轉遶甌飛雪輕。銀瓶瀉湯誇第二。未識古人煎

水意君不見昔時李生好客手自煎。貴從活火發新泉。又不見今時潞公煎茶學西蜀。定州花瓷琢紅玉

我今貧病長苦飢分爲玉盌捧蛾眉且學公家作茗飲磚爐石銚行相隨。不用撐腸拄腹文字五千卷，但

願一甌常及睡足日高時。

月兔茶
前　人

環非環玦非玦。中有迷離玉兔兒。一似佳人裳上月。月圓還缺缺還圓。此月一缺圓何年君不見鬭茶公
子不忍鬭小團。上有雙銜綬帶雙飛鸞。

和錢安道寄惠建茶
前　人

我官於南今幾時。嘗盡溪茶與山茗。胷中似記故人面。口不能言心自省。爲君細說我未暇。試評其略差
可聽。建溪所產雖不同。一一天與君子性。森然可愛不可慢。骨淸肉膩和且正。雪花雨脚何足道。啜過始
知眞味永縱復苦硬終可錄。汲黯少戇寬饒猛。草茶無賴空有名。高者妖邪次頑犷。體輕雖復強浮汎。性
滯偏工嘔酸冷。其間絕品豈不佳。張禹縱賢非骨鯁。葵花玉誇不易致。道路幽險隔雲嶺。誰知使者來自
西。開緘磊落收百餅。嗅香嚼味本非別。透紙自覺光焰焰。粃糠團鳳友小龍。奴隸日注臣雙井。收藏愛惜
待佳客。不敢包裹鑽權倖。此詩有味君勿傳。空使時人怒生癭。

和蔣夔寄茶
前　人

我生百事常隨緣。四方水陸無不便。扁舟渡江適吳越。三年飲食窮芳鮮。金虀玉膾飯炊雪。海螯江柱初
脫泉。臨風飽食甘寢罷。一甌花乳浮輕圓。自從捨舟入東武。沃野便到桑廱川。翦毛胡羊大如馬，誰記鹿
角腥盤筵。廚中蒸粟堆飯甕。大杓更取酸生涎。柘羅銅碾棄不用。脂麻白土須盆研。故人猶作舊眼看。謂

我好尚知當年。沙谿北苑強分別。水腳一線爭誰先清詩兩幅寄千里紫金百餅費萬錢吟哦烹唯兩奇絕只恐像乞煩封纏老妻稚子不知愛一半已入薑鹽煎人生所遇無不可。南北嗜好知誰賢死生禍顛久不擇更論甘苦爭媸妍。知君窮旅不自釋因詩寄謝聊相鑱。

魯直以詩饋雙井茶次其韻為謝
<div align="right">前　人</div>

相如明年我欲東南去畫舫何妨宿太湖。

江夏無雙種奇茗。汝陰六一誇新書磨成不敢付僮僕自看雪湯生璣珠列仙之儒瘠不腴只有病渴同

送南屏謙師
<div align="right">前　人</div>

道人曉出南屏山來試點茶三昧手。忽驚午盞兔毛斑打作春甕鵝兒酒天台乳花世不見玉川風液今安有。先生有意續茶經會使老謙名不朽。

怡然以垂雲新茶見餉報以大龍團仍戲作小詩
<div align="right">前　人</div>

妙供來香積珍烹具大官揀牙分雀舌賜茗出龍團曉日雲菴暖春風浴殿寒聊將試道眼莫作兩般看。

惠山謁錢道人烹小龍團登絕頂望太湖
<div align="right">前　人</div>

踏遍江南南岸山逢山未免更留連獨攜天上小團月來試人間第二泉石路縈迴九龍脊水光翻動五湖天孫登無遇空歸去半嶺松聲萬壑傳。

心一堂　飲食文化經典文庫

次韻曾輔寄壑源試焙新茶　　　　　　　　　　前人

仙山靈雨濕行雲洗遍香肌粉未勻。明月來投玉川子，清風吹破武林春。要知冰雪心腸好，不是膏油首
面新。戲作小詩君莫笑，從來佳茗似佳人。

汲江煎茶　　　　　　　　　　　　　　　　　前人

活水還須活火烹，自臨釣石汲深清。大瓢貯月歸春甕，小杓分江入夜鐺。雪乳已翻煎處腳，松風忽作瀉
時聲。枯腸未易禁三碗，臥聽山城長短更。

遊諸佛舍一日飲釀茶七盞戲書勤師壁。　　　　孔平仲

示病維摩元不病，在家靈運已忘家。何須魏帝一丸藥，且盡盧仝七椀茶。

和子瞻煎茶　　　　　　　　　　　　　　　　蘇轍

年來病懶百不堪，未廢飲食求芳甘。煎茶舊法出西蜀，水聲火候猶能諳。相傳煎茶只煎水，茶性仍存偏
有味。君不見閩中茶品天下高，傾身事茶不知勞。又不見北方茗飲無不有，鹽酪椒薑誇滿口。我今倦遊
思故鄉，不學南方與北方。銅鐺得火蚯蚓叫，匙腳旋轉秋螢光。何時茅簷歸去炙背讀文字，遣兒折取枯
竹女煎湯。

記夢迴文二首　序并　　　　　　　　　　　　前人

十二月二十五日大雪始晴。夢人以雪水烹小團茶使美人歌以飲余。夢中爲作迴文詩覺而記其一

句云亂點餘花吐碧衫意用飛燕故事也。乃續之爲二絕句云

酡顏玉盌捧纖纖亂點餘花吐碧衫歌咽水雲凝靜院夢驚松雪落空巖。

空花落盡酒傾缸日上山融雪漲江紅焙淺甌新火活龍團小碾鬪晴窗。

靈山試茶歌　　　　　　陳　襄

乳源淺淺交寒石松花墮粉愁無色明皇玉女跨神雲鬪輕羅縷殘壁我聞灊山二月春方歸苦霧迷

天新雪飛仙鼠潭邊蘭草齊霧芽吸盡香龍脂轆轤繩細井花暖香塵散碧瑠璃椀玉川冰骨照人寒瑟

瑟祥風滿眼前紫屏冷落沈水煙山月堂軒金鴨眠麻姑癡爲丹井泉不識人間有上仙。

以雙井茶送子瞻　　　　黃庭堅

人間風日不到處天上玉堂森寶書想見東坡舊居士揮毫百斛寫明珠我家江南摘雲腴落磑霏霏雪

不如爲君喚起黃州夢獨載扁舟向五湖。

謝送碾賜壑源揀芽　　　前　人

喬雲從龍小蒼璧元豐至今人未識壑源包貢第一春細區碾香供玉食睿思殿東金井欄甘露薦椀天

開顏橋山事嚴庇百局補衰諸公省中宿中人傳賜夜未央雨露恩光照宮燭左丞似是李元禮好事風

流有涇渭肯憐天祿校書郎。親勒家庭遣分似春風飽識太官羊不慣腐儒湯餅腸。搜攪十年燈火讀令

我脅中書傳香已戒應門老馬走客來問字莫載酒。

以小龍團及半挺贈無咎幷詩用前韻爲戲

我持元圭與蒼璧以暗投人渠不識城南窮巷有佳人。不索檳榔常宴食赤銅茗椀雨斑斑。銀粟翻光解

破顏上有龍文下棋局擔囊贈金諾已宿此物已是元豐春。先皇聖功調玉燭晃子脅中爛典禮平生自

期莘與渭故用澆君磊塊脅莫令鬢毛雪相似曲几蒲團聽煮湯煎成車聲繞羊腸。雞蘇故廳留渴羌不

應亂我官焙香肥如瓠壺鼻雷吼幸君飲此勿飲酒。

博士王揚休碾密雲龍同事十三人飲之戲作

矞雲茀鬱小盤龍貢包新樣出元豐王郎坦腹飯林東太官分物來婦翁辣圍深鎖武成宮談天進士雖

前　人

盧仝鳴鳩欲雨喚雄雌南嶺北嶺宮徵同午窗欲眠視潒潒喜君開包碾春風注湯官焙香出籠非君灌

前　人

頂甘露椀幾爲談天乾舌本。

答黃冕仲索煎雙井幷簡楊休

前　人

江夏無雙乃吾宗同舍顏似王安豐能澆茗椀濕我風袂欲把浮丘翁吾宗落筆賞幽事秋月下照澄

江空家山鷹爪是小草敢與好賜雲龍同不嫌水厄幸來辱寒泉湯鼎聽松風夜堂朱墨小燈籠惜無穀

纖來捧椀唯倚新詩可傳本。

謝王煜之惠茶　　　　　　　　　　　前人

平生心賞建谿春一丘風味極可人香包解盡寶帶胯黑面碾出明窗塵家園鷹爪玫嗢冷官焙龍文常

食陳於公歲取輕源足勿遣沙谿來亂眞

謝公擇舅分賜茶　　　　　　　　　　前人

外家新賜苔龍璧北焙風煙天上來明日蓬山破寒月先甘和夢聽春雷。

春同公擇作揀芽詠

赤囊歲上雙龍璧曾見前朝盛事來想得天香隨御所延春闊道轉輕雷。

咏茶　　　　　　　　　　　　　　　秦觀

茶實嘉木英其香乃天育芳不愧杜蘅清埭掩椒菊上客集堂葵圓月採匦盖玉鼎注漫流金磑響杖竹。

侵尋發美齶猗狔生乳粟經時不銷歇衣袂帶芬郁幸蒙中笥藏苦厭龍蘭續願君斥異類使我全芬馥。

次韻魯直謝李左丞送茶　　　　　　　晁補之

都城米貴斗論璧長饑茗椀無從識道和何暇索檳榔慚愧雲龍羞肉飣海萬晦不作欄上春伐鼓驚

出顏題封進御官有局夜行初不更驛宿冰融太液俱未知寒食新苞隨賜燭建安一水去兩水易較豈

如澀與渭。左丞分送天上餘。我試比方良有似。月團清潤珍羹羊葵花瑣細胃與腸。可憐賦罷翠玉晚寧

憶睡餘雙井香。大勝膠西蘇太守。茶湯不美誇薄酒。

魯直復以詩送茶云願君飲此勿飲酒次韻
前人

相茶眞似石韜璧至精那可皮膚識溪芽不給萬口須往往山毛俱入食雲龍正用餉近班乞與麤官試

覩顏崇朝一盌坐官局申旦形淸不成宿平生樂此臭味同故人貽我情相燭黃侯發軔日千里天育收

駒自汧渭軍聲出鼎細九盤如此佳句誰能似遺試齊民蟹眼湯扶起醉頭澌腐腸顏類他時玉川子破

鼻竹林風送信吾儕幽事動不朽但讀離騷可無酒,

陸元鈞宰寄日注茶
晁沖之

我昔不知風雅頌草木獨遺茶比諷陋哉徐鉉說茶苦欲與淇園竹同種又疑禹漏稅九州橘柚常年錯

包貢腐儒妄測聖人意遠物勞民亦安用含桃熟薦常在盤荔子生來柱飛輶羊蔬異好亦何有蚶菜殊

珍要非奉君家季疵眞禍首毀論徒勞世仍重爭新鬭試誇擊拂風俗移人可深痛老夫病渴手自煎嗜

好悠悠亦從衆更煩小陸分日注。密封細字蠻奴送槍旗却憶探擷初。雪花似是雲溪勤更期遺我但敲

前人

門。玉川無復周公夢。
簡江子之求茶

政和密雲不作團。小鈴寸許蒼龍蟠。金花絳縷如截玉。綠面彷彿松谿寒。人間此品那可得。三年聞有絲

未識老夫於此百不忙。飽食但苦夏日長。北窗無風睡不解。齒頰苦澀思清涼。故人新除協律郎交遊多

在白玉堂揀芽關夸皆飲嘗幸爲傳聲李太府煩渠折簡買頭綱。

謝人送鳳團及建茶

韓　駒

山瓶慣識露芽香。細翠勻排訝許方。猶喜晚途官樣在密羅深碾看飛霜。

飲修仁茶

煙雲吐長崖風雨暗古縣。竹輿頏兩肩。弛擔息微倦茗飲初一嘗老父有芹獻。幽姿絕媚嫵著齒得暝眩。

昏昏嗜睡翁喚起風灑面。亦有不平心盡從毛孔散。

孫　覿

李茂嘉寄茶

蠻珍分到謫仙家。斷壁殘璋裹絳紗。擬把金釵候湯眼。不將白玉伴脂麻。

前　人

次韻劉升卿惠焦坑寺茶用東坡韻

日出城門啼早鴉蔾杖投足野僧家。非關西寺鐘前飯要看南枝雪裏花。玉局偶然留妙語焦坑從此貴

王庭珪

初識茶花

新茶劉郎寄我兼長句落筆更加錐畫沙。

陳與義

戲酳嘗草茶　　沈與求

伊軋籃與不受催，湖南秋色更佳哉，青裙玉面初相識，九月茶花滿路開。慣看留客費瓜茶，政羨多藏不示夸，要使睡魔能偃草，肯慚歡伯解迷花，一旗但覺烹殊品，雙鳳何須覓瑞芽，待摘家山供茗飲，與君盟約去驕奢。

答卓民表送茶　　朱松

攪雲飛雪一番新，誰念幽人尚食陳，勢擬三生玉川子，破除千餅建谿春，喚回窈窈清都夢，洗盡蓬蓬渴肺塵，便欲乘風度芹水，卻悲狡獪得君嗔。

茶巖　　羅顧

嚴下縈經昨夜崇，風爐瓦鼎一時來，便將槐火煎巖溜，聽作松風萬壑迴。

次韻王少府送焦坑茶　　周必大

昏然午枕困漳濱，醒以清風賴子真，初似參禪逢硬語，久如味諫得端人，王程不趁清明宴，野老先分浩盪春，敢向柘羅評綵玉，待君回碾試飛塵。

胡邦衡生日以詩送北苑八銙日鑄二瓶　　前人

賀客稱觴鐵冠霞懸，知酒渴正思茶，尚書八餅分閩焙，主簿雙瓶揀葉芽，妙手合調金鼎鉉，清風穩到玉

皇家。

謝木韞之舍人分送講筵賜茶 　楊萬里

吳綾縫囊染菊水，擊砂塗印題進字。淳熙錫貢新水芽，天珍誤落黃茅地。故人戀淯紫薇郎，金華講徹花草香。宣賜龍焙第一綱，殿上走趨明月璫。御前啜罷三危露，滿袖香煙懷璧去。歸來拈出兩蜿蜒，雷鳴嗋冥驚破柱。北苑龍芽內樣新，銅圍銀範鑄瓊塵。九天寶月霏五雲，玉龍雙舞黃金鱗。老夫平生愛煮茗，十年燒穿折腳鼎。下山汲井得甘冷，上山摘芽得苦梗。何曾夢到龍遊窠，何曾喫龍芽茶。故人分送玉川子，春風來自玉皇家。鍛圭椎璧調冰水，烹龍炮鳳搜肝髓。石花紫笋可衙官，赤印白泥牛走爾。故人氣味茶樣清，故人丰骨茶樣明。開緘不但似見面，叩之咳唾金石聲。麴蘗勸人墮山幘，睡魔遣我拋書冊。老夫七椀病未能，一啜猶堪坐秋夕。

以六一泉煮雙井茶 　前人

鷹爪新茶蟹眼湯，松風鳴雷兔毫霜。細袞六一泉中味，故有焙翁句子香。日鑄建谿當退舍，落霞秋水還鄉。何時歸上膝王閣，自看風爐自煮嘗。

送新茶李聖俞郎中 　前人

頭綱別樣建谿春，小璧蒼龍浪得名。細瀉谷簾珠顆露，打成寒食杏花餳。鷗斑椀面雲縈宇，兔褐甌心雪

作泓。不待清風生兩腋清風先向舌端生。

舟泊吳江

江湖便是老生涯佳處何妨且泊家自汲淞江橋下水垂虹亭上試新茶。

前人

茶坂

攜籝北嶺西采擷供茗飲一啜夜窗寒趼趺謝衾枕。

朱熹

茶竈

仙翁遺石竈宛在水中央飲能方舟去茶烟裊細香。

前人

香茶供養黃蘗長老悟公故人之塔并以小詩見意二首
擺手臨行一寄聲故應離合未忘情爐香淪茗知何處十二峯前海月明一別人間萬事空他年何處却

前人

相逢不須更話三生石紫翠參天十二峯

賞茶

自汲香泉帶落花漫燒石鼎試新茶綠陰天氣開庭院臥聽黃蜂報晚衙。

戴昺

觀山茶過圓龍寺示邦基

僧惠洪

北窗賞新晴睡美正清熟竹雞斷幽夢朦朧不能續臥聞故人家山茶已出屋欣然一命駕妍暖快僮僕。

千朵鶴頂紅染此一叢綠。坐客例能詩。秀句抵金玉。攜過囘龍寺。掃筆爲君錄。逸筆作波險。敧斜不可讀。

坐驚般㪍鐘。暮色眩雙目。入關更淸與市非。亂燈燭。人生分萬途。稱心良易足。時平且行樂。餘賓非所欲。

和曾逢原試茶連韻

前人

霜鬚癭面豁齒牙。門前小舟賽自拿。茅炎叢竹依甖畬。君來遊時方探茶。傳呼部曲江路賒。迎門顚倒披裂毿。仙風照人虔敬加。秀如春露濕蘭芽。和如東風吹奇葩。馬蹄歸路銜飛花。靑松翰轚登龍蛇。路人聚觀不敢譁。詩筒復肯來山家。想見戟門兵衛遮。湘江玉礫無纖瑕。但聞江空響釣車。生計唯攪蝦識醉墨翻側麻。喜如小兒抱瓜宣。和官焙囊絳紗。見之美如癢初爬。愛客自試歡無涯。身世都忘是長沙。院落日長蜂趁衙。園林雨足鳴蛙。詩成句法規正邪。細窺不容銖兩差。逸塵翰墨爭傳誇。坡谷非子前身耶。沅湘萬古一長嗟。明年夜直趨東華。應有佳句懷煙霞。

與客啜茶戲成

前人

道人要我賞溫山。似識相如病裏顏。金鼎浪翻螃蟹眼。玉甌絞刷鷓鴣斑。津津白乳衝眉上。拂拂淸風產腋間。喚起晴窗春晝夢。絕憐佳味少人攀。

食新茶

永　頤

自向山中汞泉石足幽弄茶經猶挂壁庭草積已衆。拜先俄食新。香凝雲乳動。心開神宇泰。境豁謝幽夢。

心一堂　飲食文化經典文庫

至咮延冥遐爽脫塵輕靜語生雲靁逸想超戀鳳飽此巖壑眞淸風願遐送。

偶成

蟹湯兔盞鬪旗槍風雨山中枕簟涼學道窮年何所得只工掃地與焚香。

金吳激

夏至

玉堂睡起苦思茶別院銅輪碾露芽紅日韓堦簾影薄一雙蝴蝶上葵花。

趙秉文

新樣團茶

春風傾倒在靈芽纔到江南百草花未試人間小團月異香先入玉川家。

李俊民

茗飲

宿醒未破厭羹船紫笋分封入曉煎槐火石泉寒食後鬢絲禪榻落花前一甌春露香能永萬里淸風意

元好問

西域從王君玉乞茶因其韻七首

已便避逅華胥猶可到蓬萊未擬問羣仙。

元　耶律楚材

積年不啜建谿茶心竅黃塵塞五車碧玉甌中思雪浪黃金碾畔憶雷芽盧仝七碗詩難得諗老三甌夢

亦賖敢乞君侯分數餅暫教淸興遶煙霞。

厚意江洪絕品茶先生分出蒲輪茶雪花灩灩浮金蘂玉屑紛紛碎白芽破夢一杯非易得搜腸三椀不

能除瓊甌啜罷酬平昔。飽看兩山插翠霞。

高人惠我嶺南茶。爛賞飛花雪沒車。玉屑三甌烹嫩蘂青旂一葉礦新芽頓令衰叟詩魂爽便覺紅塵客

夢除兩腋清風生坐榻幽歡遠勝汎流霞。

酒仙飄逸不知茶可笑流涎見麴車。玉杵和雲舂素月金刀帶雨剪黃芽試將綺語求茶飲特勝春衫把

酒除啜罷神清淡無寐塵囂身世便雲霞。

長笑劉伶不識茶胡為買鍤謾隨車蕭蕭暮雨雲千頃穩穩春雷玉一芽建郡深甌吳地遠金山佳水楚

江除紅爐石鼎烹團月一椀和香吸碧霞。

枯腸搜盡數杯茶千卷胸中到幾車湯響松風三昧手雪香雷震一槍芽滿甌垂賜情何厚萬里攜來路

更除清興無涯騰八表騎鯨踏破赤城霞。

啜罷江南一椀茶枯腸歷歷走雷車黃金小礦飛瓊屑碧玉深甌點雪芽篝陣陳兵詩思勇睡魔卷甲夢

魂除精神爽逸無餘事臥看殘陽補斷霞。

嘗雲芝茶　　劉秉忠

鐵色皴皮帶老霜合英咀美入詩腸舌根未得天真味鼻觀先通聖妙香海上精華難品第江南草木屬

尋常待將膚腠侵微汗毛骨生風六月涼。

袁桷

煮茶圖　並序

煮茶圖一卷。仿石巃史處州燕居故事所作也。石巃諱文卿。字景賢。外高祖忠定王曾孫。儀觀清朗超

然綺紈之習。聚四方奇石。築室曰山澤居。而自號曰石巃山樵。此圖左列圖卷。比束如玉筍錦繡間錯。

旁有一童。出囊琴拂塵以俟命。右橫重屏。石巃手執烏絲蘭書展翫。疑有所構思。屏後一几。設茶器數

十。一童偏背運碾塵滿市。一童籌火候湯甆眉望鼎口。若懼主人將索者。如意塵尾巾壺研紙皆備

悉縈具。羽衣烏巾玉色絢起。望之眞飛仙人。余意永和諸賢。放浪泉石。當不過是。而其泊然官意翰墨

清瀟誠足以方駕而無媿。甲午冬十月。其孫公疇。出以相示。因記而賦之。以發千古之遠想云。

石巃山樵晉公子。獨鶴蕭蕭煙竹裏。月湖一頃碧琉璃。高樂虛堂水中沚。堂深六月生涼秋。萬柄風搖紅

旖旎。遠南更有山澤居。四面晴嵐插天倚。憶昔王門豪盛時。甲族丁黃總朱紫。曉趨黃閣袖香俯首脂

韋希寵美。一官遠去長安門。德色欣欣對妻子。豈如高懷脫榮辱。妙出清言洗紈綺。郡符一試不挂意。岸

幘看雲臥林野。平生嗜茗有癖。古井汲泉和石髓。風向翠碾落晴花。湯響雲鐺裊珠蕊。齒寒薰冷復三

咽。萬事無言歸坎止。何人丹青悟天巧。落筆毫芒研妙理。黃粱初炊夢未古。舊事凄零誰復記。展圖縹緲

憶遺蹤。玉珧珊珊響秋水。

題蘇東坡墨蹟

虞集

老却眉山長帽翁。茶煙輕颺鬢絲風。錦囊舊賜龍團在。誰爲分泉落月中。

元統乙亥余除閩憲知事未行立春十日叅政許可用惠茶寄詩以謝

春到人間纔十日。東風先過玉川家。紫薇書寄斜封印。黃閣香分上賜茶。秋露有聲浮甕葉。夜牕無夢到　　　　　薩都剌

梅花。清風兩腋歸何處。直上三山看海霞。

　雪煎茶　　　　　　　　　　　　　　　　　　　　　　　　　　　　　　　　謝宗可

夜攤寒英煮綠塵。松風入鼎更清新。月團影落銀河水。雲脚香融玉樹春。陸井有泉應近俗。陶江無酒未

爲貧。詩脾奪盡豐年瑞。分付蓬萊頂上人。

　煮土茶歌　　　　　　　　　　　　　　　　　　　　　　　　　　　　　　　洪希文

論茶自古稱螫源。品水無出中濡泉。莆中苦茶出土產。鄉味自汲井水煎。器新火活清味永。且從平地休

登仙。王侯第宅闢絕品。揣分不到山翁前。臨風一啜心自省。此意莫與他人傳。

　土銼茶煙　　　　　　　　　　　　　　　　　　　　　　　　　　　　　　　李謙亨

熒熒石火新湔湔。山泉洌汲水煮春芽。清煙半如滅。香浮石鼎花淡鎖松膩月。隨風自悠揚標緲林梢雪。

　茶竈石　　　　　　　　　　　　　　　　　　　　　　　　　　　　　　　　蔡廷秀

仙人應愛武夷茶。旋汲新泉煮嫩芽。啜罷驂鸞歸洞府。空餘石竈鎖煙霞。

龍門茶屋圖

倪　瓚

龍門秋月影茶屋白雲泉。不與世人賞瑤草自年年。上有天池水松風舞漣漪。何當躡飛鳧去采池中蓮。

煑茗軒

謝應芳

聚蚊金谷任葷羶煑茗留人也自賢。三百小團陽羨月。尋常新汲惠山泉。星飛白石量敲火煙出青林鶴

上天午夢覺來湯欲沸松風初響竹爐邊。

竹爐

馬瑧

竹爐西日晚來明。桂子香中鶴夢清侍立小童閒不動蕭蕭石鼎煑茶聲。

綠爐詩

孫淑

小閣烹香茗疎簾下玉鉤燈光翻出鼎欵影倒沈甌婢捧消春困親嘗散莫愁吟詩因坐久月轉晚糚樓。

采茶詞

明　高啓

雷過谿山碧雲暖幽叢半吐槍旗短銀釵女兒相應歌筐中摘得誰最多歸來清香猶在手高品先將呈

太守竹爐新焙未得嘗籠盛販與湖南商山家不解種禾黍衣食年年在春雨。

過山家

前　人

流水聲中響繰車板橋春暗樹無花。風前何處香來近隔隖人家午焙茶。

送翰林宋先生致政歸金華　　　　　　　　　　　孫　蕡

紅輕金帶荔枝花三品詞林內相家歸去山中無個事瓦瓶春水自煎茶。

白雲泉煮茶　　　　　　　　　　　　　　　　　　韓　奕

白雲在天不作雨石罐出泉如五乳。追尋能自遠師來。題詠初因白公語。山中知味有高禪採得新芽莊

雨前欲試點茶三昧手上山親汲雲間泉物品由來貴同性骨清肉膩味方永客來如解喫茶去何但令

人塵夢醒。

送茶僧　　　　　　　　　　　　　　　　　　　陸　容

江南風致說僧家。石上清香竹裏茶法藏名僧知更好香烟茶暈滿袈裟。

煎茶圖　　　　　　　　　　　　　　　　　　　徐禎卿

惠山秋淨水泠泠煎其隨身挈小瓶欲點雲腴還按法古藤花底閱茶經。

秋夜試茶　　　　　　　　　　　　　　　　　　前　人

靜院涼生冷燭花風吹翠竹月光華悶來無伴傾雲液。銅葉開嘗紫筍茶。

是夜酌泉試宜興吳大本所寄茶　　　　　　　　　文徵明

一醉思雪乳不能眠活火沙缾夜自煎白絹旋開陽羨月。竹符新調惠山泉。地爐殘雪貧陶穀破屋清風病

玉川莫道年來塵滿腹，小睡寒夢已醒然。

和茅孝若試眇茶歌兼訂分茶之約
<div style="text-align: right">汪道會</div>

昔聞神農辨茶味，功調五臟能益思。北人重酪不重茶，途令齒頰饒韮氣。江東顧渚夙擅名，會稽靈笋君稱羨。日鑄松羅晚歲出吾鄉，幾與虎邱爭市利。評者往往為吳興，清虛談穆有幽致。去年春盡客西冷，茅君遺我一器更寄新篇賦。歟歌蠅頭小書三百字，為言明月峽中生洞山。廟後皆其次，朝采擷不盈筐。阿顏手澤柔羃焙，急然石鼎勢如聆。松上吹，須臾縹碧泛盜甌，菲然鼻觀微芳注。金蕋晨露細碎方，玉泉寒冰詎能配，頓浣枯腸淨掃愁。乍消塵慮醒忘睡，因知品外貴夷羹穠郁均非至，陸羽細碎搏紫芽點難失眞意，常笑令人不如古。此事今人信超詣，馮公已死周郎在，當日風流猶未墜。良友吳與臧，可能不為茲山誌。嗟予耳目日漸衰，老失聰明慚智慧。君能歲贈葉千片，我報除塵常十劑。涼颺杖策尋黃山，倘過陸家茶酒會。

贈歐道士賣茶
<div style="text-align: right">施　漸</div>

靜守黃庭不煉丹，因貧却得一身閒。自看火候蒸茶熟，野鹿銜筐送下山。

某伯子惠虎丘茗謝之

虎丘春茗妙烘蒸，七椀何愁不上升。青箬舊封題穀雨，紫砂新罐買宜興。却從梅月橫三弄，細攪松風

<div style="text-align: center">213</div>

一燈合向吳儂彤管說好將書上玉壼冰。

雨後過雲公問茶事

雨洗千山出氣氣絲滿空開門飛燕子吹面落花風野色行人外經聲流水中因來問茶事不覺過雲東。

居　節

題唐伯虎烹茶圖爲喻正之太守三首

太守風流嗜酪奴行春常帶煑茶圖圖中傲吏依稀似紗帽籠頭對竹爐。

靈源洞口採旗槍五馬來乘穀雨嘗從此端明茶譜上又添新品綠雲香。

王稚登

伏龍十里盡香正近吾家別墅東他日千旄能見訪休將水厄笑王濛。

吳　兆

暮春偶過山家

山村處處採新茶一道春流遶幾家石徑行來微有跡不知滿天是松花。

僧得祥

題詩經室

池邊木筆花新吐牕外芭蕉葉未齊正是欲書三五偈煑茶香過竹林西。

詞

品令　茶詠

宋　黃庭堅

鳳舞團團餅。恨分破教孤另。金渠體淨隻輪慢碾。玉塵光瑩湯響松風早減二分酒病。　味濃香永醉鄉

路成佳境恰如燈下故人萬里歸來對影口不能言心下快活自省。

前　人

一斛珠　前題

紅牙板歇韶聲斷六雲初徹。小槽酒滴真珠竭紫玉甌圓淺浪泛春雪。　香芽嫩茶清心骨醉中襟景與

天闊夜闌似覺歸仙闕走馬章臺踏碎滿街月。

阮郎歸　前題

躍金鞍歸時人倚闌。

前調　煎茶

歌停檀板舞停鸞高陽飲興闌獸烟噴盡玉壺乾香分小鳳團。　雲浪淺露珠圓捧甌春筍寒絳紗籠下

前　人

烹茶留客駐金鞍月斜總外山見郎容易別郎難有人愁遠山。　歸去後憶前歡畫屏金博山一杯春露

前　人

莫留殘與郎扶玉山

解語花　題美人捧茶

中冷年汲穀雨初收寶鼎松聲細柳腰嬌倚熏籠畔鬪把碧旗碾試蘭芽玉藥勾引出清風一縷翠翠蛾

明　王世貞

斜捧金甌暗送春山意。微臭露縈雲髻瑞龍涎尤自沾戀纖指流鶯新脆低低道卯酒可醒還起鬟鬟

古今茶事

215

小婢越顯得那人清麗臨飲時須索先嘗添取櫻桃味。

前調 題前

王世懋

春光欲醉午睡難醒。金鴨沈煙細。畫屏斜倚銷魂處。漫把鳳團剖試。雲翻露蕊早礀破愁腸萬縷傾玉甌

徐上閒堦。有個人如意。坦愛素甃小鬘向璚芽相映寒透纖指柔鶯聲脆香飄勸喚卻玉山扶起銀瓶

小婢偏點綴幾般佳麗憑陸生空說茶經何似儂家味。

蘇幕遮 題夏發茶

雙鬟喚覺江郎起。一片金波誰得似半入松風半入丁香味。

前人

竹牀涼。松影碎沈水香消尤自貪殘睡。無那多情偏著意碧礀旗槍玉沸中泠水。 捧輕甌沾弱醑色授

百字令 試茶穀雨

黃遵昌

春風著意助才華又有一番新致花褪殘紅添綠葉正是困人天氣燕尾翻覷鶯喉宛轉粧點遊春記此

時此景誰念孤清風味。幸有翠葉初抽瓊枝細礀竹裹爐聲沸謖謖松風多逸興諒亦覺家不試雅沁

詩脾幽來琴韻更浣愁人胃名花美酒于中作何位置。

選句

唐李嘉祐晚秋招隱寺東峯茶宴詩萬畦新稻傍山村。數里深松到寺門。幸有香茶留釋子。不堪秋草送王孫。

嚴維奉和獨孤中丞游雲門寺詩異跡焚香對。新詩酌茗論。

陸羽六羨歌。不羨黃金罍。不羨白玉杯。不羨朝入省。不羨暮入臺。千羨萬羨西江水。曾向竟陵城下來。

于鵠贈李太守詩擣茶書院靜。講易藥堂春。

劉禹錫送蘄州李郎中赴任詩雍葉照人呈夏簟。松花滿碗試新茶。

張籍贈合少府詩爲客燒茶竈。教兒掃竹庭。

姚合宿友人山居詩摘花浸酒春愁盡。燒竹煎茶夜臥遲。

章孝標方山寺松下泉詩野客偷煎茗。山僧惜淨牀又送饒州張蒙使君赴任詩日暖持筐依茗樹天陰

抱火入銀坑。

杜牧題禪院詩茶烟輕颺落花風。

許渾送人歸吳興詩春橋懸酒幔。夜檻集茶檣。

喻鳧送潘咸詩賣雪問茶味。當風看鷺行。

薛能閑居新雪詩茶興留詩客瓜情想戍人又寄終南山隱者詩飯後嫌身重茶中見鳥歸。

溫庭筠宿一公精舍詩茶爐天姥客。碁罷刻溪僧。又 贈隱者詩採茶溪樹綠养藥石泉淸。

鄭愚茶詩嫩芽香且靈吾謂草中英夜臼和煙搗寒爐對雪烹惟憑碧粉散常見綠花生。

司空圖重陽日訪元秀上人詩別畫長懷吳寺壁宜茶偏賞霅溪泉。

方干山中言事詩曰奧村家事漸同燒畬掇茗學隣翁又 初歸鏡中寄陳端公詩雲塢採茶常失路雪窗

中酒不開扉。

鄭谷題興善寺詩薛侵隋畫暗茶助越甌深。又 寧中偶題詩亂飄僧舍茶烟濕密邐高樓酒力微。

曹松山中寒夜呈進士許棠詩讀易明高燭煎茶取折冰。

李洞贈昭應沈少府詩華山僧別留茶鼎渭水人來鎖釣船。又 寄淮海慧澤上人詩他日顧師容一榻煎

茶掃地習忘機。

釋無可送邶錫及第歸湖州詩橘青逃暑寺茶長隔湖溪。

皎然陪盧判官水堂夜宴詩愛君高野意烹茗酌淪漣。

宋魏野書友人屋壁詩洗硯魚吞墨烹茶鶴避煙。

黃庭堅新喻道中寄元明詩喚客煎茶山店遠看人秧稻午風涼。

張載登成都樓詩芳茶冠大淸溢味播九區。

元長憲送晳古心往吳江報恩寺詩花雨隨風散茶烟隔竹消。

周砥玉山草堂詩細雨茶烟清晝遲。

謝應芳煮茗軒詩三百小團湯澁月尋常新汲惠山泉。

明周憲王有燉詩澹愁茶煮雙團鳳縈恨香盤九篆龍。

詹同寄方壺道人詩臥雲歌酒德對雨著茶經。

高啓送董湖州詩山籠輸茶至溪船摘茗行又臨頓里詩
穀雨收茶早梅天曬藥忙。

楊基卽景詩小橋小店沽酒新火新烟煮茶又春江對雪
詩莫煮淸資學士茶又立夏前一日詩蟄熟新

絲後茶香煮酒前。

徐賁題周伯陽所居詩花盡繰收蜜烟生正培茶。

魏觀寧國溪上詩鼎沸茶初煮爐香粟自煨。

陳汝言睡起詩漠漠茶烟當戶起丁丁樵響隔林聞王彝
鄮江漁者歌明朝擬入五湖裏且載茶竈尋鴟
夷。

韓奕白雲泉煮茶詩山中知味有高禪采得新芽社雨前
欲試點茶三昧手上山親汲雲間泉又山院詩

入社陶公寧止酒品泉陸子解煎茶。

陳憲章南歸途中先寄諸鄉友詩酒爲老夫開甕盎茗和春露摘旗槍。

魏時敏殘年曹事詩待到春風二三月石鑪敲火試新茶。

陸容送茶僧詩石上清香竹裏茶。

馬中錫旱春自述詩一碗午茶慶醉北半溪春水帶愁東。

邵寶病起山行詩漫道坐來多渴思一茶還待老僧還又寒日懷臥雲上人詩載酒定須三宿返送茶時

復一僧來。

顧清北野同南村訪北花園廢址詩消憂滿貯北海酒破悶亦有南山茶。

唐寅題畫詩春風修禊憶江南酒榼茶鑪共一擔。

王守仁登憑虛閣和石少宰韻松間鳴瑟憼樓鶴竹裏茶烟起定僧。

浦瑾詩暘羡紫茶團小月吳江白苧剪輕霜又開居漫與詩草堂幽事許誰分石鼎茶烟隔戶聞。

文徵明初夏次韻荅石田先生詩方牀醒起茶煙細矮紙詩成小草斜又初夏到遣與詩小憩團扇春寒

盡竹榻茶杯午困醒又雪夜鄭太后送惠山泉詩青箬小壺冰共裹寒燈新茗月同煎又酌泉賦宜與吳

大本所寄茶詩醉思雪乳不能眠活火沙缾夜自煎白絹旋開陽羡月竹符新調惠山泉又與次明道復

汎舟出江村橋飲白雲亭詩殘酒未醒春困劇汲溪聊試雨前茶又過道復束堂時雨後牡丹狼籍存葉

底一花。感而賦詩矮紙凝霜供小草淺甌吹雪試新茶。又夏日閒居詩羽扇茶甌共晚涼。

蔡羽與陸無蹇宿資慶寺詩春隨落花去人自探茶忙。

徐渭謝惠虎丘茗詩虎丘春茗妙烘蒸七椀何愁不上升。

王稺登題唐伯虎烹茶圖爲喩正之太守詩太守風流嗜酪奴行春常帶煑茶圖。又靈源洞口採旗槍五

馬來乘穀雨嘗。

黃居中有澹軒宴集詩茗渚抽烟鳥報春。

袁宏道皇甫仲璋邀飲惠山詩白石靑松，如畫裏臨流乞得惠泉茶。又正月四日張次公先生過遇琴館

留宿對雪卽事詩松蘿頻瀹小春茶。

吳兆法海寺詩烟起炊茶罏聲開汲井甌。

吳鼎芳寄趙凡夫詩十里寒山路香風正採茶。又前溪詩何處茶烟起漁舟繫竹西。

方登自述詩山雲茶屋暖海月竹牕虛。

釋良琦莫春雍熙寺訪沈自誠不遇詩爐存散微篆茗熟獨成斟，

德祥許起宗見過詩雨氣來山北茶香過竹西。又春雪有懷澹然禪師詩寂窣南山下茶烟出樹林。又竹

亭詩花溝安釣艇蕉地著茶瓶。

維則山居四景詩茶罷焚香獨坐時。

道衍茶軒詩晴旭曉微烘遊蜂掠芳藥澹香勻密露繁艷照煙水。

宗林題鐘欽禮所畫雪山江水隱者圖詩道人家住中峯上時有茶烟出薜蘿。

第三輯　故事

方法

李約

兵部員外郎李約，天性嗜茶能自煎。謂人曰：『茶須緩火炙活火煎；』活火謂炭火之焰者也。客至不限甌數，竟日執持茶器不倦。嘗奉使行至陝州硤石縣東，愛渠水清流，旬日忘返（因話錄）

陸鴻漸

陸鴻漸採越江茶，使小奴子看焙。奴失睡，茶燋爍，鴻漸怒以鐵繩縛奴投火中（雲仙雜記）

陸鴻漸

楚人陸鴻漸爲茶論，并煎炙之法，造茶具二十四事以都統籠貯之。常伯熊者因廣鴻漸之法，伯熊飲茶過度，遂患風氣，或云北人未有茶，多黃病後飲病多腰疾偏死。（續博物志）

煎茶加酥椒

德宗好煎茶加酥椒之類。李泌戲曰：『旋末翻成碧玉池，添酥散作琉璃眼。』（事詞類奇）

饌茶

饌茶而幻出物象於湯面者，茶匠通順之藝也。沙門福全生於金鄉，長於茶海，能注湯幻茶成一句詩，共

點四甌，共一絕句，泛乎湯表。小小物類唾手辦耳。（清異錄）

朱蒙

朱蒙，字昧之，別性桂精茶理。先是，岕山茶葉俱用柴焙，蒙易以炭益香冽；又創諸製法，茶遂推岕山第一。

今山中肖像祀每開園日必先祭蒙。其書法亦名家。（太倉州志）

茶百戲

茶至唐始盛。近世有下湯運匕別施妙訣，使湯紋水脈成物象者，禽獸蟲魚花草之屬，纖巧如畫，但須臾

即就散滅，此茶之變也。時人謂之茶百戲。（清異錄）

漏影春

漏影春法用鏤紙貼盞糝茶而去紙，偽為花身，別以荔肉為葉，松實鴨脚之類珍物為藥，沸湯點攪。（清

異錄）

藝茶

藝茶欲茂法如種瓜三歲可采，野者上園者次；陽崖陰林，紫者上綠者次；笋者上芽者次，捲者上舒者次。

用薑

唐人煎茶用薑，故薛能詩云：「鹽損添常戒，薑宜著更誇。」據此，則又有用鹽者矣。近世有用此二物者，輒大笑之。然茶之中等者若用薑煎信佳也，鹽則不可。（東坡志林）

瀹茶

余同年李南金云：「茶經以魚目湧泉連珠為煮水之節。然近世瀹茶鮮以鼎鑊，用瓶煮水，難以候視，則當以聲辨一沸二沸三沸之節。」又陸氏之法以未就茶鑊，故以第二沸為合量而下未若以金湯就茶甌瀹之，則當用背二涉三之際為合量，乃為聲辨之詩云：「砌蟲唧唧萬蟬催，忽有千車捆載來。聽得松風並澗水，急呼縹色綠瓷杯。」其論固已精矣。然瀹茶之法湯欲嫩而不欲老，蓋湯嫩則茶味甘，老則過苦矣。若聲如松風澗水而遽瀹之，豈不過於老而苦哉！惟移瓶去火，少待其沸止而瀹之，然後湯適中而茶味甘，此南金之所未講者也。因補以一詩云：「松風檜雨到來初，急引銅瓶離竹爐。待得聲聞俱寂後，一甌春雪勝醍醐。」（鶴林玉露）

煎法

茶卽藥也。煎服則去滯而化食，以湯點之，則反滯膈而損脾胃，蓋市利者多取他葉，雜以爲末，人多忌於煎服，宜有害也。今法采芽或用碎擘以活水煎之，飲後必少頃乃服。云：「飯後茶甌未要深」此煎之法也。陸羽亦以江水爲上，山與井俱次之，今世不惟不擇水其又入鹽及茶果殊失正味，不知唯葱去昏梅去倦，如不昏不倦亦何必用古人之嗜茶者無如玉川子，未聞煎歃。如以湯點則安能及七碗乎。山谷詞云：「湯響松風早減了七分酒病」倘知此味「口不能言心下快活自省」之禪遠矣。（山家清供）

坡公詩云：「活水須將活火烹」又

蓮花茶

蓮花茶就池沼中早飯前日初出時，擇取蓮花蕊略破者，以手指撥開入茶滿其中，用麻絲縛紮定，經一宿明早連花摘之，取茶紙包曬，如此三次，錫罐歷紮口收藏。（雲林遺事）

藏法

徐茂吳云：藏茶法實茶大甕底，置箬封固倒放，則過夏不黃，以其氣不外泄也。子晉云：常倒放有蓋缸內，缸宜砂底，則不生水而常燥，時常封固不宜見日；見日則生翳損茶性矣。藏又不宜熱處新茶不宜驟用，過黃梅其味始佳。（快雪堂漫錄）

炒茶幷藏法

心一堂　飲食文化經典文庫

鍋令極淨茶要少火要猛以手拌炒令軟潔取出攤匾中略用手揉之揉去焦梗冷定復炒極燥而止不得便入瓶置淨處不可近濕。一二日再入鍋炒令極燥攤冷先以瓶用湯煮過烘燥燒栗炭透紅投瓶中覆之令黑去炭及灰入茶少分投入冷炭將滿實宿箬葉封固厚用紙包以燥淨無氣味磚石壓之置透風處不得傍牆壁及泥地。如欲頻取宜用小瓶。（快雪堂漫錄）

　　處理得宜

採茶欲精藏茶欲燥烹茶欲潔。

茶見日而味奪墨見日而色灰。

品茶：一人得神二人得趣三人得味七八人是名施茶。（岩棲幽事）

　　琉球烹茶

琉球亦曉烹茶設古鼎于几上，水將沸時投茶末一匙，以湯沃之少頃奉飲，味甚清。（太平清話）

　　馮先生

馮開之先生喜飲茶，而好親其事人或問之，答曰：『此事如美人，如古法書畫豈宜落他人手！』聞者歎美之然先生對客談輒不止童子滌壺以待會盛談未及着茶時傾白水而進之先生未嘗不欣然自謂得法客亦不敢不稱善也世號「白水先生」云（梅花草堂筆談）

煎茶

童子鼻鼾故與茶聲相宜。水沸聲喧，致有松風之嘆。夢眼特張，沫濺灰怒，亦是煎茶蹭蹬舟中書。（梅花草堂筆談）

品茶

古人論茶事者，無慮數十家。若鴻漸之經，君謨之錄，可謂盡善。然其時法用熟碾，爲丸爲挺，故所稱有龍鳳團密雲龍瑞雲翔龍。至宣和間，始以茶色白者爲貴，漕臣鄭可聞，始創爲銀絲冰芽以茶剔葉取心清泉漬之去龍腦諸香，惟新跨小龍蜿蜒其上稱龍團勝雪，當時以爲不更之法。而吾朝所尚又不同，其烹試之法亦與前人異。然簡便異常，天趣悉備可謂盡茶之眞味矣。至於洗茶候湯擇器皆各有法甯特侈言烏府雲屯苦節建城等目而已哉！（長物志）

岕

浙之長與者佳，價亦甚高，今所最重。荆溪稍下。採茶不必太細，細則芽初萌而味欠足。不必太青，青則茶已老而味欠嫩。惟成梗帶葉綠色而團厚者爲上不宜以日晒，炭火焙過扇冷以箬葉襯器貯高處。蓋茶最喜溫燥而忌冷溼也。（長物志）

洗茶

先以滾湯候少溫洗茶，去其塵垢以定碗盛之俟冷點茶，則香氣自發。（長物志）

候湯

緩火炙活火煎。活火謂炭火之有焰者。始如魚目爲一沸，緣邊泉湧爲二沸，奔濤濺沫爲三沸。若新火方交水釜纔熾急取旋傾，水氣未消謂之嫩若水踰十沸湯已失性謂之老皆不能發茶香。（長物志）

古茶

古時之茶曰煮曰烹曰煎須湯如蟹眼茶味方中今之茶惟用沸湯投之稍着火卽色黃而味澀不中飲矣。酒知古今之法亦自不同也。（廣陽雜記）

以花點茶

花點茶之法以錫瓶置茗雜花其中隔水煮之，一沸卽起，令乾，將此點茶，則皆作花香：梅、蘭、桂、菊、蓮、茉莉、玫瑰、薔薇、木樨、橘諸花皆可。諸花開時摘其半含半放之蕊，其香氣全者量茶葉之多少以加之，花多則太香而分茶韻花少，則不香而不盡其美必三分茶葉一分花而始稱也。（清稗類鈔）

梅花點茶

梅花點茶者梅將開時，摘半開之花帶蒂置於瓶，每重一兩，用炒鹽一兩洒之，勿用手觸，必以厚紙數重，密封之置陰處次年取時先置蜜於盞然後取花二三朵沸水泡之，花頭自開而香美。（清稗類鈔）

蓮花點茶

蓮花點茶者以日未出時之半含白蓮花，撥開放細茶一撮，納滿蕊中以麻皮略繫令其經宿，明晨摘花，傾出茶葉用建紙包茶焙乾，再如前法隨意以別蕊製之焙乾收用。（清稗類鈔）

茉莉花點茶

茉莉花點茶者以熟水半杯候冷鋪竹紙一層，上穿數孔，日暮採初開之茉莉花，綴於孔上用紙封，不令泄氣，明晨取花簪之，水香可點茶。（清稗類鈔）

玫瑰花點茶

玫瑰花點茶者取未化之燥石灰，研碎鋪罐底隔以兩層竹紙置花於紙，封固，俟花間淫氣盡收極燥，取出花置之淨錫以點茶香色絕美。（清稗類鈔）

桂花點茶

桂花點茶法與上同。（清稗類鈔）

香片茶

茶葉用茉莉花拌和而窨藏之，以取芳香者謂之香片。然羣芳譜云上好細茶忌用花香，反奪眞味，是香片在茶中實非上品也。然京津間人皆嗜飲之。（清稗類鈔）

230

馮正卿論烹茶

馮正卿名可賓，益都人，明湖州司理，入國朝隱居不士；嗜茶，曾著岕茶牋，其論烹茶云：先以上品泉水滌烹器，務鮮務潔，次以熱水滌茶葉，水不可太滾滾則一滌無餘味矣。以竹筋夾茶，於滌器中反復滌蕩去塵土黃葉老梗，使淨。以手搦乾寘滌器中蓋定少頃開視色青香烈急取沸水澆之。夏則先貯水而後入茶葉，冬則先貯茶葉而後入水。

飲茶之所宜者一無事二佳客三幽坐四吟詩五揮翰六徜徉七睡起八宿酲九清供十精舍十一會心，十二賞鑒十三文僮。

飲茶亦多禁忌一不如法二惡具三主客不韻，四冠裳苛禮，五葷肴雜陳六忙宂，七壁間案頭多惡趣。

（清稗類鈔）

馮正卿嗜飲岕茶

飲岕茶者壺以小爲貴每一客則一壺，任其自斟自飲方爲得趣。蓋壺小則香不渙散，味不耽閣況茶中香味，不先不後只有一時太早則未足太遲則已過見得恰好一瀉而盡化而裁之存乎其人施於他茶亦無不可。此馮正卿之言也。（清稗類鈔）

楊道士善煮茶

平湖道士楊某善煮茶，其術取片紙以硃書符入爐焚之，紅光爛然筆盡都成烈火比移鐺卽作松風聲，旋作蟹眼沸矣。客或不知者曰勿煩再煮則火頓熄。（清稗類鈔）

孝欽后飲茶

宮中茗盌以黃金爲托白玉爲盌。孝欽后飲茶喜以金銀花少許入之甚香。（清稗類鈔）

工夫茶

閩中盛行工夫茶，粵東亦有之蓋閩之汀漳泉粵之潮凡四府也烹治之法本諸陸羽茶經，而器具更精。爐形如截筒，高約一尺二三寸以細白泥爲之。壺出宜興者爲最佳圓體扁腹努嘴曲柄，大者可受半升許。所用盃盤多爲花瓷，內外寫山水人物極工緻，類非近代物。爐及壺盤各一惟盃之數，則視客之多寡。盃小而盤如滿月，有以長方磁盤置一壺四盃者且有壺小如拳盃小如胡桃者。此外尚有瓦鐺棕墊紙扇竹夾製皆樸雅。壺盤與盃舊而佳者，先將泉水貯之鐺，用細炭煎至初沸，投茶於壺而冲之，蓋定復徧澆其上，然後斟而啜之。其飽客也，客至將啜茶則取壺，先取涼水漂去茶葉塵滓乃撮茶葉置之壺注滿沸水旣加蓋，乃取沸水徐淋壺上，俟水將滿盤覆以巾久之始去巾注茶盃中奉客，客必銜盃玩味若飲稍急主人必怒其不韻也。

閩人邱子明篤嗜之。其法先置玻璃甕於庭，經月，輒汲新泉水滿注一甕烹茶一壺越宿卽棄之，別汲以

注第二甌。侍僮數人供爐火，爐以不灰木製之，架無煙堅炭於中，有發火機以器焫之，熾矣。壺皆宜興砂

質，每茶一壺需爐銚三。湯初沸爲蟹眼，再沸爲魚眼，至聯珠沸而熟，湯有功候，過生則嫩，過熟則老，必如

初寫黃庭，恰到好處。其烹茶之次第一銚，水熟注空壺中盪之潑去，第二銚，水已熟預置酌定分兩之

葉於壺，注水以蓋覆之，置壺於銅盤中；第三銚水又熟，從壺頂灌其四周，茶香發矣，注茶以甌甚小，客至，

餉一甌，令其汩滴而咂嚼之，若能陳說茶之出處功効，則更烹尤佳者以進。（清稗類鈔）

　　茗飲時食鹽薑葵菔

長沙茶肆凡飲茶者旣入座，茶博士即以小碟置鹽薑菜菔各一二片以餉客。客於茶資之外，必別有所

酬。（清稗類鈔）

又有以鹽薑豆子芝蔴置於中者曰芝蔴豆子茶。（清稗類鈔）

　　茗飲時食餚

鎮江人之啜茶也，必佐以餚，餚即饌也，凡饌皆可曰餚，而此特假之以爲專名。餚以豬豚爲之，先數日漬

以鹽，使其味略鹹，色白如水晶，切之成塊，於茗飲時佐之甚可口，不覺其有脂肪也。（清稗類鈔）

　　茗飲時食乾絲

揚州人好品茶清晨即赴茶室枵腹而往，日將午始歸就午餐，偶有一二進點心者，則茶癖猶未深也。蓋

揚州啜茶例有乾絲以佐飲亦可充飢乾絲者縷切豆腐乾以爲絲瀹之加蝦米於中調以醬油廂油也。

食時蒸以熱水得不冷。（清稗類鈔）

水泉

陸張

陸龜蒙嗜茶置園顧渚山下歲取租茶自製品第張又新爲冰說七種其二惠山泉三虎丘井六松江人

助其好者雖百里爲致之。（唐書隱逸傳）

陳知新

陳知新以朝散大夫知州事始歐陽至滁得醴泉於醉翁亭東南一日讌僚佐有獻新茗者公敕汲泉瀹

之汲者道仆覆水僞汲他代之公窮問之乃得泉幽谷山下名曰豐樂作亭其上其好奇如此。（滁州志）

七寶泉

光祿徐達左橋龔賢樓于鄧尉山中一時名士多集于此雲林爲猶數焉常使童子入山擔七寶泉以前

桶煎茶後桶濯足人不解其意或問之。曰：『前者無觸故用煎茶後者或爲泄氣所穢故以爲濯足之用

耳』（駒陰冗記）

活水

東坡汲江水煎茶詩云：「活水還須活火烹自臨釣石取深清。大瓢貯月歸春甕，小杓分江入夜瓶」此詩奇甚道盡烹茶之要且茶非活水則不能發其鮮馥東坡深知此理矣。余頃在富沙嘗汲溪水烹茶，香味俱成三絕又況其地產茶爲天下第一宜其水異于他處，用以烹茶水功倍之，至於浣衣尤更潔白，則水之輕清益可知矣近城山間有陸羽井水亦清甘實好事者名之羽著經言建州茶未得詳則知羽不曾至富沙也。（茗溪漁隱叢話）

味潭水

蘇子由鳳味石硯銘云：北苑茶冠天下，歲貢龍鳳團，不得鳳凰山味潭水，則不成潭中石苔黑堅緻如玉，以爲研與筆墨宜世初莫知也。熙寧中太原王顥始發其妙吾兄子瞻始名之。然石性薄，即厚者不及徑寸，最後得此，長博豐碩，蓋石之傑也。子瞻方爲易傳日劬于前，與有功焉；故特援筆凝神而爲之銘曰：「陶土塗鑒崖石元之蠹穎之賊涵清泉閟重谷聲如銅色如鐵性滑堅善凝墨。」茗溪漁隱曰予爲閩中漕幕常被檄於北苑修貢蓋熟知其地掉西伯。發祕藏與有力。非相時誰爲出」矣。造茶堂之後鳳凰山之麓有一泉覆以華屋榜曰御泉，其廣三四尺深五六尺，石甃其底止留泉眼特一小井耳泉之東西二十餘步間兩山回抱各有小淺澗水流出其水皆可造茶，即無深水瀦蓄匯以爲

潭者，子由所言唻潭其地初無之，又安得潭中石蒼黑堅緻如玉，以為研乎又云，歲貢龍鳳團，不得鳳凰

山唻潭水，則不成此言愈誤也。子瞻亦云，建州鳳凰山，如飛鳳下舞之狀，山下有石聲如銅鐵作研至美

如有肩理此殆玉德也疑其太滑然至溢墨，熙寧五年，國子博士王頤始知以為研，而求名於余余名曰

鳳味又云僕好用鳳味石研然議者異同蓋少得真者皆為黯灘石所亂，盡出於逐利之所為。余以叢話

前集已辨鳳味研出於北苑，乃劍浦黯黮灘石。蘇氏伯仲為王頤所紿信以為然，故反以此灘之石為亂

真耳。（茗溪漁隱叢話）

南雪水

茗溪漁隱曰：張又新煎茶水記云：代宗朝李季卿刺湖州，至維揚，逢陸處士鴻漸李素熟陸名，有傾蓋之

懽，因之赴郡抵揚州驛將食，李曰陸『君善於茶蓋天下聞名矣況揚子南零水又殊絕今者二妙千載

一遇可曠之乎』令軍士謹信者挈瓶操舟深詣南零陸執器以俟之俄水至，陸以杓揚其水曰：『江則

江矣非南零者似臨岸之水。』使曰『某榷舟深入見者累百敢虛給乎』陸不言既而傾諸盆至半，陸

遽止之乃以杓揚之曰：『自此南零者矣。』使蹶然大駭馳下曰：『某自南零賚至岸舟蕩覆半愧其少，

把岸水增之。處士之鑒神鑒也其敢隱焉』李與賓從數十人皆大駭愕又蘇長公惠通井記云：『禹貢

濟水入於河，溢為滎，河南曰滎陽河北曰滎驛。沱潛本梁州二水亦見於荊州。水行地中出沒數千里外，

雖河海不能絕也。」唐相李文饒好飲惠山泉，置驛以取水。有僧言長安天觀井水，與惠山泉通，雜以他水十餘缶試之僧獨指其二缶曰：『此惠山泉水也。』文饒為罷水驛二事頗相類故併錄之。（茗溪漁隱叢話）

　　雙井

冷齋夜話云：海南城東，有兩井相去咫尺而異味，號雙井；井源出曲石罅中。東坡酌水異之曰：『吾尋白龍不見，今知家此水中乎？』同游者怪問其故曰『白龍常為東坡出請徐待之』俄見其脊尾如生銀蛇狀忽水渾有雲氣浮水面舉首如插玉筋乃泳而去。余至二井太守張子修為造庵井上號思遠亭名洞酌岸有怪樹樹枝之腋，有詩曰：「巖泉末入井蒙然冒沙石泉嫩凹為髓石老生罅隙異言寸波中露此橫海脊先生酌泉笑泉香神龍蟄舉首玉筋插忽去銀丁擲大身何時布天矯翔霹靂誰言鷗背大更覺宇宙窄字畫如顏書無名銜年月。」此詩氣格似東坡，而言泉嫩石老似非東坡；又語散漫疑學者為之也龍如蛇形小如玉筋。（茗溪漁隱叢話）

　　谷簾泉

余嘗酌中泠劣于惠山殊不可解後考之，乃知陸羽原以廬山谷簾泉為第一。山疏云：「陸羽茶經言瀑瀉湍急者勿食。」今此水瀑瀉湍急無如矣乃以為第一，何也又雲液泉在谷簾泉側山多雲母泉其液

也。洪纖如指，清冽甘寒，遠出谷簾之上，乃不得為第一，又何也（太平清話）

為賓主始雙翠衾丈之沼疏為懸流，使瀑布下鍾甘流淜激惠泉蓋自唐始。」（太平清話）

獨孤及慧山新泉記云：「無錫令敬澄字源深，考古篆圖，有客陸羽，多識名山大川之名與此峯白雲相

惠泉

禊泉出城中，水遞者日至。藏獲到庵借炊，索薪索菜米後酒索肉無酒肉輒揮老拳，僧苦之無計脫

此苦，乃罪泉，投之芻穢不已，乃決溝水敗泉泉大壞。張子知之，至禊井命長年浚之。及半見竹管積其下，

皆熟脈作氣。見芻穢又作奇臭。張子漱洗數次，俟泉至。泉實不壞又甘冽。張子去僧又壞之不旋踵

至再至三，卒不能救，禊泉竟壞矣。是時，食之而知其壞者半食之之不知其壞而仍食之者半食之之知其壞

而無泉可食，不得已而仍食之者半。是時，有稱陽和泉者，張子試之，空靈不及禊，而清冽過之。特

以玉帶名不雅馴，張子謂陽和嶺實為余家祖慕誕生我文恭遺風餘烈，昔孤山泉出東坡

名之六一今此泉名之陽和，至當不易，蓋生嶺生泉俱在文恭之前，不待文恭而天固已陽和之矣夫復

何疑。土人有好事者，恐玉帶失其姓，遂勒石署之且曰：「自張志禊泉而禊泉為張氏有今琶山是其祖

塋擅之益易立石署之權其奪也。」時有傳其語者，陽和泉之名益著銘曰：「有山如礪，有泉如砥，太史

陽和泉

心一堂　飲食文化經典文庫

遺烈，落落磊磊孤嶼溢流，六一擅之千年巴蜀，寶繁其齒。」但言眉山自屬蘇氏。（陶庵夢憶）

中泠泉

金山中泠泉又曰龍井，水經品為第一舊嘗波險中汲汲者患之。僧於山西北下穴一井以給游客又不微堂前一井與今中泠相去又數十步而水味迥劣按泠一作零又作灜太平廣記李德裕使人取金山中泠水蘇軾蔡肇並有中泠之句。雜記云石碑山北謂之北灜，釣者餘三十丈則中泠之外似又有南零北灜者潤州類集云江水至金山分為三泠今寺中亦有三井其水味各別，疑似三泠之說也。（偃曝餘談）

婆娑泉

婆娑泉出思恩縣，形如玉白潔似清冰，飲者呼之渴盡（作消渴）一本則止一人千人亦復如是。（赤雅）

漱玉泉

漱玉泉出白石洞天每鐘鼓勤則踴躍而來，聲歇隨縮三泉靈異可與壽州咄泉，茅山喜（作嘉）（一本 客泉撫掌泉）無為州笑泉並入靈品。（赤雅）

運水

昨曹幼安遣訊書尾云：「且運第二泉，六月後當還。」乃領報乞水之便，無甚於此而某不知寄罈缸上，

少可十斛。其明日，奴子以泉酒告，方悔之。然俟其歸可稅也。朝來索報則又忘之矣。吾每日科頭起，都是噉粥想喘喘思茶耳，而念不及泉，此何故歟？僧孺曰：『爲懶而忘之者性也，爲念不及泉而忘之者境也。』某笑曰：『願以性』。（梅花草堂筆談）

惠登山

瓊州三山庵，有泉味類惠山蘇子瞻過之，名之曰「惠通。」二年前有鉤惠水者淡惡如土心疑之聞之客云，有富者子亂決上流幾害泉脈久乃復之，味如故矣泉力能通數千里之外乃不相渾于咫尺之間此惠之所以常貴也歟！李文饒置水驛以汲惠泉，而不知脈在長安昊天觀下。鮮能知味，大抵然耳今日與鄒公履茹紫房陳元瑜登惠山，酌泉飲之，因話其事。顧謂桐曰：『凡物行遠者必不雜豈惟水哉！』時丙午冬仲十二日月印梁溪風緩緩着聽松上。

公履再命酒數酌頹然別去。（梅花草堂筆談）

移喜泉

朱方黠宅有喜泉，每齋中惠泉竭，輒取之，其味故在季孟間。而炊者不知，悉以供盥濯賞耳賤目，古今智恐一也。（梅花草堂筆談）

山谿泉

山谿橋有新泉，味極冷澈，日可濡百十戶。聞之僧孺云，雨露且訪之。（梅花草堂筆談）

井竭

井竭多作淡鹹味，然猶不惡。取之鹹井，直鹽水矣。往時不飲井水，必惠必寶雲，必天泉，此念竟安往哉。童子提一甖絵炊，意頗祕某亦欣然啜之。舌端權衡固在政作古人點茶觀耳。（梅花草堂筆談）

運水

有人運惠水于白下而車致之，句曲者且誇于衆。明日常會茶車至而亡其水，主人詰之，對曰：『相公故運竭耳，水何運焉！』坐客大笑，主人怒不止。然因是以水癖聞，拙者之功不可沒也。戊申四月十五日，

榜人頋三能，為予買鰣置水得二十斛喜甚戲書所聞貽之。（梅花草堂筆談）

洞山茶

王祖玉貽一時大彬壺，平平耳。而四維上下虛空色色可人意。今日盛洞山茶，酌已，飲倩郎，問此茶何似。

答曰：『似時彬壺』予輒然洗盞更酌飲之。（梅花草堂筆談）

試茶

茶性必發于水，八分之茶，遇水十分，茶亦十分矣。八分之水，試茶十分，茶只八分耳。貧人不易致茶尤難得水。歐文忠公之故人有懷中冷泉者公詫曰：『某故貧士，何得致此奇貺？』其人謙謝請解所謂公熟

視所饋器，徐曰：『然則水味盡矣。』蓋泉洌性駛，非局以金銀，未必不破器而走故曰貧士不能致此奇

覩也。然予聞中泠泉故在郭璞慕慕上有石穴轉取竹作筒，鉤之乃得。郭墓故當急流間，難爲力矣。況必

金銀器而後味不走乎貧人之不能得水亦審矣予性蓋拙茶與水皆無揀擇而云然者今日試茶聊爲

茶語耳。（梅花草堂筆談）

天泉

秋水爲上梅水次之。秋水白而洌梅水白而甘春冬二水，春勝於冬。蓋以和風甘雨故。夏月暴雨不宜，或

因風雷蛟龍所致最足傷人雪爲五穀之精取以煎茶最爲幽況。然新者有土氣稍陳乃佳承水用布於

中庭受之不可用簷溜（長物志）

地泉

乳泉漫流，如惠山泉爲最勝，次取清寒者泉不難於清而難於寒土多沙膩泥凝者，必不清寒又有香而

甘者然甘易而香難未有香而不甘者也瀑湧湍急者勿食食久令人有頭疾。如廬山水簾，天台瀑布以

供耳目則可入水品則不宜溫泉下生硫黃亦非食品（長物志）

流水

江水取去人遠者，揚子南泠，夾石渟淵，特入首品。河流通泉竇者必須汲置，候其澄澈，亦可食。（長物

（志）

丹泉

名山大川仙翁修煉之處。水中有丹，其味異常能延年却病。此自然之丹液，不易得也。（長物志）

水樹

喇嘛國僧至京師，其所經塞外地，累月無泉。道旁有樹，槲膚高大，僧渴則以佩刀刲之，輒水出如注，飲之清甘。駝馬亦給。抽刃水止，樹膚復合，不知其何名也。（甌臍）

百花潭水

百花潭有巨石三，水流其中，汲水煎茶，清冽異他水。（隴蜀餘閒）

夾錫錢鎮水

汝州之治諸井皆以夾錫錢鎮之，每井率數十千，問其故，一老兵曰：『此邦饒風沙，沙入井中，人飲之則成癭。夾錫錢所以治沙土也。』楮記室曰因思惠山泉清甘於二浙者以有錫也。余謂冰與茶之性最相宜，錫餅貯茶葉香氣不散。錫壺煎水久則土下沈皆成鹹也。（廣陽雜記）

黃河水

子騰言黃河之水，泥沙在上其下乃清流也。靖逆侯張勇令人於蘭舟橋施百尺之緪，而沈桶於底桶上

有蓋以機約之桶至底而機張，蓋啓水入，緻之而上，則機復閉其蓋，濁水絲毫不混也以之烹茶美過金

山第一泉矣。（廣陽雜記）

中泠泉記

中泠伯芻所謂第一泉也。昔人遊金山吸中泠胸腋皆有仙氣其知味者乎。庚辰春正月，予將有澄江之行初四日，自眞州抵潤州舟中望金山波心一峯，突兀雲表飛閣流丹夕陽映紫躊躇不肯艤岸但不知中泠一勺清澈何所耳次日覓小舟破浪登山周石廊一匝聽濤聲嗡咳激石哮吼迤邐從石磴陟第二層穿茶肆中數折得見世所謂中泠者瓦亭覆井石龍蟠井闌鱗甲飛動寺僧爭汲井水入肆。吳人謂錢神誕爭詣寺中爲壽摩肩連袂不下數萬人茶坊滿不納客凡三往得伺便飲數甌細啜之味與江水無異予心竊疑之默然起履巉陟險窮盡金山之勝力疲小憩仰觀石上蒼苔剝蝕中依稀數行磨刷認之乃知古人所品別在郭璞墓間其法於子午二辰用銅瓶長綆入石窟中，尋若千尺始得眞泉。若淺深先後少不如法即非中泠正味不禁爽然汗下浹背然亦無從得銅瓶長綆如古人法俯汲之而飲之也。郭公爪髮故在山足西南隅，洪濤巨浪中亂石嶙森森若奇鬼異獸去金山數武而徘徊踟躕空復望洋蓋杳乎不可卽矣日暮歸舟悒怏若有所失自恨不逮古人。佛印談禪坡公解帶爾時酒甕茶鐺，皆挾中泠香氣奈何不獲親見之也越數日舟自澄江還同舟憨道人者有物藏破衲中琅琅有聲索視

心一堂　飲食文化經典文庫

之，則水葫蘆也。朱中黃外徑五寸許，高不盈尺，傍三耳，銅紐連環，及丈餘三分入環，耳中一縷勾蓋上銅圈，上下隨縷機轉動，銅丸一枚，繫葫蘆傍其一綰蓋上。怪問之，祕不告人，良久謂余曰：『能從我乎？願分中泠一舫。』予躍然起拱手敬謝，遂別諸子從道人上夜行船，兩日抵潤州，則譙鼓鳴矣。是夕上元節，雨後遲月出不見。然天光初霽不甚晦冥鼓三下，小舟直向郭墓石。五六步石竇洞洞然道人曰：『此中泠泉窟也』取葫蘆沉石窟中，銅九傍鎮，葫蘆橫側。下約丈許道人發繩上機則銅九中鎮葫蘆仰盛又發第二機則蓋下覆之篘圍若膠漆不可解，乃徐徐收銅繩啓之，水盎然滿。亟旋舟就岸烹以瓦鐺須臾沸起，就道人瘦瓢微吸之，但覺清香一片從齒頰間沁人心胃，二三盞後則薰風滿頤頤覺塵襟滌淨乃哨然曰：『水哉水哉古人誠不我欺也！嗟乎，天地之靈秀有所聚必有所藏乃至扶而為山穴而為泉山不徒山而峙於江心泉不徒泉而萃乎江水屑罌之下，而顧令屠狗賣漿菜傭倉父皆得傾頃茲山味茲泉則人人皆有仙氣矣。今古以來，眞才埋沒腎鼎爭傳獨中泠泉也乎哉！』次日辰刻道人別去予亦發棹渡江。而鄰舟一貴介方狐裘箕踞，命俊童敲火煑井上中泠未熟也道人姓張，其先蓋閩人云。

張山來曰：吾鄉趙桓夫先生謂金山江心水與郭璞墓無異。因以兩巨舟相並，中離二尺許，以大木橫絚其上中亦空二尺許，如井狀。以有蓋錫罌一，上繫大長繩，別一小長繩繫其蓋，繩之長凡若干丈縋於井。

繩盡，先曳小繩起其蓋，而水已滿甖徐曳大繩，則所汲皆江心水矣，想以郭璞墓不得其汲之法耳若

遇此道人效其製當更佳也。（虞初新志）

玉泉雪水

高宗純皇帝巡蹕所至，製銀斗命內侍精量泉水京師玉泉山之水斗至一兩塞上伊遜之水亦如之其

餘諸水濟南珍珠重逾二厘揚子江金山下中泠重逾三厘惠山虎跑各重逾四厘平山重逾六厘清涼

山白沙虎邱及西山之碧雲寺各重逾一分遂定玉泉為第一作玉泉山天下第一泉記又量雪水較玉

泉輕三厘遇佳雪必收取以松實梅英佛手烹茶謂之三清嘗於重華宮集延臣及內庭翰林等聯句賦

三清茶詩天章昭煥洵為昇平韻事。（冷廬雜識）

品泉

唐宋以還古人多講求茗飲，一切湯火之候，瓶盞之細，無不考索周詳著之為書。然所謂龍團鳳餅皆須

碾碎方可入飲，非惟煩碎弗便，即茶之真味恐亦無存其直取茶芽投以淪水即飲之者，不知始自何時。沈

德符野獲編云：「國初四方供茶以建寧陽羨為上時猶存制所進者俱碾而揉之為大小龍團至洪

武二十四年九月，上以重勞民力罷造龍團惟採茶芽以進其品有四日探春日先春日次春日紫筍置

茶戶五百充其徭役。」乃知今法實自明祖創之真可令陸鴻漸蔡君謨心服憶余嘗再游武夷在各山

頂寺觀中，取上品者以嚴中瀑水烹之，其芳廿百倍於常時，固由茶佳，亦由泉勝也。按品泉始於陸鴻漸

然不及我朝之精。記在京師，恭讀純廟御製玉泉山天下第一泉記云：「嘗製銀斗較之京師玉泉之水，

斗重一兩，塞上伊遜之水亦斗重一兩二厘；濟南珍珠泉，斗重一兩二厘；揚子金山泉，斗重一兩三厘則較玉

泉重二厘三毫矣。至惠山虎跑則各重玉泉四厘，平山重六厘，清涼山白沙虎邱，及西山之碧雲寺各重玉

玉泉一分」然則更無輕於玉泉者乎曰有，乃雪水也。常收積素而烹之，較玉泉斗輕三厘。雪水不可恆

得，則几出山下而有列者誠無過京師之玉泉，故定爲天下第一泉。（歸田瑣記）

以水洗水

世以鎮江城西北石山簿東之中冷泉水爲通國第一，然高宗嘗製一銀斗以品通國之水，則以質之輕

重分水之上下乃遂定京師海淀鎮西之玉泉爲第一，而中冷次之，無錫之惠泉杭州之虎跑又次之。此

外惟雪水最輕可與玉泉並，然自空下，非地出故不入品。鑾輅時巡，每載玉泉水以供御，然或經時稍久，

舟車顚簸色味或不免有變，可以他處泉水洗之。一洗則色如故爲其法以大器儲水，刻分寸入他水攪

之，攪定則汚濁省沈澱於下，而上面之水清澈矣蓋他水質重則下沈；玉泉體輕，故上浮挹而盛之不差

錙銖，古人淄澠之辯良有以也。（清稗類鈔）

京師飲水

古今茶事

247

京師井水多苦茗具三日不拭則滿積水鹼然井亦有佳者安定門外較多而以在極西北者爲最其地
名上龍又若姚家井及東長安門內井與東廠胡同西口外井皆不苦而甜凡有井之所謂之水屋子每
日以車載之送入家曰送甜水以爲所飲若大內飲料則專取之玉泉山也。（清稗類鈔）

王文簡以第二泉餉友

王文簡自淮上遺揚州靑籠畫舫乘風南下與汪某相値於秦鄧湖遙語曰有事欲附致家博士及遺信
至乃寄舫中所有第二泉四罌而已某以道遠稍難之文簡攢眉曰汪大乃成俗吏。（清稗類鈔）

章次白試第一泉

仁和章次白廣文坤嘗登金山寺試第一泉而懷許楮因此詩云：「衝寒獨倚江天閣瀹若評第一泉。
忽憶詩人許丁卯香浮綠雪竹鑪邊」（清稗類鈔）

陳香泉飲香泉

海寧陳香泉太守奕禧令深澤時飲泉廿之作亭其上署曰香泉因以自號。（清稗類鈔）

烹茶須先驗水

欲烹茶須先驗水可貯水於杯以酒精溶解肥皂滴三四點如爲純粹之水則澄清如故倘含有雜物必
生白泡又法貯水於杯加礬砂少許水惡則濁水良則淸。

心一堂　飲食文化經典文庫

若無良水，亦可化惡爲良，如井水之有鹹味者，或洇濁之水，旣煮沸置數小時，汚物悉沈於底，再取其上之澄清者煮沸數次遂成良水。

烹時須活火活火煮者有焰之炭火也旣沸以冷水點住，再沸再點，如此三次色味俱進。（清稗類鈔）

松柴活火

浙蒨菜秩滿將入都，受藎王善煮之賜，令輦致杭州虎跑泉水百甕爲煎茶之用。某病其瑣，意且謂蕭亦耳食耳，至滬乃市西人之濾水器載以往，至京即取都中水濾之以進。蕭諳其贗，會某入謁語之曰『吾果得眞虎跑水，當以松柴活火煎之矣』（清稗類鈔）

地域

傾筐會

僞閩甘露堂前兩株茶鬱茂婆娑，宮人呼爲淸人樹。每春初，嬪嬙戲摘新芽，堂中設傾筐會。（清異錄）

武陵茶

武陵七縣通出茶最好。（荆州土地記）

蒙山

古今茶事

名山縣出茶，有山曰蒙山，聯延數十里，在縣西南。按拾遺志：尚書所謂蔡蒙旅平者蒙山也，在雅州凡蜀茶盡出此。（雲南記）

大茗

丹丘出大茗，服之生羽翼。（天台記）

占城國

占城國地不產茶，亦不知醞釀之法。（宋史占城國傳）

闍婆國

闍婆國地不產茶。（宋史闍婆國傳）

北苑

北苑置使領之。（夢溪筆談）

北苑

古人論茶唯言陽羨、顧渚、天柱、蒙頂之類，都未言建溪。然唐人重串茶粘黑者，則已近乎建餅矣。建茶皆喬木，吳蜀淮南唯叢茭而已，品自居下，建茶勝處曰郝源曾坑，其間又岔根山頂二品尤勝，李氏時號為建茶之美者號北苑茶，今建州鳳凰山，土人相傳謂之北苑。言江南嘗置官領之，謂之北苑使。予因讀李

後主文集有北苑詩及文記，知北苑乃江南禁苑，在金陵，非建安也。江南北苑使，正如今之內園使，李氏時有北苑使，善製茶，人競貴之謂之北苑茶。如今茶器中有學士甌之類皆因人得名非地名也。丁晉公謂北苑茶錄云：「北苑里名也。」今曰龍焙又云苑者天子園圃之名，此在列郡之東隅綠何卻名北苑，丁亦自疑之。蓋不知北苑茶本非地名始因慢傳自晉公寘之於書至今遂謂之北苑。（補夢溪筆談）

白鶴茶

灉湖諸山舊出茶謂之灉湖茶李肇所謂岳州灉湖之含膏也。唐人極重之，見於篇什今人不甚種植，惟白鶴僧園有千餘本土地頗類北苑，所出茶一歲不過一二十兩土人謂之白鶴茶味極甘香非他處草茶可比並茶園地色亦相類但土人不甚植爾（岳陽風土記）

北苑

北苑茶正所產，為曾坑，謂之正焙，非曾坑為沙溪謂之外焙二地相去不遠，而茶種懸絕沙溪色白過於曾坑，但味短而微澀，識茶者一啜，如別涇渭也。余始疑地氣土宜不應頓異如此，及來山中，每開關徑路，剗治岩竇，有尋丈之間土色各殊，肥瘠緊緩燥潤亦從而不同，並植兩木於數步之間，封培灌溉路等而生死豐瘁如二物者然後知事不經見不可必信也。草茶極品惟雙井顧渚，亦不過各有數畝。雙井在分寧縣其地屬黃氏魯直家也。元祐間，魯直力推賞於京師，族人交致之，然歲僅得一二斤爾。顧渚在長興

縣，所謂吉祥寺也，其半爲今劉侍郎希范家所有。兩地所產歲亦止五六斤。近歲寺僧求之者多不暇精擇不及。劉氏遠甚。余歲求於劉氏過半斤則不復佳。蓋茶味雖均，其精者在嫩芽，取其初萌如雀舌者，謂之槍，稍敷而爲葉者謂之旗，旗非所貴，不得巳取一槍一旗猶可過是則老矣，此所以爲難得也。（避暑錄話）

木女觀

木女觀望州等山茶茗出焉。（夷陵圖經）

義與茶

唐茶惟湖州紫筍入貢。每歲以清明日貢到先薦宗廟，然後分賜近臣。紫筍生顧渚，在湖常二境之間。當探茶時，兩郡守畢至。最爲盛集。此蔡寬夫詩話之言也。蔡但知其一而不知其二。按陸羽茶經云：「浙西以湖州上，常州次」湖州生長與縣顧渚山中，常州義與縣，生君山懸腳嶺北峯下。唐義與縣重修茶舍記云：義與貢茶非舊也。前此故御史大夫李栖筠實典是邦。山僧有獻佳茗者，會客嘗之。野人陸羽以爲芬香甘辣冠於他境可薦於上。栖筠從之，始進萬兩。此其濫觴也。厥後因之，徵獻浸廣，遂爲任土之貢與常賦之邦侔矣。故玉川子詩云：「天子須嘗陽羨茶，百草不敢先開花」正謂是也。當時顧渚義與皆貢茶，又鄰壤相接，白樂天守姑蘇，聞賈常州崔湖州茶山境會想羨歡宴因寄詩云：「遙聞境會茶山夜珠

翠歌鐘俱遶身盤下中分兩州界，燈前合作一家春。青娥遞舞應爭妙，紫筍齊嘗各鬥新。自歎花時北窗

下，蒲黃酒對病眼人」唐袁高為湖州刺史，因修貢顧渚茶山作詩云：「禹貢通遠俗，始圖在安人後王

失其本職吏不敢陳。亦有奸佞者，因茲欲求伸。動至千金費，日使萬姓貧。我來顧渚源，得與茶事親。黎甿

輟耕農采掇實苦辛。一夫且當役，盡室皆同臻。捫葛上敧壁，蓬頭入荒榛。終朝不盈掬，手足皆鱗皴。悲嗟

遍空山草木為不春。陰嶺芽未吐，使曹牒已頻。心爭造化先，走挺麋鹿均。選納無晝夜，搗聲昏繼晨。眾功

何枯槁，俯視彌傷神。皇帝尚巡狩，東郊路多堙。周迴繞天涯，所獻惟蠶勤。況減兵革用，兼茲困疲民。未知

供御餘，誰合分此珍。顧省忝邦守，有慚復因循。茫茫滄海間，丹憤何由申？」此詩雅得詩人諷諫之體，可

尚也。（茗溪漁隱叢話）

　　產茶地

東川之獸目，綿州之松嶺，雅州之露芽，南康之雲居，饒池之仙芝，霍山之黃芽，斬門之團黃，臨江之玉津，

蜀州之雀舌、烏嘴，潭州之獨行靈草，彭州之仙崖石花，袁州之金片綠英，建安之青鳳髓，岳州之黃翎毛，

岳陽之含膏冷，劍南之綠昌明，此皆唐宋時之產茶地及名也。（茶譜通考）

　　寶唐山

玉壘關外寶唐山有茶樹產於懸崖筍長三寸五寸，方有一葉二葉。（茶譜通考）

古今茶事

鶴嶺茶

龍州鶴嶺茶，妙極。（茶譜通考）

北苑

茗溪漁隱曰：東坡鳳味古研銘云：「帝規武夷作茶囿，山為孤鳳翔且嗅。下集芝田啄瓊玖，玉乳金沙散盧質殘璋斷壁澤而黝，治為書研美無有。至珍鶩世初莫售，黑眉黃眼爭研陋。蘇子一見名鳳味，坐令龍尾羞牛後」余至富沙按其地里。武夷在富沙之西，隸崇安縣，去城二百餘里。北苑在富沙之北，隸建安縣，去城二十五里。北苑乃龍焙，每歲造貢茶之處，即與武夷相去甚遠。其言「帝規武夷作茶囿」者非也。想當時傳聞不審，又以武夷山為鳳凰山故有「山為孤鳳翔且嗅」之句，其實北苑茶山乃名鳳凰山也。北苑土色膏腴，山宜植茶，石殊少，亦頑燥非研材。余嘗至北苑詢之土人，初未嘗以此石為研，方悟東坡為人所誑耳。若劍浦黯淡，有一種石黑眉黃眼，自昔人以為研。余意鳳味研，必此灘之石，然亦與武夷相去遠矣。又荔枝歎云：「君不見武夷溪邊粟粒芽，前丁後蔡相籠加」亦誤指其地。武夷未嘗有茶，茶之精絕者乃在北苑。自有一溪，南流至富沙城下，方與西來武夷溪水合流東去劍浦，固亦不可雷同言之。（茗溪漁隱叢話）

蜀茶至建茶

蔡寬夫詩話云：唐以前茶，惟貴蜀中所產，孫楚歌云：「茶出巴蜀」；張孟陽登成都樓詩云：「芳茶冠六情，溢味播九區」。他處未見稱者。唐茶品雖多，亦以蜀茶為重然惟湖州紫筍入貢每歲以清明日貢到，先薦宗廟，然後分賜近臣。紫筍生顧渚在湖常二境之間，當採茶時，兩郡守畢至最為盛會。杜牧詩所謂「溪盡停蠻棹旗張卓翠苔。柳村穿窈窕，松澗渡喧豗。」劉禹錫「何處人間似仙境，青山擁妓採茶時」皆以此。建茶絕亡貴者僅得掛一名爾至江南李氏時，漸見貴始有團圈之製而造作之精經丁晉公始大備自建茶出天下所產皆不復可數今出處鑿源沙溪土地相去丈尺之間品味已不同謂之外焙況他處乎，則知雖草木之微其顯晦亦自有時然唐自常衰以前閩中未有讀書者自歐陽詹之徒始出而終唐世亦不甚盛今閩中舉子常數倍天下而朝廷將相公卿每居十四五人物衍爾況草木微物也。顧渚湧金泉，每造茶時，太守先祭拜然後水漸出造貢茶畢，水稍減至貢堂茶畢已減半太守茶畢遂涸蓋常時無水也。或聞今龍焙泉亦然。茗溪漁隱曰：北苑官焙也漕司歲以入貢，茶為上壑源私焙也土人亦入貢茶為次二焙相去三四里間若沙溪外焙也與二焙相去絕遠自隔一溪茶為下山谷詩云：「莫遣沙溪來亂真」正謂此也。官焙造茶常在驚蟄後一二日與工探摘是時茶芽已皆一槍，蓋閩中地暖如此舊讀歐公詩，有蝦山之說亦傳聞之訛耳。龍焙泉即御泉也水之增減亦隨水旱初無漸出遂涸之異，但泉味極甘正宜造茶耳（茗溪漁隱叢話）

蒙頂茶

東齋記事云:蜀中數處產茶,雅州蒙頂最佳;其生最晚,在春夏之交,其地即書所謂「蔡蒙旅平」者也。

方茶之生雲霧覆其上若有神物護持之。(茗溪漁隱叢話)

琅琊山茶

琅琊山出茶類桑葉而小,山僧焙而藏之,其味甚清。(太平清話)

鄒宅茶

閩中興化府城外,鄒氏宅,有茶二株,香美甲天下,雖武夷巖茶不及也,所產無幾,鄰近有茶十八株,味亦美,合二十株。有司先時使人謹伺之,烘焙如法藉其數以充貢間有烘焙不中選者以餉大僚,然亦無幾。此外十餘里內所產皆冒鄒宅非其真也。庚戌使閩中晤汀鎮呂公啜此茶香美不可以名似詢之云爾。

(遜齋偶筆)

息屑亭烹茶

隴山在水洛城西北,乃水洛川及犢奴水所從出又明祝辞建息屑亭,嘗作象贊云:「道其人謂誰,乃隴千城之舊吏,息屑亭之主人,而鶴臞其別號。」余隴千詩:「我欲西尋犢奴水烹茶一上息屑亭。」(偶憶錄)

武夷茶

武夷諸峯皆拔立不相攝多產茶。接筍峯上，大黃次之，慢亭又次之。而接筍茶絕少不易得按陸羽經云：

「凡茶上者生爛石中者生櫟壤下者生黃土」夫爛石已上矣況其峯之最高最特出者乎大黃峯下

削上銳中周廣盤鬱諸峯無與並者然猶有土滓接筍突兀直上絕不受滓水石相蒸而茶生焉宜其清

遠高潔稱茶中第一乎吾聞其語鮮能知味也經又云：「嶺南生福州、建州、韶州、象州云」註福州生閩

方山建韶象未詳往往得之其味極佳豈方山即今武夷山耶世之推茗社者必首桑苧翁豈斯我哉

（梅花草堂筆談）

虎邱天池

虎邱天池最號精絕爲天下冠惜不多產又爲官司所據寂寞山家得一壺兩壺便爲奇品然其味實亞

於芥天龍池出池一帶者佳出南山一帶者最早微帶草氣（長物志）

龍井天目

山中早寒冬來多雪故茶之萌芽較晚採焙得法亦可與天池並。（長物志）

清源山茶　英山茶

清源山茶青翠芳馨超軼天池之上。南安縣英山茶精者可亞虎丘惜所產不若清源之多也閩地氣暖，

桃李冬花，故茶較吳中差早（泉南雜志）

閩茶

武彝男崩紫帽籠山，皆產茶，僧拙于焙，既採則先蒸而後焙，故色多紫赤，只堪供宮中浣濯用耳。近有以

松蘿法製之者，即試之色香亦具足，經旬月則紫赤如故，蓋製茶者不過土著數僧耳，語三吳之法轉輾

相效，舊態畢露。此須如昔人論琵琶法使數年不近盡忘其故調，而後以三吳之法行之，或有當也。

建州貢茶，自宋蔡忠惠始，小龍團亦瓶于忠惠時，有士人亦為此之誚。

龍焙泉在城東鳳凰山，一名御泉，宋時取此水造茶入貢。

北苑亦在郡城東先是，建州貢茶首稱北苑龍團，而彝石乳之名未著。至元設武場于武彝，遂與北苑併

稱，今則但知有武彝，不知有北苑矣。吳越間人顏不足閩茶，而甚豔北苑之名，不知北苑實在閩也。

御園茶在武彝第四曲喊山台通仙井，俱在園畔前朝著令，每歲驚蟄日有司為之致祭，祭畢鳴金擊鼓，

台上揚聲同喊曰：『茶發芽』井水既滿用以製茶上供，凡九百九十斤製畢，水遂渾濁而縮。

武彝產茶甚多，黃冠既獲茶利，逐徧種之，一時松栝樵蘇殆盡，及其後崇安令例致諸貴人所取不貲黃

冠苦于追呼，盡斫所種武彝真茶，九曲遂濯濯矣。

歙人閔汶水居桃葉渡上，予往品茶其家，見其水火皆自任，以小酒盞酌客，頗極烹飲態，正如德山擔青

龍鈔高自矜許而已，不足異也。秣陵好事者嘗諭閩無茶，謂閩客得閩茶戚製爲羅囊佩而嗅之，以代㿝

檀實則閩不重汶水也。閩客游秣陵者，宋比玉洪仲韋輩類依附吳兒，強作解事，賤家雞而貴野鶩爲

其所謔。三山薜老亦詆嘗汶水也。薜嘗言汶水假他味逼作蘭香究使茶之真味盡失。汶水而在閩此

亦當色沮。薜嘗住勇巂自爲剪焙，逐欲駕汶水上。余謂茶難以香名，况以蘭香定茶乃尼尺見也。顏以薜

老論爲善。

前朝不貴閩茶，即貢者亦只備宮中浣濯甌盞之需，貴使類以價貨京師所有者納之，間有採辦者劍津

廖地產非武彝也。黃冠每市山下茶登山貿之。

閩人以粗礶胆瓶貯茶近鼓山支提新茗出一時學新安製爲方圓錫其逐覺神朵奕奕。

太姥山茶名綠雪芽。

閩酒數郡如一茶亦類是今年予得茶甚夥學坡公義酒事盡合爲一然與未合無異也。

蔡忠惠茶錄石刻在甌寧邑庠壁間予五年前揭數紙寄所知今漫漶不如前延邵呼製茶人爲「碧豎」，

富沙陷後碧豎盡在綠林中矣，

崇安殷令招黃山僧以松蘿法製建茶堁並駕今年余分得數兩甚珍重之，時有武彝松蘿之目。

鼓山半巖茶色香風味當爲閩中第一不讓虎邱龍井也。雨前者每兩僅十錢其價廉甚一云前朝每歲

古今茶事

進貢，至楊文敏當國始奏罷之。然近來官取，其擾甚于進貢矣。（閩小記）

蒙茶

昔人謂「揚子江心水蒙山頂上茶。」蒙山在蜀雅州，其中峯頂尤極險穢，蛇虺虎狼所居得采其茶，可蠲百疾。今山東人以蒙陰山下石衣爲茶當之非矣。然蒙陰茶性亦涼可除胃熱之病。（廣陽雜記）

蒙茶

蒙山在名山縣西四十五里，有五峯最高者曰上清峯。其巔一石，大如數間屋，有茶七株生石上，無縫罅，云是甘露大師手植每茶時葉生，智炬寺僧報有司往視籍記葉之多少采製才得數錢許明時貢京師僅一錢有奇環石別有數十株曰「陪茶」則供藩府諸司而已。其旁有泉恆用石覆之味清妙在惠泉之上。（隴蜀餘聞）

店室

茶寮

大中三年東都進一僧年一百三十歲。宣宗問服何藥而致僧對曰：『臣少也賤，素不知藥性惟嗜茶凡履處惟茶是求或過百椀不以爲厭』因賜名茶五十斤，命居保壽寺名飲茶所曰茶寮。（舊唐書宣宗

紀）

露兄

崇禎癸酉，有好事者，開茶館。泉實玉帶，茶實蘭雪，湯以旋煮，無老湯器以時滌，無穢器。其火候湯候，亦時有天合之者。余喜之名其館曰「露兄」。取米顚「茶甘露有兄」句也。為之作關茶檄曰：「水淫茶癖，愛有古風瑞草雪芽素稱越，獨以烹者非法向來葛竈生塵。更蒙賞鑒無人，致使羽經積蠹遠者擇有勝地復舉湯盟水符遞自玉泉茗戰爭氷蘭雪，何須瑞草橋邊橘柚查梨出自仲山圃內；八功德水無過甘滑香潔清涼七家常事不管柴米油鹽醬醋。一日何可少此子獻竹庶可齊名七碗吃不得了，盧仝茶不算知味。一壺揮塵用暢清談半榻焚香共朝白醉。」（陶庵夢憶）

茶肆品茶

茶肆所售之茶，有紅茶，綠茶兩大別。紅者曰烏龍，曰壽眉，曰紅梅；綠者曰雨前，曰明前，曰本山。有盛以壺者，有盛以碗者，有坐而飲者，有臥而啜者。懷獻侯嘗曰吾人勞心勞力終日勤苦偶於暇日一至茶肆與二三知己淪茗深談固無不可。乃竟有日夕流連樂而忘返不以廢時失業為可惜者，誠可慨也。

京師茶館列長案茶葉與水之資須分計之有提壺以往者可自備茶葉出錢買水而已漢人少涉足八旗人士雖官至三四品亦厠身其間並提鳥籠曳長裾就廣坐作茗憩與圉人走卒雜坐談話不以為忤

也；然亦絕無權要中人之蹤跡。

乾隆末葉江寧始有茶肆鴻福園春和園，皆在文星閣東首，各據一河之勝。日色亭午，座客常滿，或憑闌

而觀水或促膝以品泉皋蘭之水烟霞漳之旱烟以次而至。茶葉則自雲霧龍井下逮珠蘭梅片毛尖隨

客所欲亦間佐以醬乾生瓜子小果碟酥燒餅春卷水晶糕花豬肉燒賣餃兒糖油饅首叟叟浮浮咄嗟

立辦但得囊中能有，直亦莫漫愁酤也。

上海之茶館，始於同治初三茅閣橋沿河之麗水臺，其屋前臨洋涇浜傑閣三層，樓宇軒敞。南京路有一

洞天與之相若。其後有江海朝宗等數家，益華麗且可就吸鴉片，福州路之青蓮閣亦數十年矣。初會華

衆會。光緒丙子粵人於廣東路之棋盤街北設同芳茶居，兼賣茶食糖果，侵晨且有魚生粥响午則有蒸

熟粉麵各色點心夜則有蓮子羹杏仁酪每日未申之時，妓女聯袂而至，未幾，而又有怡珍茶居接踵而

起望衡對宇兼售煙酒更有東洋茶社初僅三盛樓一家，設於白大橋北當壚賣茗者為妙齡女郎取貲

銀幣一二角其後公共法兩租界，無地不有，旋為駐滬領事所禁。

青蓮閣茶肆每值日晡則茶客盈座為之滿路為之塞非品茗也品姝也姝為流妓之稱，俗呼曰野雞，

四方過客爭至此以得觀野雞為快。

茶館之外，粵人有於雜物肆中兼售茶者不設座，過客立而飲之，最多者為王大吉涼茶，次之曰正氣茅

心一堂　飲食文化經典文庫

根水曰羅浮山雲霧茶，曰八寶清潤涼茶，又有所謂菊花八寶清潤涼茶者，則中有杭菊花、大生地、土藥、白廣陳皮、黑元參、乾葛粉、小京柿桂元肉八味，大半爲藥材也。

蘇州婦女好入茶肆飲茶，同光間，譚敘初中丞爲蘇藩司時禁民家婢及女僕飲茶肆相沿已久，不能禁，譚一日出門，有女郎婷婷而前將入茶肆問爲誰以實對。譚怒曰『我已禁矣何得復犯』令去履歸，曰『汝履行如此速去履必更速也。』自是無敢犯禁者（清稗類鈔）

官政

庾敬休

敬休以戶部侍郎兼魯王傳初，劍南西川山南道歲征茶戶部自遣巡院主之募賈人入錢京師。太和初，崔元略奏責本道主當歲以四萬緡上度支久之逗留多不至，敬休始請置院稱歸，收度支錢乃無逋沒。

（唐書庾敬休傳）

何易于

何易于爲益昌令鹽鐵官榷取茶利，詔下，所在毋敢隱。易于視詔書曰：『益昌人不征茶且不可活，矧厚賦毒之乎』命吏閣詔吏曰：『天子詔何敢拒吏坐死，公得免竄邪』對曰：『吾敢愛一身移暴于民乎』

亦不使罪爾曹』即自焚之觀察使素賢之，不劾也。（唐書循吏傳）

劉建鋒

建鋒為武安軍節度使，建鋒死，將吏推馬殷為留後其屬高郁敎殷民得自摘山收茗笋募高戶置邸閣居茗號八牀主人歲入笋數十萬用度遂饒。（唐書劉建鋒傳）

劉仁恭

劉仁恭為盧龍軍節度使禁南方茶自摘山為茶號山曰大恩以邀利。（唐書藩鎮傳）

馬殷

馬殷初兵力尚寡，與楊行密成汭劉龔等為敵國殷患之問策於其將高郁，郁曰：『成汭地狹兵寡不足為吾患而劉龑志在五管而已。楊行密孫儒之仇雖以萬金交之不能得其懽心然尊王使順霸者之業也。今宜內奉朝廷以求封爵而外誇鄰敵，然後退修兵農，畜力而有待爾』。於是，殷始修貢京師，然歲貢不過所產茶茗而已乃自京師至襄唐郢復等州置邸務以賣茶其利十倍郁又諷殷鑄鉛鐵以十當銅錢一又令民自造茶以通商旅而收其笋歲入萬計由是地大力完。（五代史楚世家）

母守素

守素河中龍門人父昭裔偽蜀宰相。守素弱冠起家，偽授祕書郎，累遷戶部員外郎知制誥。蜀亡入朝，授

工部侍郎，籍其蜀中莊產茶園以獻詔賜錢三百萬以充其直仍賜第於京城。（宋史毋守素傳）

給役夫茶

開寶五年正月，瀘州修河，卒賜以錢犒役夫給以茶。（宋史河渠志）

樊知古

知古授江南轉運使。先是，江南諸州官市茶十分之八；復征其餘分，然後給符聽其所往商人苦之；知古請罷其稅仍差增所市之直以便於民。（宋史樊知古傳）

李虞己

虞己，累遷殿中丞提舉淮南茶場，召知榮州未行，改遂州。（宋史李虞己傳）

劉蟠

劉蟠遷左諫議大夫卒嘗受詔巡茶淮南部民私販者衆，蟠乘羸馬，偽稱商人，抵民家求市茶民家不疑，出與之即擒寘於法（宋史劉蟠傳）

張忠定

忠定張詠尚書，宰鄂州崇陽縣。崇陽多曠土民不務耕織唯以植茶為業。忠定令民伐去茶園誘之使種桑，自此茶園漸少而桑麻特盛於岳鄂之間至嘉祐中改茶法湖湘之民苦於茶租獨崇陽茶租最少民監

他邑思公之惠立廟以報之。民有入市買菜者公召諭之曰：「邑居之民，無地種植且有他業賣菜可也；汝村民皆有土田何不自種，而費錢買菜」答而遣之，自後人家置圃至今謂盧葭為張知縣菜（補筆談）

陳晉公

陳晉公為三司使，將立茶法召茶商數十八偉各條利害。晉公閱之為第三等，語副使宋太初曰：「吾觀上等之說取利太深此可行於商賈，而不可行於朝廷；下等固減裂無取，唯中等之說公私皆濟吾裁損之可以經久。」於是為三等稅法行之數年貨財流通公用足而民富實世言三司使之才以陳公為稱首。後李侍郎諮為使改其法而茶利浸失後雖屢變然非復晉公之舊法也。（東軒筆錄）

何蒙

何蒙通判盧州巡撫使潘慎修薦其材敏驛召至京因面對訪以江淮茶法蒙條奏利害稱旨賜緋魚及錢十萬。（宋史何蒙傳）

李若谷

李若谷知宜興縣官市湖洑茶歲約戶稅為多少率取足貧下。若谷始置籍，備勾檢茶惡者舊沒官若谷使歸之民，許轉貿以償其數。（宋史李若谷傳）

索湘

索湘，為河北轉運使。先是邊州置榷場，與蕃夷互市，而自京輦物貨以充之，其中茶茗最為煩擾，復道遠多損敗。湘建議請許商買綠江載茶詣邊郡入中，旣免道途之耗，復有征筭之益。（宋史索湘傳）

李溥

李溥領順州刺史，遷歙州團練使。溥自言江淮歲入茶視舊額增五百七十餘萬斤會溥當代詔留再任，特遷宮苑使。初譙縣尉陳齊論榷茶法溥薦齊任京官御史中丞王嗣宗方判吏都銓言齊豪民子不可用眞宗以問執政馮拯對曰『若用有材豈限貧富』帝曰『卿言是也。』因稱溥畏愼小心言事未嘗不中利害以故任之益不疑。（宋史李溥傳）

姚仲孫

姚仲孫知建昌縣初建昌運茶抵南康，或露積於道間，為霖潦所敗主吏至破產不能償仲孫為券吏民輸山木卽高阜為倉邑人利之。（宋史姚仲孫傳）

王鬷

王鬷為三司鹽鐵副使時龍圖閣學士馬季良方用事建言京師買人常以賤價居茶鹽交引請官置務收市之季良挾章獻媧家衆莫敢迕其意鬷獨不可曰：『與民競利豈國體耶？』擢天章閣待制。（宋史

（王禹偁傳）

方偕

方偕知建安縣，縣產茶，每歲先社日，調民數千，鼓譟山旁，以達陽氣。偕以爲害農奏罷之。（宋史方偕傳）

李允則

李允則累遷供備庫副使，知潭州。初馬氏暴斂，州人出絹謂之地稅；潘美定湖南，計屋輸絹，謂之屋稅營田戶給牛歲輸米四斛牛死猶輸謂之枯骨稅民輸茶初以九斤爲一大斤後益至三十五斤允則清除三稅茶以十三斤半爲定制民皆便之（宋史李允則傳）

李溥

李溥爲江淮發運使。每歲奏計則以大船載東南美貨結納當途莫知紀極。章獻太后垂簾時，溥因奏事盛稱浙茶之美云：『自來進御唯建州餅茶而浙茶未嘗修貢本司以羨餘錢買到數千斤乞進入內』自國門挽船而入稱進奉茶綱有司不敢問所貢餘者悉入私室。溥晚年以賄敗竄謫海州然自此途爲發運司歲例每發運使入奏舳艫蔽川自泗州七日至京予出使淮南時見有重載入汴者求得其籍言兩浙牋紙三暖船他物稱是。（夢溪筆談）

韓憶

韓憶制大理寺丞三司更茶法，歲課不登，憶承詔劾之，由丞相而下皆坐失當之罰，其不撓如此。（宋史韓憶傳）

李師中

李師中舉進士，鄜延龐籍辟知洛川縣。民負官茶直十萬緡，追繫其衆，師中為脫桎梏語之曰：『公錢無不償之理，寬汝期與汝期可乎？』皆感泣聽命，乃令鄉置一匱籍其名，許日輸所負一錢以上輒投之書簿而去，比終歲逋者盡足。（宋史李師中傳）

尹師魯

尹師魯為帥，與劉滬董士廉諍水洛城事，既矛盾，朝旨召尹至闕，送中書給紙札供桉昭文。呂申公因聚廳啜茶，令堂吏直一甌投尹曰：『傳語龍圖，不欲縷請，只令送茶去。』時集相幸師魯之議將屈，笑謂諸公曰：『尹龍圖莫道建茶磨去磨來，漿水亦嚥不下。』師魯之懟去政堂切近，聞之擲筆於桉，屬聲曰：『是何委巷猥語輒入廟堂，真治世之不幸也。』集相愧而銜之，後致身於禍辱，根於此也。（湘山野錄）

孫長卿

長卿歷開封鹽鐵判官，江東淮南河北轉運使，江浙荆淮發運使，時將弛茶禁而收其征召長卿議，長卿曰：「本祖宗榷茶，蓋將備二邊之糴，且不出都內錢公私以爲便，今之所行，不足助邊糴什一，國用耗矣。」乃條所不便十五事不從改陝西都轉運使。（宋史孫長卿傳）

賜茶

初貢團茶及白羊酒惟見任兩府方賜之。仁宗朝，及前宰臣歲賜茶一斤，酒二壺後以爲例。（甲申雜記）

梁適

梁適進中書門下評章事京師茶買負公錢四十萬緡鹽鐵判官李虞卿案之急買榷與吏爲市內交於適子弟適出虞卿提點陝西刑獄。（宋史梁適傳）

王庠

王庠字夢易登皇祐第嘗攝興州，改川茶運置茶鋪免役民歲課亦辦部刺史恨其議不出己以他事中之鐫三秩罷歸。（宋史王庠傳）

李稷

李稷，提舉蜀部茶場甫兩歲羨課七十六萬緡擢鹽鐵判官詔推揚其功以勸在位。（宋史李稷傳）

蘇轍

公在諫垣，論蜀茶。神宗朝，量收稅。李杞、劉佑、蒲宗閔取息初輕後益重立法愈峻；李稷始議，極力搭取民間，途困。稷引陸師閔共事，額至一百萬貫。陸師閔又乞額外以百萬貫爲獻。成都置都茶場，公條陳五害，乞放權法令民自作交易，但收稅錢，不出引止令所在場務，纊數抽買博馬茶，勿失武備而已。言師閔百端陵虐細民除茶遞官吏養兵所費，所收錢七八十萬貫，蜀人泣血無所控告。講畫纖悉曲折利害昭炳，時小呂申公當軸歎曰：『只謂蘇子由儒學不知吏事精詳至于如此』。公論役法尤爲詳盡識者韙之。（欒城先生遺言）

程之邵

程之邵，元符中，主管茶馬市馬至萬匹得茶課四百萬緡。童貫用師熙岷，不俟報運茶往博羅發錢二十萬意佐用度連加直龍圖閣集賢殿修撰三進秩，爲熙河轉都運使。（宋史程之邵傳）

吳中復

吳中復從孫擇仁，知熙州，從永興軍走馬承受。藍從熙言其擅改茶法奪職免。（宋史吳中復傳）

梅執禮

梅執禮歷比部員外郎，比部職勾稽財貨文牘山委率不暇經目。苑吏有持茶卷至爲錢三百萬者以楊

職旨意，追取甚急。執禮一閱，知其妄欲白之之長貳疑不敢，乃獨列上果詐也。改度支吏部進國子司業。

（宋史梅執禮傳）

李珖

李珖知房州時，既榷官茶復彊民驗舊額貧無所出，被繫者數百人；珖至，即日盡釋之（宋史李珖傳）

唐文若

唐文若通判洋州，洋西鄉縣產茶，夵陵谷八百餘里山窮險，賦不盡括，使者韓球將增賦以市寵，闔戶避苛斂轉徙饑饉相藉，文若力爭之賦迄不增。（宋史唐文若傳）

李燾

李燾知常德府，境多茶園，異時禁切商賈率至交兵，燾曰：『官捕茶賊，豈禁茶商。』聽其自如訖無警累。表乞閒提舉興國宮秩。（宋史李燾傳）

趙崇憲

趙汝愚字崇憲，知江州郡瑞昌民負茶引錢，新舊累積為一十七萬有奇，皆困不能償，死則以責其子孫，猶弗貸會新卷行視舊價幾倍徙崇憲歎曰：『負茶之民愈困矣』亟請以新卷一償舊卷二詔從之蓋受賜者千餘家，刻石以記其事。（宋史趙汝愚傳）

272

茶商軍

鄭滉之登進士第,調峽州教授。湖北茶商,羣聚暴橫,滉之白總領何炳曰:「此輩精悍宜籍爲兵緩急可用。」炳亟下召募之令,趨者雲集,號曰茶商軍,後多賴其用。(宋史鄭滉之傳)

賈鉉

賈鉉遷左諫議大夫兼工部侍郎,上書論山東採茶事,其大槩以爲茶樹隨山皆有,一切護邏已奪民利,因而以揀茶樹執誣小民嚇取貨賂宜嚴禁止,仍令按察司約束。上從之。(金史賈鉉傳)

幹事驛官

江南有驛官以幹事自任,白太守曰:「驛中已理,請一閱之。」乃往初至一室,爲酒庫諸醞皆熟其外畫神,問:「何神也?」曰:「杜康。」刺史曰:「公有餘也」又一室曰茶庫,諸茗畢備,復有神問「何神也?」曰:「陸鴻漸。」刺史益喜又有一室曰菹庫諸菹畢具,復有神問:「何神也?」曰:「蔡伯喈。」刺史大笑曰:「不必置此。」(茶錄)

御史茶瓶

御史三院,一曰臺院,其僚曰侍御史,二曰殿院,其僚曰殿中侍御史,三曰察院,其僚曰監察御史,察院廳居南。會昌初,監察御史鄭路所葺禮察廳謂之松廳,廳南有古松也。刑察廳謂之魘廳,寢於此多鬼魘也兵

察廳寧中茶茶必市圐之佳者，貯於陶器以防暑濕，御史躬親監啓，故謂之御史茶瓶。（御史臺記）

團茶

故事，建州歲貢，大龍鳳團茶各二斤，以八餅為斤。仁宗以非故事命劾之。大臣為請，因留而免劾。然自是遂為歲額。熙寧中，賈青為福建

斤以獻斤為十餅。仁宗時，蔡君謨知建州，始別擇茶之精者為小龍團十

轉運使，又取小團之精者為密雲龍以二十餅為斤，而雙袋謂之雙角團茶。大小團袋皆用緋通以為賜

也。密雲獨用黃蓋。專以奉玉食，其後又有為瑞雲翔龍者，宣和後團茶不復貴，皆以為賜，亦不復如向日

之精，後取其精者為轉茶歲賜者不同，不可勝紀矣。（石林燕語）

茶貨

國初，沿江置務收茶名曰榷貨務，給賣客旅，如鹽貨然，人不以為便。淳化四年二月癸亥，詔廢沿江八處

應茶商並許於出茶處市之。未幾有司恐課額有虧，復請於上六月戊戌詔復舊制六飛南渡後官不能

運致茶貨，而榷貨務只賣茶引矣。（燕翼貽謀錄）

貢茶詩

袁高：「禹貢通遠俗，所圖在安人。後王失其本職，吏不敢陳。亦有奸佞者，因茲欲求伸。動生千金費，日使

萬姓貧。我來顧渚源，得與茶事親。氓輟耕農未，採掇實苦辛。一夫且當役，盡室皆同臻。捫葛上敧壁，蓬頭

心一堂 飲食文化經典文庫

入荒榛。終朝不盈掬，手足皆鱗皴。悲嗟遍空山，草木爲不春。陰嶺芽未吐，使者牒已頻。心爭造化先，走挺麋鹿均。選納無盡夜，搗聲昏繼晨。衆工何枯橋，俯視彌傷神。皇帝尚巡狩，東郊路多堙。周迴遶天涯，所獻愈艱勤。況值兵革困，重茲困疲民。未知供御餘，誰合分此珍？顧省忝邦守，又慚復因循。茫茫滄海間，丹憤何由伸！」右高所賦茶山詩也。案唐制：湖州造貢茶最多，謂之顧渚貢焙，歲造一萬八千四百斤。大曆後，始有進奉。建中二年，高刺郡進三千六百串并詩云：一章刻石在貢焙，故杜鴻漸與楊祭酒書云：「顧渚中山紫筍茶兩斤，此物但恨帝未得嘗實所嘆息。一斤上太夫人一片充昆弟同歠」開成三年以貢不如法停刺史裴充官。（全唐詩話）

貢茶得官

高齋詩話云鄰可簡以貢茶進用累官職至右文殿修撰關建路轉運使。其姪千里，於山谷間得朱草，可簡令其子待問進之因此得官好事者作詩云：「父貴因茶白兒榮爲草朱。」而千里以從父奪朱草以予子讒謗不已。待問得官而歸盛集爲慶親姻畢集衆皆贊喜可簡云，『一門僥倖』其姪遽云，『千里埋冤』衆皆以爲的對是時貢茶一方騷動故也。（茗溪漁隱叢話）

進茶

茗溪漁隱曰：余觀東坡荔支歎，注云大小龍茶，始於丁晉公，而成於蔡君謨。歐陽永叔聞君謨進小龍團，

古今茶事

驚歎曰：「君謨士人也，何至此作事？」今年閩中監司，乞進鬥茶，許之，故其詩云：「武夷谿邊粟粒芽，前

丁後蔡相籠加，爭新買寵各出意，今年鬥品充官茶。」則知始作俑者，大可罪也。（茗溪漁隱叢話）

茶額

宋南渡以前，蘇州買茶定額六千五百斤，元則無額。國朝茶課，驗科徵納計錢三百一十九萬三千有奇，

唯吳縣長洲有之。（太平清話）

茶貢

穀雨節前邑侯采辦東山「洞庭碧螺春」茶入貢謂之茶貢。

案：府志茶出吳縣西山以穀雨前爲貴。王應奎柳南隨筆云：洞庭東山碧螺峯石壁產野茶數株，每歲土

人持竹筐採歸，以供日用，歷數十年如是，未見其異也。康熙某年，按候采者如故，而其葉較多，筐不勝貯，

因置懷間。茶得熱氣異香忽發，採茶者爭呼「嚇煞人香」。「嚇殺人」者，吳中方言也。因遂以名是茶

云。自是以後，每值採茶，土人男女長幼，務必沐浴更衣，盡室而往，貯不用筐，悉貯懷間。而士人朱正元獨

精製法出自其家，尤稱妙品。康熙己卯，車駕南巡，幸太湖。巡撫宋犖購此茶以進。上以其名不雅馴，題之

曰「碧螺春」。自是地方大吏，歲必採辦，而售者往往以僞亂眞。正元沒，製法不傳，卽眞者亦不及曩時

矣。（清嘉錄）

進芽茶

舊例，禮部主客司，歲額六安州霍山縣，進芽茶七百斤，計四百袋，袋重一斤十二兩，由安徽布政司解部，其奉檄椎茶者，則六安州學正也。聞是役在昔頗爲民累，竊惟京華人海，百物充牣，聖人愛民如子，他日封疆大吏，必有奏請免進以蘇民困者。（燕下鄉脞錄）

品名

常魯公

常魯公使西蕃烹茶帳中，贊普問曰：『此爲何物？』魯公曰：『滌煩療渴，所謂茶也。』贊普曰：『我此亦有。』遂命出之，以指曰：『此壽州者此舒州者此顧渚者此蘄門者此昌明者此灃湖者』（唐國史補）

綠華紫英

同昌公主上每賜饌其茶則有綠華紫英之號。（杜陽雜編）

玉蟬膏

顯德初，大理徐恪，見貽卿信鋌子茶面印文曰「玉蟬膏」一種曰「清風使。」恪建人也。（清異

（錄）

符昭遠

符昭遠不喜茶，嘗謂御史同列會茶嘆曰：「此物面目嚴冷了無和美之態，可謂『冷面草』也。飯餘嚼佛眼芎以甘菊湯送之亦可爽神。」（清異錄）

龍坡茶

聞寶中寶儀以新茶飲予味極美區而標云：「龍坡山子茶。」龍坡，是顧渚山之別境。（清異錄）

蔡君謨別茶

蔡君謨善別茶，後人莫及。建安能仁院，有茶生石縫間，寺僧採造得茶八餅號石巖白，以四餅遺君謨，以四餅密遣人走京師，遺王內翰禹玉歲餘，君謨被召還闕訪禹玉，禹玉命子弟於茶笥中選取茶之精品者碾待君謨，君謨捧甌未嘗輒曰：「此茶極似能仁石巖白，公何從得之？」禹玉未信索茶貼驗之，乃服。

王荊公爲小學士時嘗訪君謨，君謨聞公至喜甚，自取絕品茶親滌器烹點以待公冀公稱賞公於夾袋中取消風散一撮投茶甌中併食之。君謨失色公徐曰：「大好茶味」君謨大笑，且歎公之眞率也。（墨客揮犀）

蔡君謨製小團

蔡君謨議茶者，莫敢對公發言，建茶所以名重天下，由公也。後公製小團，其品尤精於大團。一日，福唐蔡葉丞秘校召公啜下團坐久，復有一客至，公啜而味之曰：『非獨小團，必有大團雜之。』丞驚呼，童曰：『本碾造二人茶，繼有一客至，造不及，乃以大團兼之。』丞神服公之明審。（墨客揮犀）

曾坑小團

蔡君謨始作小團茶入貢，意以仁宗閭未立，而悅上心也。又作曾坑小團，歲貢一斤，歐陽文忠所謂兩府共賜一餅者是也。元豐中取揀芽不入香作密雲龍茶，小於小團，而厚實過之。終元豐外臣未始識之。宣仁垂簾始賜二府，及裕陵宿殿，夜賜碾成末茶二府兩指許二小黃袋其白如玉，上題曰：「揀芽」亦神宗所賜。至元祐末，福建轉運司又取北苑槍旗建人所作團茶者也以為瑞雲龍請進不納紹聖初方入貢歲不過八團，其製與密雲等，而差小也。（續開見近錄）

密雲龍

「密雲龍」茶極為甘馨時黃秦晁張號蘇門四學士子瞻待之厚每來必令侍妾朝雲取「密雲龍」。

山谷有「矞雲龍」亦茶名。（東坡集）

貢茶丐賜

自熙寧後始貴「密雲龍」每歲頭綱修貢奉宗廟及供玉食外賚及臣下無幾戚里貴近丐賜尤繁

仁一日慨歎曰：『令建州今後，不得造密雲龍，受他人煎炒不得也。出來道：我要密雲龍，不要團茶。揀好茶吃了生得甚意智！』此語既傳播於縉紳間，由是密雲龍之名益著。淳熙間，親黨許仲啓官蘇沙，得北范修貢錄序以刊行其間載歲貢十有二綱凡三等，四十有一名。第一綱曰龍熔貢新，止五十餘夸貴重如此。獨無所謂密雲龍豈以貢新易其名或別為一種又居密雲龍之上耶葉石林云：熙寧中，賈青為漕，建轉運使取小團之精者為密雲龍以二十餅為斤而雙袋謂之雙角大小團袋皆非通以為賜密雲龍。

獨用黃云。（清波雜志）

倪元鎮

倪元鎮素好飲茶，在惠山中，用核桃松子肉和眞粉成小塊如石狀置茶中名曰「清泉白石茶」有趙行恕者，宋宗室也慕元鎮清致訪之坐定童子供茶行恕連啜如常，元鎮艴然曰：『吾以子為王孫故出此品乃略不知風味眞俗物也』自是交絕。（雲林遺事）

無味

顧彥先曰：『有味如臟，飲而不醉；無味如荼，飲而醒焉醉人何用也？』（秦子）

皋盧茗

酉平縣出皋盧茗之利，茗葉大而澀南人以為飲。（廣州記）

無酒茶

茶，茶叢生眞煮飲爲茗茶茱萸檄子之屬膏煎之，或以茱萸煮脯胃汁爲之，曰茶有赤色者，亦米和膏煎曰

無酒茶（廣志）

過羅

茗，苦澀亦謂之過羅（南越志）

茶花

茶花狀似梔子其色稍白（桐君錄）

名品

風俗貴賞茶之名品益衆。劍南有蒙頂石花，或小方，或散芽，號爲第一。湖州有顧渚之紫筍；東川有神泉小團昌明獸目；峽州有碧澗明月，芳藥茱萸，福州有方山之露芽；夔州有香山；江陵有南木湖南有衡山岳州有㴩湖之含膏；常州有義與之紫筍；婺州有東白睦州有鳩坑；洪州有西山之白露壽州有霍山之黃芽；蘄州有蘄門團黃，而浮梁之商貨不在焉。（唐國史補）

䒢與茗

茶葉如梔子可煮爲飲。其老葉謂之䒢，嫩葉謂之茗。（魏王花木志）

草茶與龍鳳茶

臘茶出於劍建，草茶盛於兩浙，兩浙之品日注為第一。自景祐已後，洪州雙井白芽漸盛，近歲製作尤精，

囊以紅紗不過一二兩以常茶十數斤養之用辟暑濕之氣其品遠出日注上途為草茶第一。

茶之品莫貴于龍鳳謂之團茶凡八餅重一斤慶曆中蔡君謨為福建路轉運使始造小片龍茶以進其

品絕精謂之小團凡二十餅重一斤其價值金二兩然金可有而茶不可得每因南郊致齋中書樞密院

各賜一餅四人分之宮人往往綴金花于其上蓋其貴重如此（歸田錄）

雀舌

茶芽，古人謂之雀舌麥顆，言其至嫩也。今茶之美者；其質素良，而所植之木又美，則新芽一發，便長寸餘，

其細如針唯芽長為上品以其質幹土力皆有餘故也。如雀舌麥顆者極下材耳乃北人不識誤為品題

予山居有茶論嘗茶詩云：「誰把嫩香名雀舌定來北客未曾嘗不知靈草天然異一夜風吹一寸長」

（夢溪筆談）

圖茶

有唐茶品以陽羨為上供，建溪北苑，未著也。貞元中，常袞為建州刺史始蒸焙而研之謂之研膏茶其後

稍為餅樣其中，故謂之一串陸羽所烹惟是草茗爾迨至本朝建溪獨盛採焙製作前世所未有也士大

夫珍尚鑒別，亦過古先。丁晉公為福建轉運使，始製為鳳團，後又為龍團，貢不過四十餅，專擬上供雖近臣之家，徒聞之而未嘗見也。天聖中又為小團，其品迥加于大團賜兩府然止於一斤唯上大齋宿八人兩府共賜小團一餅縷之以金八人拆歸以侈非常之賜親知瞻玩以詩。故歐陽永叔有龍茶小錄或以大團問者輒方剖寸以供佛供仙家廟已而奉待客享子弟之用。熙寧末神宗有旨建州製密雲龍其品又加於小團矣然密雲之出則二團少粗以不能兩好也予元祐中詳定殿試是年秋為制舉考第官各蒙賜三餅然親誅責殆將不勝。宣仁一日歎曰『指揮建州，今後更不許造密雲龍，亦不要團茶揀好茶喫了，生得甚好意智』熙甯中，蘇子容使虜，姚麟為副曰『盍載些小團茶乎？』子容曰：『此乃供上之物，儔敢與虜人』未幾有貴公子使虜廣貯團茶自爾虜人非團茶不納也非小團不貴也。彼以二團易蕃羅一匹此以一羅酬四團少不滿則形言語近有貂使邊以大團為常供密雲為好茶。

（畫墁錄）

茶墨

司馬溫公云：『茶墨正相反。茶欲白墨欲黑茶欲新墨欲陳茶欲重墨欲輕；如君子小人不同，至如喜乾而惡濕裹之以囊水之以色皆君子所好玩則同也』（畫墁錄）

十綱

建州龍焙西北，謂之北苑，有一泉極清澹，謂之御泉。用其池水造茶味。唯龍園勝雪白茶二種謂之水芽花蒸後揀，每一芽先去外兩小葉謂之烏帶，又次取兩嫩葉謂之白合，留小心芽置於水中呼為水芽聚之稍多，即研焙為二品，即龍園勝雪白茶也。茶之極精好者，無出于此，每胯計工價近三十千，其他茶雖好，皆先揀而後蒸研其味次第減也。茶有十綱第一第二綱太嫩第三綱最妙自六綱至十綱小團至大團而上。第一名曰試新第二名曰貢新第三名有十六色龍園勝雪白茶萬壽龍芽御苑玉芽、上林第一乙夜清供龍鳳英華玉除清賞承平雅玩啓沃承恩雲葉雪英蜀葵金錢玉華千金第四有十二色無比壽芽宜年寶玉清慶雲無疆壽龍萬春銀葉玉葉長春瑞雲翔龍長壽玉圭香口焙與國岩上品揀芽新收揀芽第五次有十二色太平嘉瑞龍苑報春南山應瑞與國岩小龍又小鳳續入額御苑玉芽、萬壽龍芽無比壽芽瑞雲翔龍先春太平嘉瑞長壽玉圭以下五綱皆大小團也。（西溪叢語）

異名

茶之所產六經載之詳矣獨異美之名未備，謝氏論茶曰：「此丹丘之仙茶，勝烏程之御荈，不止味同露液、白虬霜華豈可為酪蒼頭便應代酒從事。」楊衍之作洛陽伽藍記曰：「食有酪奴」指茶為酪粥之奴也。杜牧之詩：「山實東南秀茶稱瑞草魁」皮日休詩：「十盌前皋盧」曹鄴詩「劍外尤華美」施肩吾詩：「茶為滌煩子酒為忘憂君。」此見于詩文者若南越志若苦澀為之果羅北苑曰葉布絕品，豫

章曰白露曰白茅南劍曰石花曰籛芽東川曰獸目湖常具白茶筍壽州曰黃第福建曰生第露第岳陽曰含膏外此無多顏疑似者不書若脊蝦須鵲舌蟹眼瑟瑟霏霏褐及鼓浪湧泉琉璃眼碧玉池又皆茶事中天然偶字也（臆乘）

新茶

公言茶品高而年多者必稍陳遇有茶處春初取新芽輕炙雜而烹之氣味自復在襄陽試作甚佳嘗語君謨亦以為然（王氏談錄）

精茶

茶之精者北苑名曰乳頭江左有金蠟而李氏別命取其乳作片或號曰京挺的乳二十餘品又有研膏茶即龍品也（談苑）

夾趾茶

李仲賓學士言夾趾茶如綠苦味辛烈名之曰登（研北雜志）

佳品

學林新編云茶之佳品造在社前其次則火前謂寒食前也其下則雨前謂穀雨前也佳品其色白若碧綠者乃常品也茶之佳品芽蘗細微不可多得若取數多者皆常品也茶之佳品皆點啜之其煎啜之者

皆常品也。齊己茶詩曰：「甘傳天下口，貴占火前名」又曰：「高人愛惜藏嵒裏白甀封題寄火前」丁

謂茶詩曰：「開緘試新火須汲遠山泉」凡此皆言火前蓋未知社前之品爲佳也。鄭谷茶詩曰：「入坐

半甌輕泛綠開緘數片淺含香」鄭雲叟茶詩云：「羅囊碧粉散嘗見綠花生。」沈存中論茶謂「黃金

碾畔綠塵飛碧玉甌中翠濤起」宜改綠爲玉翠爲素此論可也。而舉「一夜風吹一寸長」之句以爲

茶之精美，不必以雀舌鳥觜爲賞。今案茶至於一寸長，則其芽葉大矣，非佳品也。存中此論曲矣。盧仝茶

詩曰：「開緘宛見諫議面，手閱月團三百片」薛能謝劉相公寄茶詩曰：「兩串春團敵夜光名題天柱

印維揚。」茶之佳品珍踰金玉未易多得，而以三百片全以兩串寄薛能者皆下品可知也。盧仝詩：

「角開香滿室爐動綠凝鐺」丁謂詩曰：「未細烹還好鐺新味更全」此皆煎啜之也前啜之者非佳

品矣。唐人以茶雖有陸羽爲之說，而持論未精，至本朝蔡君謨茶錄既行，則持論精矣。以茶錄而毀前賢

之詩皆未知佳品者也。（苕溪漁隱叢話）

出處

遯齋閑覽云：茶古不著所出，本草云，出益州。唐以蒙山、顧渚、蘄門者爲上品；尚雜以蘇椒之類。故泌詩云：

「旋沫翻成碧玉池添蘇散出琉璃眼」逐以碧色爲貴止曰煎茶不知點試之妙大率皆草茶也。陸羽

茶經統言福建泉韶等一州所出者其味極佳而已今建安爲天下第一（苕溪漁隱叢話）

北苑新茶

茗溪漁隱曰：建安北苑茶，始於太宗朝，太平興國二年，遣使造之，取像於龍鳳以別庶飲，由此入貢，至道間，仍添造石乳。其後大小龍茶又起于丁謂，而成於蔡君謨，謂之將漕閩中，實董其事，賦北苑焙新茶詩。其序云：天下產茶者將七十郡半，每歲入貢皆於社前火前爲名，悉無其實，惟建州出茶有焙，焙有三十六，三十六中惟北苑發早而味尤佳。社前十五日即採其芽，日數千工聚而造之，逼社即入貢，工甚大。造甚精，皆載於所撰建陽茶錄。仍作詩以大其事云：「北苑龍茶者，甘鮮的是珍。四方惟數此，萬物更無新。纔吐微茫綠，初沾少許春。散尋縈樹遍，急採上山頻。宿葉寒猶在，芳芽冷未伸。茅茨溪口焙，籃籠雨中陳。長疾勾萌俳，開齊分兩均。帶煙蒸雀舌，和露疊龍鱗。作貢勝諸道，先嘗祇一人。緘封瞻闕下，郵傳渡江濱。特旨留丹禁，殊恩賜近臣。啜爲靈藥助，用與上樽親。頭進英華盡，初烹氣味醇。細香勝卻麝，淺色過于筠。顧渚慚投木，宜都愧積薪。年年號供御，天產壯甌閩。」此詩敍貢茶頗爲詳盡，亦可見當時之事也。又謂謨茶錄序云：「臣前因奏事，伏蒙陛下諭臣先任福建轉運使日，所進上品龍茶最爲精好，臣退念草木之微，首辱陛下知鑒，若處之得地，則能盡其材。昔陸羽茶經不第建安之品，丁謂茶圖獨能採造之本，至於烹試曾未有聞，輒條數事，簡而易明，勒成二篇，名曰茶錄。」至宣政間，鄭可簡以貢茶進用，久領漕計，創添續入，其數浸廣，今猶因之。細色茶五綱，凡四十三品，形製各異，共七千餘餅，其間貢新試新龍團勝

零，白茶御苑玉芽，此五品乃水揀爲第一，乃生揀次之；又有粗色茶七綱，凡五品，大小龍鳳併揀芽悉入

龍腦和膏爲團餅茶共四萬餘餅。東坡題文公詩卷云：「上人間我留連意待賜頭綱八餅茶」即今龍

色紅綾袋餅八者是也。蓋水揀茶即社前者生揀茶即火前者粗色茶即雨前茶也，園中地暖雨前茶已老，

而味加重矣。山谷和陽王休點密雲龍詩云：「小璧雲龍不入香」元豐龍焙承詔作」今細色茶中御無

此一品也。又有石門乳吉香口三外焙亦隸于北苑皆採摘茶芽送官焙添造每歲廬金共二萬餘緡日

役千夫兒兩月方能訖事，第所造之茶不許過數入貢之後，市無貨者人所罕得惟堅源諸處私焙茶其

絕品亦可敵官焙自昔至今，亦皆入貢，其流販四方悉私焙茶耳。蘇黃皆有詩稱道堅源茶，蓋堅源與北

苑爲鄰，山阜相接纔二里餘，其茶甘香特在諸私焙之上。東坡和曹輔寄堅源試焙新茶詩云：「仙山靈

雨溼行雲洗遍香肌粉未勻。好月來投玉川子，清風吹破武陵春。要知玉雪心腸好，不是膏油首面新。戲

作小詩君一笑，從來佳茗似佳人。」山谷謝送堅源揀芽詩云：「喬雲從龍小蒼璧，元豐至今人未

識堅源包貢第一春，緗區碾香供玉食。睿思殿東金井欄，甘露薦椀天開顏。橋山事嚴庀百局，補袞諸公

省中宿，中人傳賜夜未央，雨露恩光照宮燭。右丞似是李元禮，好事風流有涇渭，肯憐天祿校書郎，親勒

家庭遺分似春風飽識大官羊，不慣廝儔湯餅腸，搜攪十年燈火讀令我胸中書傳香已戒應門老馬走，

客來問字莫載酒。」（茗溪漁隱叢話）

茶色

茗溪漁隱曰：東坡詩，「春濃睡足午窗明，想見新茶如潑乳。」又云，「新火發茶乳。」此論皆得茶之正色矣。至贈謙師點茶則云「忽驚午盞兔毫斑，打作春甕鵝兒酒。」蓋用老杜詩「鵝兒黃似酒，對酒愛鵝兒。」若是則其色黃烏得爲佳茗矣今東坡前集，不載此詩想自知其非故刪去之。（茗溪漁隱叢話）

風味

湖八于茗，不數顧渚而數羅岕，然顧渚之佳者其風味已遠出龍井下岕稍清儁然葉纖而作草氣。孺嘗以半角見餉，且教余烹煎之法追試之殊類羊公鶴此余有解有未解也。余嘗品茗以武夷虎丘第一淡而遠也。松羅龍井英次之，香而艷也。天池又次之，常而不厭也。餘子瑣瑣勿置齒喙。（西吳枝乘）

茶樹

茶樹初採爲茶老爲茗再老爲荈今槪稱茗當是錯用事也。（枕譚）

騎火茶

龍安有騎火茶最上不在火前，不在火後故也。清明改火，故曰騎火茶。（五色線）

仙人茶

洞庭中西盡處，有仙人茶乃樹上之苦鮮也，四皓採以爲茶。（太平清話）

品茶

昨同徐茂吳至老龍井買茶山民十數家各出茶，茂吳以次點試，皆以爲贋曰：『眞者甘香而不洌稍洌便爲諸山贋品』得一二兩以爲眞物，試之果甘香若蘭而山民及寺僧反以茂吳爲非吾亦不能置辨。僞物亂眞亦如此。茂吳品茶以虎邱爲第一常用銀一兩餘購其斤許寺僧以茂吳精鑒不敢相欺他人所得雖厚價亦贋物也。子晉云本山茶葉微帶黑不甚淸翠點之色白如玉而作寒荳香宋人呼爲白雪茶，稍綠便爲天池物。天池茶中雜數莖虎邱則香味迥別。虎邱其茶中王種耶芥茶精者庶幾妃后天池龍井便爲臣種餘則民種矣。（快雪堂漫錄）

茶

松蘿之香馥馥廟後之味閒閒顧渚撲人鼻孔齒頰都異久而不忘然其妙在造凡宇內道地之產性相近也習相遠也吾深夜被酒發張震封所貽顧渚連啜而醒書此。（梅花草堂筆談）

秋葉

飲茶故富貴事茶出富貴人政不必佳何則？紛名者不旨其味貴耳者不知其神嚴重者不適其候馮先生有言此事如法書名畫玩器美人不得着人手辯則辯矣先生嘗自爲之不免白水之誚何居今日試

塔先生所貽秋葉色香與水相發，而味不全。民窮財盡巧偽萌生，雖有盧仝陸羽之好，此道未易恢復也。

甲子春三日。（梅花草堂筆談）

茶菊

甘菊單辦味甜性宜分植，骄久則辦漸稠，香亦漸減。塞菊差小而滿中，小鈴簇湊成枝，俗謂之金鈴菊。予所意東籬故種不過如此，顧未聞有茶菊也。黃介子自顧山來貽茶菊一本花似馬蘭中滿不鈴而香韻清遠殊有金石苣花之氣，絕不纇菊名茶當不誣耳。顧山菊冠江南其小品亦自超。（梅花草堂筆談）

雲霧茶

洞十從天台來，以雲霧茶見投蚤惠水瀹之，勃勃有苣花氣，而力韻微怯若不勝水者。故是天池之兄，虎丘之仲耳。然世莫能知豈山深地迴，絕無好事者賞識耶？洞十云：『他山焙茶多夾雜此獨無有。』果然，即不見知何患乎夫使有好事者一日露其聲價苦他山，山僧競起雜之矣。是故實衰于知名物敝于長價。（梅花草堂筆談）

天池茶

夏初天池茶都不能三四碗。寒夜瀹之覺有新興豈厭常之習某所不免耶？將岕之盈足，覺池之有餘乎？

或笑某子有芥癖當不然。癖者豈有二嗜歟某曰：『如君言，則曾西以羊棗作贐，屈到取芰而飲之也。孤

山處士妻梅子鶴，可謂嗜矣。道經武陵溪，酌桃花水一笑何傷乎。』（梅花草堂筆談）

雨窗

焚香啜茗，自是吳中人習氣，雨窗卻不可少。（梅花草堂筆談）

品泉

料理息庵方有頭緒，便擁爐靜坐其中，不覺午睡昏昏也偶聞兒子書聲心樂之，而爐間蓼蓼如松風響，

則茶且熟矣。三月不雨井水若甘露競屙其門，而以瓶罌相遺何來惠泉，乃厭饜生饞口訊之家人輩云：

舊藏得惠水二器寶雲泉一器，亟取二味品之，而令兒子快讀李秃翁焚書惟其極醒極健者。因憶壬寅

五月中著屐燒燈品泉于吳城王弘之第，自謂壬寅第一夜今日豈減此耶！（梅花草堂筆談）

紫筍茶

長興有紫筍茶土人取金沙泉造之乃勝。而泉不常有，禱之然後出事已輒涸。某性嗜茶而不能通其說。

詢往來貿茶人絕末有知泉所在者又不聞茶有紫筍之目大都矜稱廟後洞山派沙止矣。宋有紫茸玉，

豈是耶？東坡呼小龍團，便知山谷諸人為客，其貴重如此。自今思之，政堪與調和鹽醯作伴耳。然莫須另

風味在古人當不浪說也爐無炭茶與水各不見長書此為雪士一笑。（梅花草堂筆談）

六合

宜入藥品，但不善炒，不能發香而味苦，茶之本性實佳。（長物志）

松蘿。

十數畝外皆非眞松蘿。茶山中亦僅有一二家，炒法甚精，近有山僧手焙者更妙。眞者在洞山之下天池之上，新安人最重之，兩都曲中亦尚此，以易於烹煮且香烈故耳。（長物志）

廟後茶

陽羨茶數種，岕爲最。數種，廟後爲最。廟後方不能畝，外郡人亦爭言之矣。然雜以他茶，試之不辨也。色香味三淡，初得口泊如耳。有間廿入喉，有間靜入心脾；有間淸入骨嗟乎淡者道也，雖吾邑士大夫家，知此者可屈指焉。（秋園雜佩）

岕林茶

衡山水月林主僧靜音，餽余岕林茶一包，葑菜一瓶，閟則安切，音鑽平聲，衡人俗字也。此茶出石罅中，乃鳥銜茶子墮罅中而生者極不易得，衡岳之上品也，最能消脹。（廣陽雜記）

武夷茶

武夷茶佳甚，天下茶品，常以陽羨老廟後爲第一，武夷次之，他不入格矣。（廣陽雜記）

品茶

余僑寓浦城，艱於得酒，而易於得茶。蓋浦城本與武夷接壤，即浦產亦未嘗不佳，而武夷焙法實甲天下，浦茶之佳者往往轉運至武夷加焙，而其味較勝其價亦頓倍。其實古人品茶初不重武夷，亦不精焙法也。叢墻錄云：「有唐茶品以陽羨為上供，建溪北苑不著也。貞元中，常袞為建州刺史，始蒸焙而研之，謂之研膏茶。丁晉公為福建轉運使，始置為鳳團。」今考北苑雖隸建州，然其名為鳳皇山，其旁為壑源沙溪，非武夷也。東坡作鳳味硯銘有云：「帝規武夷作茶圖，山為孤鳳翔且嗅。」又作荔支嘆云：「君不見武夷溪邊粟粒芽，前丁後蔡相籠加」，直以北苑之名鳳皇山者為武夷，漁隱叢話辯之甚詳，謂北苑自有一溪，南流至富沙城下，方與西來武夷溪水合流，東去劍溪。然又稱武夷未嘗有茶，則亦非是。據武夷雜記云：「武夷茶賞自蔡君謨始，謂其過北苑龍團，周右父極抑之，蓋緣山中不曉焙製法，一味計多狗利之過」，是宋時武夷已非無茶，特焙法不佳，而世不甚貴爾。元時始於武夷置場官工員，茶園百有二所，設焙局於四曲溪，今御茶園喊山臺，其遺迹並存，沿至今日，則武夷之茶不脛而走四方。且粵東歲運番舶通之外夷，而北苑之名遂泯矣。武夷九曲之末為星村，鬻茶者駢集交易於此，多有販他處所產，學其焙法以膺充者，即武夷山下人亦不能辨也。

余嘗再遊武夷，信宿天游觀中，每與靜參羽士夜談茶事。靜參謂茶名有四等，茶品有四等。今城中州府

官癖及豪富人家，競尚武夷茶，最著者曰花香；其由花香等而上者曰小種而已。山中則以小種爲常品，其等而上者曰名種。此上以下所不可多得。即泉州廈門人所講工夫茶號稱名種者，實僅得小種也。又等而上之曰奇種，如雪梅木瓜之類，即山中亦不可多得。大約茶樹與梅花相近者即引得梅花之味；與木瓜相近者，即引得木瓜之味。他可類推。此亦必須山中之水方能發其精英。閱時稍久，而其味亦即稍退。三十六峯中，不過數峯有之。各寺觀所藏每種不能滿一斤，用極小之錫瓶貯之，裝在各種大瓶中間，遇貴客名流到山始出少許，鄭重淪之。其用小瓶裝贈者，亦題奇種，雜以木瓜梅花等物以助其香，非眞奇種也。至茶品之四等，一曰香花小種之類皆有之。今之品茶者以此爲無上妙諦矣。不知等而上之則曰清香而不清猶凡品也。再等而上之則曰甘。香而不甘，則苦茗也。再等而上之則曰活而不活亦不過好茶而已。活之一字須從否本辨之，微乎微乎，然亦必淪以山中之水方能悟此消息。此等語，余屢爲人述之，則皆閩所未聞者，且恐陸鴻漸茶經未曾夢及此矣。憶吾鄉林越亭先生武夷雜詩中，有句云：「他時詫朋罷，直飮玉漿迴」非身到山中鮮不以爲欺人語也。（歸田瑣記）

靜參品茶

梁茝林中丞嘗再游武夷，信宿天游觀，與靜參羽士談茶，靜參曰茶名有四等，茶品有四等，福州城中官吏富豪競尚武夷，最著者曰花香有由花香等而上者曰小種山中則以小種爲常品又等

而上者曰名種，此爲山下所不可多得者，卽泉州廈門人所講之工夫茶，號稱名種者，實僅得小種也。又等而上之曰奇種如雪梅木瓜之類，卽山中亦不可多得。大抵茶樹與梅花相近者，卽引得梅花之味與木瓜相近者卽引得木瓜之味，他可類推。且烹時亦必須山中之水方能發其精英，閱時稍久而其味亦卽稍退三十六峯中亦僅數峯有之。寺觀所藏每種不能滿一斤，以極小錫瓶貯之，裝於各種大瓶遇有貴客名流至山始出少許鄭重淪之。其用小瓶裝者亦題曰奇種實皆名種，雜以木瓜梅花等物助其香，非眞奇種也。

至茶品之四等，一曰香花香小種之類皆有之，今之品茶者以此爲無上妙諦矣；不知等而上之，則曰清，香而不清猶凡品也；再等而上之，則曰甘香而不甘則苦茗也；再等而上之，則曰活甘而不活亦不過尋常好茶而已活之一字須從舌本辨之，微乎微矣，然亦必淪以山中之水，方能悟此消息也。（清稗類鈔）

猴茶

溫州雁宕山有猴，每至晚春，輒採高山茶葉以遺山僧，蓋僧嘗於冬時知猴之無所得食也以小袋盛米投之，猴之遺茶所以爲答也。烹以泉水味清而腴，平陽宋燕生徵君怨嘗得之。（清稗類鈔）

效能

斛二瘕

桓宣武時有一督將，因時行病後虛熱，更能飲複茗，必一斛二斗乃飽，纔減升合，便以爲不足；非復一日。

家貧後有客造之，正遇其飲複茗，亦先聞世有此病，仍令更進五升，乃大吐，有一物出如升大，有口形質

縮縐狀如牛肚，客乃令置之於盆中，以一斛二斗複茗澆之，此物喙之都盡而止，覺小脹，又加五升便悉

混然從口中涌出。既吐此物其病遂差。或問之此何病答云此病名斛二瘕。（搜神後記）

茶贊

文帝微時夢神易其腦骨，自爾腦痛，忽遇一僧曰：『山中有茗草，煮而飲之當愈』，常服之有效。由是競

朵天下始知飲茶。茶有贊其略曰：「窮春秋演河圖不如載茗一車」（隋書）

李德裕

昔有人授舒州牧，李德裕謂之曰：『到彼郡日，天柱峯茶可惠三角。』其人獻之數十斤，李不受，退還。明

年罷郡用意精求，獲數角，投之。德裕閱而受曰：『此茶可以消酒食毒』乃命烹一甌，沃於肉食內，以銀

合閉之。詰旦，因視其肉已化爲水，衆服其廣識。（玉泉子）

吳僧文了

吳僧文了善烹茶游荊南，高保勉白於季與，延置紫雲菴，日試其藝，保勉父子呼爲「湯神」奏授華定

冰大師上人目目曰「乳妖」。（清異錄）

眞茶

飲眞茶令少睡眠。（博物志）

雷鳴茶井

有僧在蒙山頂見一老父云：『仙家有雷鳴茶井候雷發聲井中採擷一兩祛宿疾二兩當眼前無疾三

兩換骨四兩爲地仙矣』（集靈記）

長年

東坡以茶性寒，故平生不飲，惟飲後濃茶漱齒而已。然大中三都，進一僧百三十歲，宣宗問服何藥云性

惟好茶飲至百碗少猶四五十碗以坡言律之必且損壽反得長年則又何也（唐錦夢餘錄）

香茗

香茗之用其利最溥。物外高隱，坐語道德，可以清心悅神。初陽薄暝，與味蕭騷，可以暢懷舒嘯。睛窗榻帖，

揮塵閑吟，篝燈夜讀可以遠辟睡魔。青衣紅袖密語談私可以助情熱意。坐雨閉窗，飯餘散步可以遣寂

心一堂　飲食文化經典文庫

除煩醒醉筵醒客，夜雨蓬牕長嘯空樓冰絃瓦指，可以佐歡解渴品之最優者，以沉香岕茶爲首第焚煮有

法必貞夫韻士乃能究心耳志香茗第十二（長物志）

飲啜

王肅

王肅，字恭懿，憶父非理受禍，常有子胥報楚之意擧身素服，不聽音樂時人以此稱之。肅初入國不食羊

肉及酪漿等，常飯鯽魚羹渴飲茗汁京師士子見肅一飲一斗號爲漏卮經數年已後，肅與高祖燕會，食

羊肉酪粥，高祖怪之謂肅曰『卿中國之味也羊肉何如魚羹茗飲何如酪漿』肅對曰『羊者是陸產

之最魚者是水族之長所好不同並各稱珍。以味言之，是有優劣羊比齊魯大邦，魚比邾莒小國唯茗不

中與酪作奴。』高祖大笑因擧酒曰『三三橫兩兩縱誰能辨之賜金鍾』御史中丞李彪曰『沾酒老

嫗甖注坯屠兒割肉與稱同』尚書右丞甄琛曰『吳人浮水自云工妓兒擲繩在虛空』彭城王勰曰

『臣始解此是習字。』高祖卽以金鍾賜彪，朝廷服彪聰明有知。甄琛和之亦速，彭城王謂肅曰『卿不

重齊魯大邦而愛邾莒小國？』肅對曰『鄉曲所美不得不好。』彭城王重謂曰『卿明日顧我，爲卿設

邾莒之食亦有酪奴。』時給事中劉鎬，慕肅之風專習茗飲。彭城王謂鎬曰『卿不慕王侯八珍好蒼頭

水厄，海上有逐臭之夫里內有學顰之婦，以卿言之，卽是也。」其彭城王家有吳奴以此言戲之，自是朝貴燕會雖設茗飲，皆恥不復食，唯江表殘民遠來降者飲焉。後蕭衍子西豐侯蕭正德歸降時，元義欲爲設茗，先問『卿於水厄多少。』正德不曉義意答曰：『下官雖生於水鄉，而立身已來，未遭陽侯之難。』元義與擧坐之客大笑焉。（洛陽伽藍記）

　　岑羲

三月上巳日上幸司農少卿王光輔莊，駕遷朝後中書侍郎南陽岑羲設茗飲葡萄漿，與學士等討論經史。（景龍文館記）

　　陸贄

陸贄字敬與，蘇州嘉與人，十八第進士，中博學宏辭，調鄭尉罷歸。壽州刺史張鎰有重名，贄往見語三日，奇之，請爲忘年交。旣行餉錢百萬曰：『請爲母夫人一日費』贄不納止受茶一串曰：『敢不承公之賜』

（唐書陸贄傳）

　　六班茶

樂天方入關，劉禹錫正病酒。禹錫乃餽菊苗虀蘆菔鮓，換取樂天六班茶二囊以醒酒。（燈阱志）

　　志崇

覺林院志崇收茶三等，待客以驚雷莢，自奉以萱草帶，供佛以紫茸香，蓋最上以供佛，而最下以自奉也，

客赴茶者皆以油囊盛餘瀝以歸。（雲仙雜記）

順義進茶

順義四年春王遣右衞上將軍許確進賀郊天細茶五百斤於唐。秋遣右威衞將軍需峴，獻新茶於唐。

（十國春秋吳睿帝本紀）

李嗣源

六年夏四月唐主殂李嗣源卽皇帝位改元天成。是月，王遣使獻新茶於唐。（十國春秋吳睿帝本紀）

酣重兒

通文二年國人貢建州茶膏製以異味，膠以金縷名曰酣重兒，凡八枚。（十國春秋閩康宗本紀）

建州茶膏

有得建州茶膏，取作酣重兒八枚膠以金縷，獻於閩王曦，遇通文之禍，爲內侍所盜轉遺貴臣。（清異

錄）

的乳茶

保大四年二月，命建州製的乳茶號曰京挺腦茶之貢始罷貢陽羨茶。（十國春秋南唐元宗本紀）

湯社

和凝在朝率同列遞日以茶相飲，味劣者有罰，號爲湯社。（清異錄）

孫樵

孫樵送茶與焦刑部書云：「晚甘侯十五人遣侍齋閣。此徒皆請雷而摘，拜水而和。蓋建陽丹山碧水之鄉，月澗雲龕之品，愼勿賤用之。」（清異錄）

龍鳳飾

章獻明肅劉皇后，舊賜大臣茶，有龍鳳飾。太后曰：『豈人臣可得！』命有司別製入香京挺以賜之。（宋史后妃傳）

范鎭

范鎭拜端明殿學士，起提舉中太一宮，兼侍讀，且欲以爲門下侍郎。鎭雅不欲起，遂固辭，改提舉崇福宮。祖禹謁告歸省，詔賜以龍茶，存勞甚渥。（宋史范鎭傳）

蘇軾

蘇軾拜龍圖閣學士，知杭州。宣仁后心善軾，軾出郊，用前執政恩例，遣內侍賜龍茶銀合，慰勞甚厚。（宋史蘇軾傳）

滌硯贈茶

黃寶自言為發運使，大暑泊清淮樓，見米元章衣懷鼻自滌硯于淮口索篋中一無所有獨得小龍團二餅，亟遣人送入趁其滌硯未畢也（銷夏）

陳俊卿

俊卿淳熙二年，再命知福州累章告歸，除特進起判建康府兼江東安撫召對垂拱殿命坐賜茶（宋史陳俊卿傳）

陳也罷

莆田愧齋陳公膏，性寬坦，在翰林時夫人嘗試之會客至公呼茶夫人曰：『未買』公曰『也罷。』客為捧腹時因號陳也罷（雲林遺事）

代酒

乾茶，夫人曰：『未買』公曰『也罷。』又呼南人好飲茶，孫皓以茶與韋昭代酒；謝安詣陸納，設茶果而已北人初不識此，開元中，太山靈岩寺，有降魔師教禪者以不寐人多作茶飲因以成俗。（續博物志）

茗戰

建人謂鬥茶為茗戰。（雲仙雜記）

茶湯

茶見于唐時，味苦而轉甘，晚採者爲茗。今世俗客至則啜茶，去則啜湯，湯取藥材甘香者屑之，或溫或涼，未有不用甘草者，此俗徧天下。先公使遼，遼人相見，其俗先點湯後點茶，至飲會亦先水飲然後品味但欲與中國相反本無義理。（可談）

始飲

飲茶，或云始於梁天監中，事見洛陽伽藍記，非也。按吳志韋曜傳：孫皓時，每宴饗無不竟日坐席無能否，飲酒率以七升爲限，雖不悉入口皆澆灌取盡。曜素飲不過二升，初見禮異時或爲裁減或賜茶荈以當酒如此言則三國時已知飲茶；但未能如後世之滅耳。逮唐中世榷利，遂與貢酒相抗迄今國計賴此爲多。（南窗紀談）

襄字茶

文昌雜錄云：倉部韓郎中言叔父魏國公喜飲酒，至數十大觥，猶未醉；不甚喜茶，無精粗共置一籠，每盡，即取碾亦不問新舊嘗暑日曝茶於庭，見一小角上題「襄」字，蔡端明所寄也。因取以歸，直王家物。日後見蔡說當時祇有九餅又以葉圍一餅充數十以獻魏公，其難得者如此。（苕溪漁隱叢話）

賜茶

昔人以陸羽飲茶，比于后稷樹穀及觀韓翃序茶云：「吳主禮賢，方閒置茗；晉人愛客，纔有分茶。」則知

開創之功，非關桑苧老翁也。若云在古茶勳未普，則比時賜茶已一千五百串矣。（筆記）

閔老子茶

周墨農向余道閔汶水茶不置口。戊寅九月，至留都，抵岸，即訪閔汶水於桃葉渡。日晡，汶水他出，遲其歸，

乃婆娑一老。方敘話，遽起曰：「杖忘某所。」又去。余曰：「今日豈可空去。」遲之又見，汶水喜，自起當鑪煮茶。

余曰：「客尚在耶？客在奚為者？」余曰：「慕汶老久矣，今日不暢飲汶老茶決不去。」

旋煮速如風雨。導至一室，明窗淨几，荊溪壺，成宣窰瓷甌十餘種，皆精絕。燈下視茶色，與瓷甌無別，而香

氣逼人，余叫絕。余問汶水曰：「此茶何產？」汶水曰：「閬苑茶也。」余再啜之曰：「莫紿余，是閬苑製法，

而味不似。」汶水匿笑曰：「客知是何產？」余再啜之曰：「何其似羅岕甚也？」汶水吐舌曰：「奇！奇！」

余問水何水，曰：「惠泉。」余又曰：「莫紿余；惠泉走千里，水勞而圭角不動，何也？」汶水曰：「不復敢隱。

其取惠水必淘井，靜夜候新泉至，旋汲之。山石磊磊藉甕底，舟非風則勿行，故水不生磊。即尋常惠泉，猶

遜一頭地，況他水耶！」又吐舌曰：「奇！」言未畢，汶水去。少頃，持一壺滿斟余曰：「客啜此。」余曰：「香

撲烈，味甚渾厚，此春茶耶？向瀹者的是秋採。」汶水大笑曰：「予年七十，精賞鑒者無客比！」遂定交。

（陶庵夢憶）

李于鱗岕茶

李于鱗爲吾浙按察副使，徐子與以岕茶最精者餉之。比看子與昭慶寺問及，則已賞皂役矣。蓋岕茶葉大多梗于鱗北士不過宜矣紀之以發一粲。季象說（快雪堂漫錄）

董小宛

姬能飲自入吾門，見余量不勝焦葉途罷飲，每晚侍荆人數杯而已。而嗜茶與余同性又同嗜片界每歲半塘顧子兼擇最精者緘寄具有片甲蟬翼之異文火細烟小鼎長泉必手自炊滌。余每誦左思嬌女詩：「吹嘘對鼎鏣」之句，姬爲解頤。至沸乳看蟹目魚鱗傳瓷選月魂雲魄尤爲精絕每花前月下靜試對嘗碧沈香泛真如木蘭霑露瑤草臨波備極盧陸之致東坡云：「分無玉椀捧蛾眉，」余一生淸福九年占盡九年折盡矣。（影梅菴憶語）

對花啜茶

對花啜茶唐人謂之「殺風景，」宋人則不然。張功甫「梅花宜稱，」有掃雪烹茶一條。放翁詩云：「花塢茶新滿市香」蓋以此爲韻事矣。（冷廬雜識）

茶始

古人以謂飲茶始於三國時，謂吳志韋曜傳：孫皓每飲羣臣酒率以七升爲限。曜飲不過二升或爲裁減，

或賜茶茗以當酒，據此以爲飲茶之證案。趙飛燕別傳：成帝崩後，一日夢中驚啼甚久，侍者呼問，方覺，

乃言曰：『吾夢中見帝賜吾坐，命進茶，左右奏帝云向者侍帝不謹，不合啜此茶。』然則西漢時已嘗

有啜茶之說矣非始於三國也。（廣陽雜記）

高宗飲龍井新茶

杭州龍井新茶，初以釆自穀雨前者爲貴，後者於淸明節前採者入貢爲頭綱，頒賜時，人得少許，細僅如

芒，淪之微有香，而未能辨其味也。

高宗命製三淸茶，以梅花佛手松子淪茶，有詩紀之，茶宴日卽賜此茶，茶碗亦摹御製詩於上，宴畢諸臣

懷之以歸。（淸稗類鈔）

李客山與客啜茗

李客山名果，長洲布衣，艱苦力學，忍飢誦經，樵蘇不繼，怡然自得，所居亦湫隘，良友至，輒呼小童取一餤，

就茶肆澄茗共啜之。（淸稗類鈔）

姚叔節從母乞茗飲

桐城姚永概字叔節，爲慕庭運同之叔子，母光恭人，同邑直隸布政使聰諧女也。叔節兒時，從塾中歸一

日恭人與其適馬其昶之長女方坐齗下論家事，旁置茗一甌，叔節乞就飲之，頷蠡恭人笑曰『兒長苦

耶，何吾嗜之不覺也。」（清稗類鈔）

詩文

陸羽

陸羽字鴻漸，一名疾，字季疵，復州竟陵人，不知所生，或言有僧得諸水濱畜之，旣長，以易自筮得蹇之漸曰「鴻漸於陸其羽可用爲儀」乃以陸爲氏名而字之，幼時其師教以旁行書答曰『終鮮兄弟而絕後嗣得爲孝乎』師怒使執糞除汚塓以苦之，又使牧牛三十。羽潛以竹畫牛背爲字得張衡南都賦不能讀危坐效羣兒囁嚅若成誦狀師拘之令薙草莽常其記文字懵懵若有遺過日不作主者鞭苦因歎曰『歲月往矣奈何不知書』嗚咽不自勝因亡去匿爲優人作詼諧數千言。天寶中州人酬吏署羽伶師太守李齊物見異之，授以書遂廬虎門山貌倪陋口吃而辯聞人善若在己，見有過者規切至杵人朋友燕處意有所行輒去人疑其多嗔與人期，雨雪虎狼不避也。上元初，更隱苕溪，自稱桑苧翁闔門著書，或獨行野中，誦詩擊木裴回不得意，或慟哭而歸，故時謂今接與也。久之，詔拜羽太子文學徙太常寺太祝，不就職。羽嗜茶著經三篇言茶之原之法之具尤備天下益知飲茶矣。時鬻茶者，至陶羽形，置煬突間祀爲茶神。有常伯熊者因羽論復廣著茶之功，御史大夫李季卿宣慰江南，次臨淮，知伯熊善

308

羹茶，召之。伯熊執器前，季卿為再舉杯，至江南，又有薦羽者，召之。羽衣野服，挈具而入。季卿不為禮，羽愧

之，更著毀茶論。其後尚茶成風，時回紇入朝，始驅馬市茶。（唐書隱逸傳）

右補闕

每曰，博學有著述才，上表請修古史，先撰目錄以進，元宗稱善，賜絹百匹。性不飲茶，製茶飲序其略曰：

「釋滯消壅，一日之利暫佳；瘠氣侵精，終身之累斯大。獲益則歸功茶力，貽患則不為茶災豈非福近易

知禍遠難見」（大唐新語）

陸龜蒙

甫里先生陸龜蒙嗜茶，置園於顧渚山下，歲入茶租，自為品題以繼茶經。（茶譜）

撰茶歌

蔡君謨謂范文正公曰：「採茶歌云黃金碾畔綠塵飛，碧玉甌中翠濤起。今茶絕品其色甚白翠綠乃下

者耳，欲改為玉塵飛素濤起如何？」希文曰「善。」（珍珠船）

龍團稱屈

東坡先生與魯直文潛諸人會飯，既食骨墜兒血羹。客有須薄茶者，因就取所碾龍團，逼啜坐人或曰：

「使龍茶能言常須稱屈。」先生撫掌久之曰：「是亦可為一題。」因援筆戲作律賦一首以俾薦血羹

龍團稱屈爲韻。山谷繫節，稱咏不能已已無藏本聞關子開能誦今亡矣惜哉（春渚紀聞）

焦坑

先人嘗從張晉彥覓茶，張答以二小詩：「內家新賜密雲龍，只到調元六七公，賴有家山供小草，猶堪詩老鵰春風。」「仇池詩裏識焦坑，風味官焙可抗衡鑽餘權倖亦及我，十輩遣前公試烹」詩總得偶病，此詩倮其子代書後誤刊在于湖集中。焦坑產庾嶺下，味苦硬久方回廿。「浮石已乾霜後水，焦坑新試雨前茶，」坡南還回至章貢顯聖寺詩也後屢得之初非精品特彼人自以爲重包裹鑽權倖亦豈能望建谿之勝。（清波雜志）

磨茶絕句

先人三弟季字德紹，爲輝同庚同月，輝先十三日，自幼從竹林遊。德性敏而靜中年後文筆加進嘗題悅川磨茶絕句云：「獨抱遺經舌本乾，笑呼赤角磨龍團但知兩腋清風起未識捧甌春筍寒」頗有唐人風致死已十年遺藁失於收拾但宗族間得傳一二。（清波雜誌）

謝餉茶書

楊廷秀謝傅尚書茶書：「遠餉新茗，當自攜大瓢走汲溪泉束澗底之散薪燃折脚之石鼎烹玉麐啜香乳以享天上故人之意媿無胷中之書傳但一味攪破菜園耳。」（銷夏）

代茶飲子

外臺祕要有代茶飲子一首云格韻高絕惟山居逸人乃當作之予嘗依法治服其利甚高調中信如所云。而其氣味乃一服卷散耳與茶了無干涉辟能詩云：「粗官乞與眞抛却賴有詩情合得嘗」又作烏嘴茶詩云：「鹽損添嘗戒葢宜羨更誇」乃知唐人之於茶蓋有河朔脂麻氣也。（王建集）

水聲

裴晉公詩云：「飽食緩行初睡覺，一甌新茗侍兒煎；脫巾斜倚繩牀坐，風送水聲來耳邊。」公爲此詩必自以爲得志然吾山居七年享此多矣。今歲新茶適佳，夏初作小池導安樂泉注之，得常熟破山重臺白蓮植其間葉已覆水，雖無淙潺之聲，然亦澄澈可喜此晉公之所誦詠，而吾得之，可不爲幸乎！（避暑錄話）

歐公詩

歐公和劉原父揚州時會堂絕句云：「積雪猶封蒙頂樹，驚雷未發建溪春，中洲地暖萌芽早，入貢宜先百物新。」注云：「時會堂造貢茶所也。」余以陸羽茶經考之，不言揚州出茶惟毛文錫茶譜云：「揚州禪智寺隋之故宮寺傍蜀岡，其茶甘香味如蒙頂焉。不知入貢之因起於何時，故不得而誌之也。（苕溪漁隱叢話）

茶詩

詩云:「誰謂茶苦。」

《爾雅》云檟苦茶。注:樹似梔子今呼早采者為茶晚采者為茗,一名荈,蜀人名之苦茶,

故東坡乞茶栽詩云:「周詩記苦茶茗飲出近世初綠脈粱肉假此雪昏滯」蓋謂是也。六一居士嘗新

茶詩云:「泉甘器潔天色好,坐中揀擇客亦佳。」東坡守維揚,於石塔寺試茶詩云:「禪窗麗午景蜀井

出冰雪坐客皆可人鼎器手自潔」正謂諺云三不點也(《苕溪漁隱叢話》)

茶詞

魯直諸茶詞,余謂品令一詞最佳,能道人所不能言,尤在結尾三四句。詞云:「鳳舞團團餅,恨分破、教孤

另。余渴休淨隻輪慢碾,玉塵光瑩湯響松風,早減二分酒病。味濃香永醉鄉路成佳境恰如燈下故人萬

里歸來對影口不能言心下快活自省」(《茗溪漁隱叢話》)

茶

九經無茶字或言茶苦卽是也見于《爾雅》謂之檟茗則是今之茶,但經中只有茶字耳。(《學齋呫嗶》)

茶磨銘·

山谷作茶磨銘云:「楚雲散叢,燕山雪飛江湖歸夢從此祛機。」(《談苑》)

奇俊語

張又新煎茶水記：「粉槍木旗，蘇蘭薪桂；陸羽茶經，煮華救沸。」皆奇俊語。（墐戶錄）

參寥茶詩

東坡云昨夜夢參寥師，攜詩見過而記其飲茶兩句云：「寒食清明都過了，石泉槐火一時新。」夢中問火固新矣泉何故新答曰俗以清明淘井當續成詩以記其事（茗溪漁隱叢話）

綠茶詩

三山老人語錄云：五代時鄭遨茶詩云：「嫩芽香且靈吾謂草中英夜白和烟搗寒爐對雪烹羅叟碧粉散嘗見綠花生最是坒珍重能令睡思清。」范文正公詩云，「黃金碾畔綠塵飛碧玉甌中翠濤起」茶色以白為貴二公皆以碧綠言之何耶（茗溪漁隱叢話）

試茶詩

西清詩話云葉濤詩極不工而喜賦詠嘗有試茶詩云「碾成天上龍兼鳳煮出人間蟹與蝦」好事者戲云「此非試茶乃礛玉匠人嘗南食也」（茗溪漁隱叢話）

茶筅子詩

茗溪漁隱曰，子苕謝人寄茶筅子詩云：「看君眉宇真龍種，尤解橫身戰雪濤。」盧駿元亦有此詩云：「到底此君高韻在，清風兩腋為渠生」皆善賦詠者然盧優於韓。（茗溪漁隱叢話）

殺風景

西清詩話云：義山雜纂品目數十，蓋以文滑稽者其一曰殺風景，謂清泉濯足，花上曬褌背山起樓燒琴煮鶴對花啜茶松下喝道。晏文獻慶曆中罷相守潁以惠山泉烹日注從容置酒賦詩曰「稽山新茗綠如煙靜挈都藍煮惠泉未向人間殺風景更持醪醑醉花前。」王荆公元豐末居金陵蔣大漕之奇夜謁公於蔣山驟喝甚都公取松下喝道語作詩戲之云：「扶衰南陌望長楸，燈火如星滿地流但怪傳呼殺風景，豈知禪客夜相投」自此殺風景之語頗著於世。

三山老人語錄云唐人以對花啜茶謂之殺風景，故荆公寄茶與平甫詩，有「金谷看花莫謾煎」之句。

（苕溪漁隱叢話）

魯直詩

苕溪漁隱曰：魯直以雙井茶送孔常文，常文答詩有「煎點徑須煩綠珠」之句，因戲答云，「知公家亦闕掃除但有文君對相如，政當為公乞如願，作書遠寄宮亭湖」錄異傳云盧陵歐陽明道彭蠡以船中所有投湖中云以為禮。積數年復過有數吏來候明云：「青洪君相邀」且曰：「感公有禮且厚遺公顧勿取獨求如願耳。」明既見，逐求如願，如願者，青洪君婢也。明將歸所願輒得數年大富。（苕溪漁隱叢

話）

茶歌

藝苑雌黃云：玉川子有謝孟諫議惠茶歌，范希文亦有關茶歌，此二篇皆佳作也，殆未可以優劣論。然玉

川歌云：「至尊之餘合王公，何事便到山人家；」而希文云：「北苑將期獻天子，林下雄豪先鬪美」若

論先後之序，則玉川之言差勝雖然，如希文豈不知上下之分者哉亦各賦一時之事耳。

茗溪漁隱曰藝苑以盧范二篇茶歌皆佳作未可優劣論今錄全篇余謂玉川之詩優於希文之歌玉川

自出胸臆造語穩貼得詩人句法希文排比故實巧欲形容宛成有韻之文是果無優劣耶。玉川走筆謝

孟諫議惠新茶云：「日高丈五睡正濃將軍打門驚周公口云諫議送書信白絹斜封三道印開緘宛見

諫議面手閱月團三百片聞道新年入山裏蟄蟲驚動春風起。天子須嘗陽羨茶百草不敢先開花仁風

暗結珠琲瓃先春抽出黃金芽摘鮮焙芳旋封裹至精至好且不奢至尊之餘合王公何事便到山人家。

柴門反關無俗客紗帽籠頭自煎喫。碧雲引風吹不斷白花浮光凝椀面。一椀喉吻潤兩椀破孤悶三椀

搜枯腸惟有文字五千卷四椀發輕汗平生不平事盡向毛孔散五椀肌骨清六椀通仙靈。七椀喫不得

也，唯覺兩腋習習清風生蓬萊山在何處？玉川子乘此清風欲歸去山上羣仙司下土地位清高隔風雨。

安得知百萬億蒼生命墮在顛崖受辛苦。便爲諫議問蒼生，到頭合得蘇息否？」希文和章岷從事鬪茶

歌云：「年年春自東南來，建溪先暖氷微開。溪邊奇茗冠天下，武夷仙人從古栽。新雷昨夜發何處家家

嬉笑穿雲去。露芽錯落一番榮，綴玉含珠散嘉樹，終朝采掇未盈襜，唯求精粹不敢貪，研膏焙乳有雅製，

方中圭兮圓中蟾。北苑將期獻天子，林下雄豪先鬥美，鼎磨雲外首山銅，瓶攜江上中泠水，黃金碾畔綠

塵飛，紫玉甌心翠濤起。鬥茶味兮輕醍醐，鬥茶香兮薄蘭芷，其間品第胡能欺，十目視而十手指勝若登

仙不可攀，輸同降將無窮恥，吁嗟天產石上英，論功不愧階前冀，眾人之濁我可清，千日之醉我可醒，屈

原試與招魂魄，劉伶却得聞雷霆。盧同敢不歌，陸羽須作經。森然萬象中，焉知無茶星。商山丈人休茹芝，

首陽先生休採薇。長安酒價減千萬，成都藥市無光輝，不知仙山一啜好，泠然便欲乘風飛，君莫羨花開，

女郎只鬥草，贏得珠璣滿斗歸。」（茗溪漁隱叢話）

雙井茶詩

茗溪漁隱曰：醉翁又有雙井茶詩云：「西江水清江石老，石上生茶如鳳爪。窮臘不寒春氣早，雙井芽生

先百草，白毛囊以紅碧紗，十斛茶養一觔芽。長安富貴五侯家，一啜尤須三日誇。」蔡君謨好茶又精

於藻鑒，答程公闢簡云：「向得雙井四兩其時人還未試，絨謝不悉尋烹治之色香味皆精好，是為茗芽

之冠，非日注寶雲可並也。涪翁又嚳雙井蓋鄉物也。」李公擇有詩嘲之戲作解嘲云：「山芽落磑風迴

雪，曾與尚書破睡來，勿以姬姜棄憔悴，逢時瓦釜亦鳴雷。」又答黃冕仲索煎雙井，并簡王揚休詩云：

「江夏無雙乃吾宗，同舍顏似王安豐能澆茗椀濡祓我，風神欲把浮邱公吾宗落筆賞幽事秋月下照

澄江空家山鷹爪是小草，敢與好賜雪龍同。不嫌水厄幸來辱，寒泉湯鼎聽松風。」（苕溪漁隱叢話）

送茶詩

錢顗在秀州監稅，舊曾作臺官，始於秀州，與之相見後錢顗作詩送茶來，某作詩謝之云：「我官於南今幾時，嘗盡溪茶與山茗。胸中似記故人面，口不能言心自省。為君細說我未暇，試評其略差可聽。建溪所產雖不同，一一與君子性森然可愛不可慢，骨清肉膩和且正。雪花雨腳何足道，啜過始知真味永。縱復苦硬終可錄，汲黯少戇寬饒猛。草茶無賴空有名，高者妖邪次頑獷。體輕雖復彊浮泛，性滯偏工嘔酸冷。其間絕品豈不佳，張禹縱賢非骨鯁。葵花玉誇不易致，道路幽險隔雲嶺。誰知使者來自西，開緘磊落收百餅。嗅香嚼味本非別，透紙自覺光炯炯。秕糠團鳳友小龍，奴隸日注臣雙井。收藏愛惜待佳客，不敢包裹鑽權倖。此詩有味君勿傳，空使時人怒生瘦」此詩云：「草茶無賴空有名，高者天邪次頑獷」以譏世之小人若不諂媚天邪，須頑獷狠劣也又云：「其間絕品豈不佳，張禹縱賢非骨鯁」亦以譏世之小人如張禹雖有學問細行謹飭終非骨鯁之人也。又云：「收藏愛惜待佳客，不敢包裹鑽權倖此詩有味君勿傳空使時人怒生瘦」以譏世之小人有以好茶鑽求富貴權要者見此詩當大怒也。（苕溪漁隱叢話）

山谷賦

山谷賦苦笋云：「苦而有味，如忠諫之可活國；多而不害，如舉士而能得賢」可謂得璧笋三昧「泓泓

乎，如澗松之發清吹浩浩乎，如春空之行白雲。」可謂得煎茶三昧（岩棲幽事）

茶字

茶字自中唐始變作茶，其說已詳之唐韻正，按困學紀聞：荼有三，誰謂荼苦茶，有女如荼，茅秀也以

藦荼蓼陸草也。今按爾雅荼荼字凡五見而各不同。釋曰：荼苦菜。

味苦可食之菜。本草一名選一名游冬，易緯通卦驗元圖云荼苦菜生於寒秋經冬歷春乃成月令孟夏苦

菜秀是也。葉如苦苣而細斷之有白汁花黃似菊堪食但苦耳。又曰：蔈荂茶。注引詩誰謂荼苦其甘如薺疏云此

及詩有女如荼皆云荼茅秀也其別名此二字皆從草從余又曰荼委葉

有細刺可以染赤疏云荼茅秀也。陶注本草云田野甚多壯如大馬蓼莖斑而葉圓是也又曰荼虎杖注云似紅草而麤大

注引詩以荼蓼蓼疏云荼一名委葉王蕭說詩云荼陸璣穢草然則荼者原田蕪穢之草非苦荼也今詩本

袾作薅此二字皆從涂。釋木曰檟苦茶。注云樹小如梔子冬生葉可煮作羹飲今呼早采者為荼晚取者

為茗一名荈蜀人名之苦荼此一字亦從草從余今以詩致之，邶風之荼苦，七月之采荼縣之董荼皆

苦荼之荼也又借而為荼毒之荼桑柔湯誥皆苦茶之荼也。夏小正取荼莠周禮地官掌荼儀禮既夕禮

茵著用荼實絞澤焉。詩鴟鴞捋荼傳曰荼萑苕也。正義曰謂亂之秀穗茅亂之秀其物相類故皆名荼也。

茅秀之茶也，以其白也，而象之出其東門，有女如荼。國語，吳王夫差，萬人爲方，陳白常白旗素甲白羽之

燈望之如荼。荼考工記望而眠之，欲其荼白亦茅秀之茶也。良粗之荼蔘委葉之蕊也。唯虎杖之蕊與橰之

苦荼不見於詩體。而王褒僮約云陽武買茶張載登成都白菟樓詩云芳茶冠六淸孫楚詩云薑桂茶荈

出巴蜀。本草衍義晉溫嶠上表貢茶千斤茗三百斤是知自秦人取蜀而後始有茗飲之事王褒僮約云：

匏鼇烹茶，後云陽武買茶注以前爲苦荼後爲茗（日知錄）

茶經等

陸羽嗜茶，自此後，茶字，減一畫爲茶。著經三篇言茶之原之法、之具尤備。天下益知飲茶矣。有常伯熊者，因羽論復

廣著茶之功其後尚茶成風。時囘紇入朝始驅馬市茶至明代設茶馬御史。而大唐新語言右補闕綦母

奭性不飲茶著茶飲序曰：「釋滯消壅一日之利暫佳瘠氣侵精終身之害斯大獲益則功歸茶力貽患

則不謂茶災豈非福近易知害遠難見？」宋黃庭堅茶賦亦曰：「寒中瘠氣莫甚於茶或濟之鹽勾賊破

家。」今南人往往有茶癖而不知其害此亦攝生者之所宜戒也（日知錄）

大觀茶論

宋徽宗有大觀茶論二十篇皆爲碾餅烹點而設不若陶穀十六湯韶美之極（太平淸話）

品惠爾賦

徐長谷品惠泉賦序云「叔皮阿子遠遊來歸，汲惠山泉一器遺余東皋之上。余方靜掩竹門消詳鶴夢，奇事忽來逸與橫發乃乞新火煑而品之使童子歸謝叔皮焉」（太平清話）

乞梅茶帖

乞梅茶帖，顧僧孺與某往來絕筆也。帖在正月五日十三日某從婁東歸則僧孺死一日矣其帖云「病寒發熱思喫臘梅花意甚切敢移之高齋更得秋茗啜之尤佳此二事兄必許我不令寂寞也雨雪不止，將無上元後把臂耶」此帖字盡遒勁不類病時作人生奄忽如此何以堪之往與僧孺相酬答不下萬紙，後無存者使人神傷朋友手澤亦何與人事要可發一時之相憶云爾。（梅花草堂筆談）

茶史

趙長白作《茶史》，攷訂頗詳要以識其事而已矣。龍團鳳餅紫茸驚芽泆不可用於今之世予嘗論今之世筆貴而愈失其傳茶貴而愈出其味此何故茶人皆其口鼻穎人不知書字天下事未有不身試之而出者也。（梅花草堂筆談）

許然明

許次紓字然明，號南華，方伯茗山公之幼子。跛而能文，好蓄奇石好品泉又好客性不善飲宴客每徹宵且金錯到手隨盡坐是屢困因出遊閩楚燕齊數千里外嘗裹金數鎰歸歸數月又盡貧自若也。與黃貞

、吳伯霖、張仲初、馮開之諸公善家東城，近慈雲寺，並城對池，境甚瀟洒。所著詩文甚富，有小品宝薁柳齋二集。今失傳予曾得其所著茶疏一卷論產茶采摘炒焙烹點諸事凡三十六條深得茗柯至理與陸羽茶經相表裏。前有吳興姚叔度紹憲同里許才甫世奇二序稱然明歿後三年感夢於才甫曰：「欲以茶疏災木今以累子」。才甫因授剞劂文士結習不能忘情於身後事亦奇矣。（東城雜記）

采茶歌

舊春上元，在衡山縣會臥聽采茶歌賞其音調而於辭句僧如也。今又口衡山於其土音雖不盡解，十可三四領其意義因之而歎古今相去不甚遠村婦稚子口中之歌而有十五國之章法顧左右無言者浩歎而止（廣陽雜記）

施茶所

黃廓嶺有望蘇亭施茶所也其上有菴僧見母子出家於內衡人全俊公讀予為聯以贈予題茶亭云：「趙州茶一口吃乾臺山路兩腳走去。」題堂前云：「奉親入道成真孝教子離塵是大慈。」題山門云：「門外鳥啼花落菴中飯熟茶香。」（廣陽雜記）

蟹殼泉詩

仁和馬小藥嘗從其鄉人秋藥太常視學陝廿，得嘗蟹殼泉，而作詩曰「何年老阿旁乘潮上絕壁誤墮

嚴隙中，遺筐化爲石。紅膏變玉腴，元津漬礫蟻窠同九迴蚌承時一滴承以淸絲瓶重之素錦羅玉孫喜茗事延客松風宅。小甌侍獠奴輕甌捧詞伯晴先魚眼生爪從兎毫別（得窯誰兎褐色有豬鬃蟹爪紋 琴聲聽爬沙詩情）到郭索釀酒當更佳蟹黃同一脈」，（通州雪酒以蟹黃井釀之，朱人易以西湖，味稍劣。）

鎖吟竹茂才成，系出囘紇嘉道間之錢塘諸生也亦有試蟹殼泉詩云，「山深有石蜕，其色黝如鐵。云是試淸泠迥與江水別。煎茶固其宜釀酒亦甘潔」（淸稗類鈔）

吳秋農飲鍋焙茶

鍋焙茶產邛州火井漕篛裹囊封遠致西藏味最濃冽，能蕩滌腥羶厚味，喇嘛珍爲上品乾隆末錢塘吳秋農茂才開世隨宦蜀中，嘗飲之而爲詩曰：「我聞蜀州多產茶，檟蔎茗荈誇詭陵丹陵種數十，中項上淸爲最嘉。臨邛早春出鍋焙，彷彿蒙山露芽翠。壓膏入臼築萬杵紫餅月團留古意。火井檟邊萬樹叢馬馱車載千城通。性醇味厚解毒癘，此茶一出凡品空竹君憐我病渴久，一鞭雙籠長驅走淸風故人與俱來不思更貰當壚酒滌罋洗礪屑桂薑活火烹試第二湯綠塵碧乳瀉百盞蘇我病骨津枯腸庭前一葉秋容淺天末懷人情輾轉何時辟井汲新泉共聽羊腸看蟹眼」（淸稗類鈔）

祝斗巖詠羡茶

嗜習

海寧祝斗嚴員外翼權嘗作羨茶歌，以和傅筬嚴歌云：「曉院鹿盧如轉轂古牆不礙詩城築。春雲入頰細無痕卷簾長嘯清酣獨十年間為一官忙乘輿何當頻看竹故園箈巌夢中肥覺來初報凌霄熟我昔最慕武夷茶解事還能散馥郁沸鼎松聲噴綠濤雲根漱玉穿飛瀑此時挂頰意超越置身彷彿南泠曲。小軒蘭淆午晴初個中自有真清福不須斗酒換西涼春芽絕勝葡萄麴習習生風兩腋間狂來潑袖忘杯覆所謂伊人在水湄詩來百讀沁心脾鶴怨猿啼歸未得文成應有北山移。」（清稗類鈔）

吳我鷗喜雪水茶

以雪水烹茶俊味也吳我鷗喜之嘗為詩曰，「絕勝江心水飛花注滿甌纖芽排夜試古甓隔年留寒憶冰階掃香參玉乳浮詞清應可比曾浣一襟秋。」（清稗類鈔）

朱古微不嗜茶

朱古微侍郎祖謀不嗜茶嘗有睡起二絕句云：「病入梅天信有魔，透簾風與藥烟和，策勛茗椀非吾事，孤負一封春碧螺。」〔碧螺春，茶名，產太湖洞庭山，其味在龍井之上。〕「蒼鳩喚客語連晨草樹風乾不動塵，睡起南塘知有雨野雲爐篆雨輪囷。」（清稗類鈔）

王濛

晉司徒長史王濛，好飲茶，人至輒命飲之，士大夫皆患之，每欲往候，必云今日有水厄。（世說）

皮光業 一

天福二年，國建拜光業丞相美容儀善談論，見者或以爲神仙中人性嗜茗常作詩以茗爲「苦口師」

國中多傳其辯。（吳越春秋皮光業傳）

皮光業 二

皮光業最耽茗事。一日中表請嘗新柑筵具殊豐簪紱叢集纔至未顧尊罍而呼茶甚急徑進一巨甌題

詩曰：「未見甘心氏先迎苦口師。」衆噱曰：『此師固清高而難以療饑也』（清異錄）

喊山

文昌雜錄云庫部林郎中說建州上春探茶時茶園人無數擊鼓聲聞數里；然一園中才間壟茶品已相

遠又況山園之異邪。茗溪漁隱曰歐陽永叔嘗茶詩云「年窮臘盡春欲動蟄雷未起驅龍蛇夜聞擊鼓

滿山谷千人助叫聲哈呀萬木寒凝睡不醒惟有此樹先萌芽」余官富沙凡三春備見北苑造茶但其

地暖纔驚蟄茶芽已長寸許初無聲鼓喊山之事。永叔詩與文昌所紀皆非也。北苑茶山凡十四五里茶

味惟均豈有間壟茶品已相遠之說邪（茗溪漁隱叢話）

心一堂　飲食文化經典文庫

半斤

馬令南唐書云：豐城毛炳好學不能自給入廬山與諸生講詩獲鏹即市酒盡醉時彭會好茶而炳好酒，時人爲之語曰：「彭生坐賦茶三片毛氏詩傳酒半斤。」（天祿識餘）

此坐

一鳩呼雨修篁靜立茗椀時供野芳暗度又有兩鳥呦嚶林外均節天成童子倚爐翛屛忽鼾忽止念旣虛閒室復幽曠無事此坐長如小年。（梅花草堂筆談）

濟南人

濟南人不重茗飲而好酒雖大市集無茶肆故勞動界之金錢消耗較少而士夫之消耗光陰亦不至如南人之甚朋羣徵逐惟飲酒酒多高粱（清稗類鈔）

張則之嗜茶

丹徒張則之名孝思嗜茶有茶癖謂天地間物無不隨時隨境隨俗而有變遷茶何獨不然古宜而今未必宜有今然而古未必然茶亦有世輕世重焉其嗜茶也出入陸氏之經酌古準今定其不刊之宜神明變化得乎口而運乎心矣且善別水性若他往必以已品定之水自隨能入其室而營其茶者必佳士也則之順治時人。（清稗類鈔）

長沙人食茶

湘人於茶不惟飲其汁輒并茶葉而咀嚼之。人家有客至，必烹茶若就壼斟之以奉客，爲不敬，客去，啟茶碗之蓋，中無所有，蓋茶葉已入腹矣。（清稗類鈔）

蒙古人食茶

茶，飲料也，而蒙古人乃以爲食，非加水而烹之也。所用爲磚茶，輒置於牛肉牛乳中，雜羹之，其平日雖偏於肉食而不患壞血病者，亦以此。（清稗類鈔）

葉仰之嗜茶酒

葉仰之茂才觀文，康熙朝之錢塘人。初嗜酒，醉輒嫚罵已而病，涓滴不能飲，復嗜茶。（清稗類鈔）

德宗嗜茶煙

德宗嗜茶，晨與必盡一巨甌，兩脚雲花，最工選擇其次閒鼻煙少許，然後詣孝欽后宮行請安禮。（清稗類鈔）

茶癖

人以植物之葉製爲飲料實爲五洲古今之通癖，其源蓋不可考。西人嗜咖啡椰子，東人好茶，其物雖以所居而異，好飲一也。然據醫士研究謂此種飲料含水之多，由百分之九十至九十八，而此少許之飲料，

於身體實無所益，飲者亦藉其芬芳之氣，爲進水之階而已。茶癖非生而有也，乳臭之童飲茶常苦其澀，不雜以糖果則不能下飲長隨社會之所好，然後成癖成人有終歲不飲茶者於身體之健康殊無影響，其非生命必需之物，蓋無疑義。

世界產茶之地，首推吾國，次則印度日本錫蘭，西人視烏龍爲珍品，卽吾國之紅茶也茶之上者，製自嫩葉幼芽間以花蕊其能香氣襲人者以此耳。劣茶則成之老葉枝幹枝幹合製革鹽最多此物爲茶中最多之部故飲劣茶害尤甚也茶味皆得之茶素茶素能激剌神經，飲茶覺神旺心清能激夜不眠者以此。然枵腹飲之使人頭暈神亂，如中酒然，是曰茶醉。

茶之功用仍恃水之熱力食後飲之，可助消化力。西人加以糖乳，故亦能益人，然非茶之功也。茶中妨害消化最甚者爲製革鹽，此物不易融化，惟大烹久浸始出若僅加以沸水味足卽傾出飲之無害也吾人飲茶頗合法特有時浸漬過久爲可憂耳久煮之茶味苦色黃以之製革則佳詛之腹中不可也青年男女年在十五六以下者以不近茶爲宜其神經統系幼而易傷又健於胃無需茶之必要爲父母者宜戒之。（清稗類鈔）

器物

蠟環樏子

始建中，蜀相崔寧之女以茶杯無襯病其熨指，取樏子承之，既啜而杯傾，乃以蠟環樏子之央，其杯遂定。

即命匠以漆環代蠟，進於蜀相。蜀相奇之，爲製名而話於賓親，人人爲便用於代，是後傳者更環其底愈

新其製，以至百狀焉。（資暇錄）

王城東茶囊

古人謂貴人多知人，以其閱人物多也。張鄧公爲殿中丞，一見王城東，遂厚遇之語，必移時，王公素所厚，

惟楊大年公有一茶囊，惟大年至，則取茶囊具茶，他客莫與也。公之子弟但聞取茶囊，則知大年至。一日，

公命取茶囊，羣子弟皆出窺大年；及至，乃鄧公他日公復取茶囊又往窺之，亦鄧公也。子弟乃問公：『張

殿中者何人公待之如此』？公曰：『張有貴人法，不十年當據吾座』。後果如其言。（夢溪筆談）

蜀公茶器

蜀公與溫公同遊嵩山，各攜茶以行。溫公以紙爲貼，蜀公用小木合子盛之。溫公見之驚曰：『景仁乃有

茶器也』。蜀公聞其言，留合與寺僧而去。後來士大夫茶器精麗，極世間之工巧，而心尤未厭，晁以道嘗

以此語客曰：『使溫公見今日茶器，不知云如何也』！（曲洧舊聞）

茶羅子

心一堂　飲食文化經典文庫

張芸叟曰：『申公知人，故多得於下僚。家有茶羅子一，金飾，一棕欄。方接客索銀羅子，常客也，金羅子，禁近也；棕欄則公輔必矣。家人常挨排於屏間以候之。』申公溫公同時人，而待客茗飲之器，顧飾以金銀，分等差益知溫公儉德世無其比（清波雜志）

第一綱茶

仲春上旬，顧建漕司，進第一綱茶名「北苑試新」方寸小夸，進御止百夸，護以黃羅輭盝籍以青篛，裹以黃羅夾複臣封朱印外用朱漆小匣鍍金鎖又以細竹絲織笈貯之，凡數重此乃雀舌水芽所造一夸之直四十萬僅可供數甌之啜耳。或以一二賜外邸則以生線分解轉遺好事以為奇玩茶之初進御也，翰林司例有品賞之費皆漕司邸吏賂之，間不滿欲則入鹽少許茗花為之散漫，而味亦漓矣。禁中大慶會則用大鍍金鑒以五色韻果簇酊龍鳳謂之繡茶不過悅目亦有專其工者外人罕知因附見於此。

（乾淳歲時記）

水豹囊

豹革為囊風神呼吸之具也。煑茶啜之可以滌滯思而起清風；每引此義稱茶為水豹囊。（清異錄）

銅葉

凍坡後集從駕景靈宮詩云：「病貪賜茗浮銅葉，」按今御前賜茶皆不用建盞，用大湯鐅，色正白但其

制樣，似銅葉湯斝耳銅葉色黃褐色也。（演繁露）

茶具

長沙茶具精妙甲天下，每副用白金三百星或五百星凡茶之具悉備外則以大樓銀合貯之。趙南仲丞相帥潭日，嘗以黃金千兩爲之以進上方。穆陵大喜蓋內院之工所不能爲也。因記司馬公與范蜀公游嵩山各攜茶以往溫公以紙爲貼，蜀公盛以小黑合，溫公見之曰：『景仁乃有茶具耶』蜀公聞之因留合與寺僧而歸。向使二公見此當驚倒矣。（癸辛雜識）

茶器

長沙匠者造茶器極精緻工直之厚，等所用白金之數士夫家多有之寶几案間，但知以侈靡相夸，初不常用也。司馬溫公偕范蜀公游嵩山各攜茶往溫公以紙爲貼，蜀公盛以小黑合，溫公見之驚曰：『景仁乃有茶器！』蜀公開其言，遂留合與寺僧。凡茶宜錫竊意若以錫爲合適用而不侈，貼以紙則茶味易損，豈亦出雜以消風散意欲矯時繁耶！邵氏聞見錄云：「溫公嘗與范景仁共登嵩頂，由轘轅道至龍門，涉伊水至香山憩石臨八節灘凡所經從，多有詩什作自序曰：遊山錄攜茶遊山當是此時。」（清波雜誌）

釣雪

趙凡倩人製茶壺式類時彬輒毀之或云求勝彬壺非也時彬壺不可勝，凡夫恨其未極壺之變故補

爾聞有釣雪藏錢受之家僧純如云狀似帶笠而釣者然無牽合，意亦奇矣，將請觀之。（梅花草堂筆

談）

茶寮

構一斗室相傍山齋，內設茶具，教一童專主茶役，以供長日清談寒宵兀坐幽人首務不可少廢者。（長

物志）

滌器

茶瓶茶盞不潔，皆損茶味。須先時洗滌淨布拭之以備用。（長物志）

茶洗

以砂爲之製如碗式，上下二層。上層底穿數孔，用洗茶沙垢皆從孔中流出最便。（長物志）

茶爐湯瓶

有姜鑄銅饕餮獸面火鑪及純素者，有銅鑄如鼎彝者皆可用。湯瓶鉛者爲上錫者次之銅者不可用形

如竹筒者既不漏火又易點注瓷瓶雖不奪湯氣然不適用，亦不雅觀。（長物志）

茶壺

331

壺以砂者爲上，蓋既不奪香，又無熟湯氣。供春最貴，第形不雅，亦無差小者。時大彬所製又太小。若得受水半升而形製古潔者，取以注茶更爲適用。其提梁、臥瓜、雙桃、扇面、八稜細花、夾錫茶替青花白地諸俗式者俱不可用。錫壺有趙良璧者亦佳。然宜冬月間用。近時吳中歸錫嘉禾黃錫價皆最高。然製小而俗。金銀俱不入品。（長物志）

茶盞

宣廟有尖足茶盞，料精式雅，質厚難冷，潔白如玉，可試茶色。盞中第一。世廟有檀盞中有茶湯果酒，後有金籙大醮檀用等字者亦佳。他如白定等窰藏爲玩器，不宜日用。蓋點茶須熁盞令熱，則茶面聚乳。舊窰器熁熱則易損，不可不知。又有一種名崔公窰差大可置果實。果亦僅可用榛、松、新笋、雞豆、蓮實不奪香味者。他如柑橙、茉莉、木樨之類，斷不可用。（長物志）

擇炭

湯最惡煙，非炭不可。落葉、竹篠、樹梢、松子之類，雖爲雅談，實不可用。又如暴炭、膏薪、濃烟蔽室，更爲茶厄。炭以長與茶山出者名金炭，大小最適用。以麩火引之，可稱湯友。（長物志）

時大彬壺

時壺名遠甚，卽遐陬絕域，猶知之。其制始於供春壺式古樸風雅，茗具中得幽野之趣者，後則如陳壺徐

壺皆不能髣髴大彬萬一矣。一云，供春之後四家，董翰、趙良、遠衰錢其一則大彬父時鵬也彬弟子李仲芳芳父小圓壼李四老官號養心在大彬之上爲供春勁敵今罕有見者或淪鼠菌或重鷄葬壺亦有幸有不幸哉。（秋園雜佩）

　供春

宜與砂壺供春爲上時大彬次之。時壺尙可得供春則絕蹟矣供春者，陽羨名陶錄以爲童子，查初白詞注以爲吳家婢也未知孰是。（兩般秋雨菴隨筆）

古今雅事叢刊

書名	編著者	裝訂	定價
古今酒事		精裝本	七元
古今茶話	胡山源編	精裝本	四元
象棋與棋話	胡山源編	精裝本	五元
圍棋與棋話	沈子丞編	精裝本	印刷中
食譜大觀	沈子丞編	精裝本	三元六角
京調指南	周家森編	平裝本	各一元
樂學大綱	吳虞公編	平裝本二冊	一六元
圖書館學大觀	許志豪編	精裝本	一元八角
書法正傳	鄭寄人編	平裝本	三元六角
圖繪寶鑑	沈志人著	平裝本二冊	二元四角
藝林名著叢刊	馮武著	精裝本	七元四角
(足本)芥子園畫譜	夏文彥著	精裝(合訂本)	一元八角
馬駘畫寶	包世臣等	平裝本	四元
圖畫類典	馬企周繪	平裝本	二元四角
楹聯大全	陳抱一繪	精裝本	一元八角
幽默筆記	胡源編	精裝本	八元八角
幽默詩話	胡山源編	精裝本	二元四角
小品妙選	蘇淵雷編	精裝本	四元
詩詞精選	蘇淵雷袁編	精裝本	四元六角
美化文學名著叢刊	葉紹鈞等	精裝本	三元六角
章台紀勝名著叢刊	朱劍芒編	精裝本	三元二角

世界書局出版

中華民國三十年九月初版

古今茶事

翻印必究費匯業

編輯者　胡山源

發行人　陸高誼

出版者　世界書局

發行所　上海及各埠　世界書局

書名：古今茶事
系列：心一堂・飲食文化經典文庫
原著：【民國】胡山源
主編・責任編輯：陳劍聰

出版：心一堂有限公司
通訊地址：香港九龍旺角彌敦道六一〇號荷李活商業中心十八樓〇五一〇六室
深港讀者服務中心：中國深圳市羅湖區立新路六號羅湖商業大廈負一層〇〇八室
電話號碼：(852) 67150840
網址：publish.sunyata.cc
淘宝店地址：https://shop210782774.taobao.com
微店地址： https://weidian.com/s/1212826297
臉書： https://www.facebook.com/sunyatabook
讀者論壇： http://bbs.sunyata.cc

香港發行：香港聯合書刊物流有限公司
地址：香港新界大埔汀麗路36號中華商務印刷大廈3樓
電話號碼：(852) 2150-2100
傳真號碼：(852) 2407-3062
電郵：info@suplogistics.com.hk

台灣發行：秀威資訊科技股份有限公司
地址：台灣台北市內湖區瑞光路七十六巷六十五號一樓
電話號碼：+886-2-2796-3638
傳真號碼：+886-2-2796-1377
網絡書店：www.bodbooks.com.tw
心一堂台灣國家書店讀者服務中心：
地址：台灣台北市中山區松江路二〇九號1樓
電話號碼：+886-2-2518-0207
傳真號碼：+886-2-2518-0778
網址：http://www.govbooks.com.tw

中國大陸發行　零售：深圳心一堂文化傳播有限公司
深圳地址：深圳市羅湖區立新路六號羅湖商業大廈負一層008室
電話號碼：(86)0755-82224934

版次：二零一七年九月初版，平裝

心一堂微店二維碼　　心一堂淘寶店二維碼

定價：　港幣　　　一百五十八元正
　　　　新台幣　　五百九十八元正

國際書號 ISBN 978-988-8317-73-8